CATALOGUE OF THE
ETCHINGS AND DRY-POINTS OF
CHILDE HASSAM

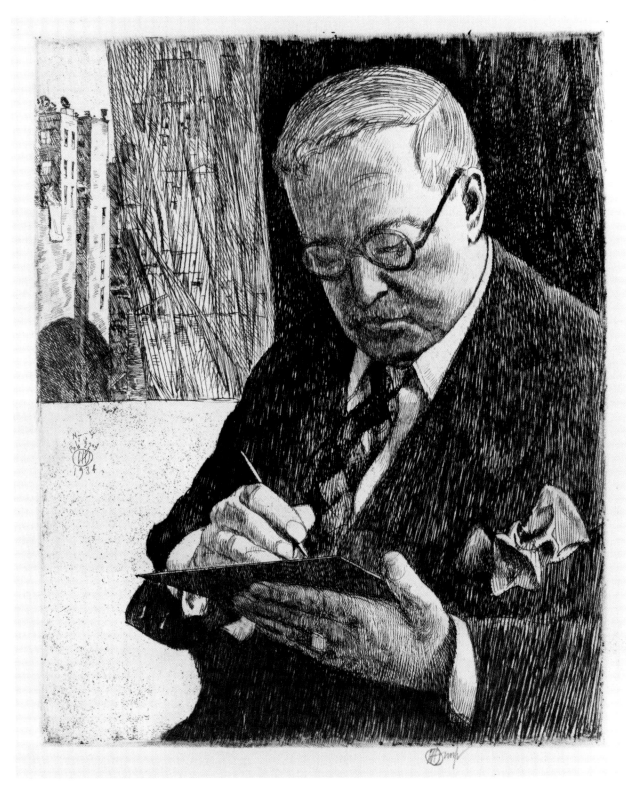

380. C.H. ETCHING

CATALOGUE OF THE ETCHINGS AND DRY-POINTS OF CHILDE HASSAM, N.A.

OF THE AMERICAN ACADEMY OF ARTS AND LETTERS

1869-1948.

ROYAL CORTISSOZ
and the
LEONARD CLAYTON GALLERY

Revised Edition

ALAN WOFSY FINE ARTS
SAN FRANCISCO
1989

This Work combines and revises the Catalogues
first published in 1925 and 1933 with the addition
of several new descriptions and many new illustrations.

© Alan Wofsy Fine Arts 1989
P.O. Box 2210
San Francisco, CA 94126

ISBN 1-55660-029-1

Printed in the U.S.A.

CONTENTS

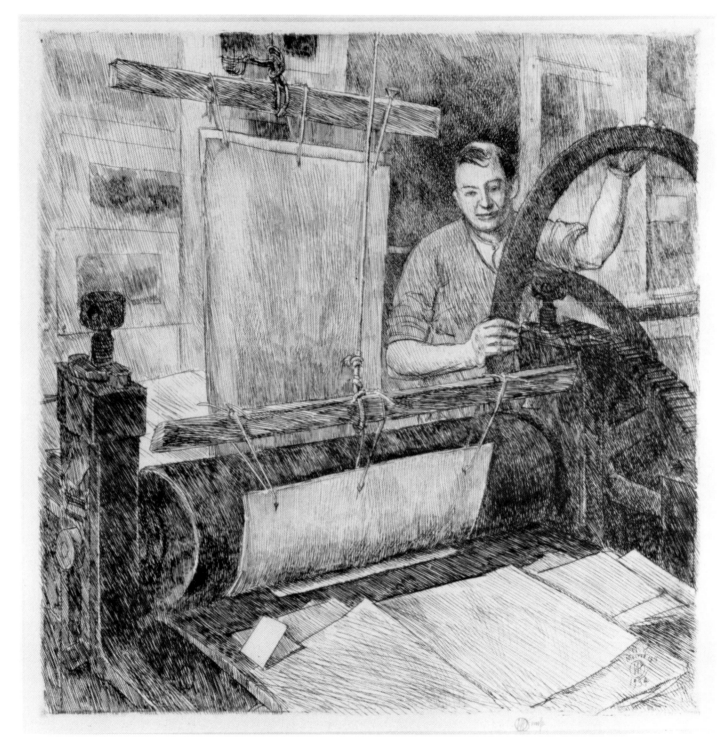

379. THE PLATE PRINTER, PETER J. PLATT

INTRODUCTION

THE test of the painter-etcher is his ability to do with the needle what he can do with the brush, to carry over into a black and white art something of the quality which is characteristic of his work in color, to be himself, in other words, though he may change his wonted instrument. It is his meeting of this test that vitalizes Mr. Hassam's plates. Nothing about them, to my mind, is more significant than their complete detachment from that vein of sedulous emulation of this or that master which is so often perceptible in contemporary etching. The influence of Whistler, for example, has been widespread and profound. The play of his line has fascinated one junior of his after another. Artists of high talent have found the readiest outlet for their energy in being "Whistlerian." Mr. Hassam has escaped the temptation to form himself on Rembrandt's latter-day rival. Doubtless, with an artist's appreciation of masterpieces, he has felt the magic in Whistler and even received some obscure inspiration from him. I should be surprised if this were not the case. But the contact has left his artistic individuality untouched.

In a measure, his originality must be due to the date of his serious concern with etching, a date coming after his outlook upon life and art had been fixed. As this catalogue shows, he drew a couple of French plates as far back as 1898, but the first of these was not finished until 1915, and the essential work here recorded begins as recently as that year. The artist was then forty-six, when he could look back over a long experience as a painter. He had been trained in Paris and reviving my memories of the first things he exhibited on his return from abroad I see him as an exemplar then of the polished realistic method typical of the Salon. He painted some capital street scenes at that time but he was in spirit a man of the studio, whose key is set by a north window. Presently his art suffered a beautiful expansion. Like his friends, Twachtman and Weir, he responded to the appeal of Monet and his luminous impressionism, not in a mood of imitation but with a heightened sense of the values latent in just the free play of light and air. Thenceforth he beat out a style of his own in which color and atmosphere were no less important than the truths

of form which it had previously been his leading occupation to denote. I speak here of what might be called the canonical elements in pictorial art—form, color, light, and shade, and the great factor of design. But it would be an incomplete analysis that failed to take account of a certain *joie de vivre* implicit in all Mr. Hassam's work. The thing that has stamped him has been the happy, inspiriting nature of his impressions of the American scene.

Always interested in urban motives, such as appear in more than one of his etchings, he has nevertheless been primarily a painter of landscape and the sea, of flowers *en masse*, of the old houses which belong to the very structure of our countryside, and of the vivid skies that envelop the whole spectacle. I recall designs of his painted long ago on the Isles of Shoals. The sea-stained rocks in them and the glittering gardens are bathed in light and they seem murmurous with sweet winds. These pictures had brilliant color in them and the color was touched by the brightness of a jocund world. Along with this truth there came a new personal charm, the accent of a fresh and strong temperament. It was in the full possession of these resources, with an art ripened and accomplished, that some ten years ago Mr. Hassam launched upon the making of his etchings and it is only with a realization of his development as a painter that you arrive at a just appreciation of his etched work.

This is the work of an objective designer who may be interested in the fashioning of an æsthetic pattern but is really far more solicitous about the innate character of the subject portrayed. Some of the plates, I know, might seem to contradict my remark. The "Elms in May" (No. 43) has that balanced rhythmic suggestiveness which one is tempted to ascribe to a purely decorative intention. Then it is obvious that a plate like the "Rain-drops and Surf" (No. 170) could only have been put together with the idea of subordinating the freedom of nature to formal composition. In all of those beach scenes which he has enlivened by nude figures the tendency toward abstract design is plain. But I am taking a large view of the subject and despite his not infrequently deliberate movement toward a conscious pictorial unity I would say that the broad purpose of Mr. Hassam's etchings is to give an absolutely direct representation of the thing seen. If he does not take it exactly as he finds it we may be sure that at any rate he registers visible fact, never seeking in any way to romanticize or poetize his subject. Take, in illustration, one of his high-water marks,

the study of the bridge over the inlet at Cos Cob which he calls "Old Lace" (No. 56). There is a pretty flourish in the title but the plate is a sincere statement of ponderable facts, of stout masonry, and swirling waters. I would cite this as an outstanding example of the etcher's simple force, and especially, of his painter-like feeling, which transmutes into black and white much of both the body and subtlety of color. Note, too, in this beautiful design, the potency of the cool, pervasive light. And observe finally the nature of the technique. Problems involving the use of long, sustained line do not invite Mr. Hassam as successfully as those which call for a terser stroke. You feel this in such a plate as the "Fifth Avenue at Noon" (No. 77), and you feel it again in the nudes and figure-subjects generally. He does not deal in the supple flowing contour, denoted in one broad stroke. His touch is rather brief, instead, and he gets his tones through fine webs of line. He gets them thereby in a very skilful and sensitive manner.

His sensitiveness, I cannot too often repeat, is that of the painter as well as that of the etcher and it is further enriched by that instinct for character at which I have already glanced. These prints are in large number portraits of places and as such they possess extraordinary merit. I am not thinking so much of the early pieces done in France as of those, more characteristic of the whole collection, which have an intensely American savor. No one has more sympathetically interpreted towns like Cos Cob or East-hampton, no one has more delightfully made us feel the charm in an old Connecticut barn, a tumble-down dock or a bridge flung across one of our pastoral rivers. If the etchings are interesting as so many works of easy and adroit craftsmanship they are also to be valued as so many studies of nature, so many contributions toward the beautiful celebration of American landscape. There is something in the nature of a *tour-de-force* about this mass of work. Absorbed in the activity of a painter, of one phenomenally prolific, too, Mr. Hassam turns aside and adds a matter of more than two hundred etchings to his *œuvre*. It is rather a feat. But, *tour-de-force* though it may be, there is in it nothing factitious, nothing of the artificiality which the phrase customarily connotes. Mr. Hassam has never been more spontaneous or more genuine than in his etchings.

ROYAL CORTISSOZ.

LETTER FROM JOSEPH PENNELL

February 23, 1923.

DEAR HASSAM:

I have been looking at your new plates, and at some of the old ones, which Keppels tell me you are about to show in their gallery. I think it will be a most interesting exhibition, for two reasons: first, because the plates are good, and, second, because they are your own subjects. They are *you* and that is what most etchers' work is not, though that to be yourself, to be personal, as you and I know, is the basis of all etching which is worth anything, but most etching is worth nothing! Besides your things are not the products of sudden commissions to fill a long-felt want, or to be in the fashion of the moment, of rapid trips with only time to make bad sketches, often only to buy picture postcards, and then rush back to try to accomplish the impossible, though the manufacture of such machines may fill the manufacturer's pockets and fool his public—but the subjects of your plates are the subjects you know, the motives about you that you always have known, and now in your ripe years are able to put on copper when you want and because you know they can only be done by that fascinating, entangling, maddening method—etching!

But, my dear Hassam, why am I writing this poppy-cock and drivel? You know and I know, and mighty few other of the people who have rushed into art in this country know, that America, our country, is full of subjects, and that our New York is the most marvellous and endless subject on the face of the earth. We have been trying to show this, and teach this, and put our preaching before the blind, the halt, and the thieves we have been the prey of for years, and your show is another proof that New England is also worth doing, that there are American women still left who do not look like flappers, that there are other methods besides tracing photographs, of drawing nudes, and that there are other ways and other motives than even yours and mine for etching New York.

These are the reasons why I like your work, built up "on the knowledge of a lifetime," and not upon expressionism, cubism, incompetence and conceit, the backbone of the rot and rubbish foisted by strange sharpers and incompetents—there are lots of blatant Americans, as they call themselves, among them—fooling the most gullible and ignorant public in the world, crying they know not why, save as an investment, for art and getting artlessness, but cocksure in the valor of their ignorance.

We also know that James McNeill Whistler is the greatest of etchers, because his aims and his accomplishments were the highest in his practice of "the science of the beautiful" in the science of etching the most perfect and not the easy, empty products of a misspent day. And sure in our convictions and in our beliefs we will go on, my dear Hassam, till the end of the chapter, to the best of our ability, founded upon the traditions of the ages in art, and not upon the latest fake and cut to escape beauty and avoid work; for we know that without the highest aims and the hardest work, nothing decent can be done. Most people in art don't know enough to come in when it rains, or dare to go out for fear they will get their feet wet. And we are also, though that is not our aim, showing the people that they can collect good work without being millionaires, and that if they collect—these collectors—the works of their contemporaries rather than confining themselves to the works of their predecessors, they will be doing something for art, something for artists, and something for themselves. We, you and I, in our prints are giving them the chance and are going to go on doing so. Because we love art, and because we love this undiscovered country—our country—which is full of art—though near swamped by artless artfulness.

So let us go on together. We started together, we have worked together as friendly rivals, each in his own way, and we will go on together to the end.

JOSEPH PENNELL.

BIOGRAPHICAL NOTE

FREDERICK CHILDE HASSAM was born at Dorchester, now part of the city of Boston, October 17, 1859, of direct English and American (1776) stock. Frederick Fitch Hassam and Rose Hathorn were his parents. Hassam is a variant (one of several as found on old deeds) of Horsham. This first William Horsham settled near Salem. William Hathorn came to Dorchester from Salem in 1631, having one of the Dorchester grants of land. His middle name is for an uncle by marriage, George Childe. His father's mother was Mary Hunt, of Charlestown, New Hampshire, daughter of Roswell Hunt. This family is made eminent by William Morris Hunt the painter and his brother the architect. It is perhaps worthy of note that the artist is connected with two names well known in the annals of the art of his country and in the case of Hawthorne—of the world.

Childe Hassam was educated in the Boston public schools and then studied art in Boston and, later, in Paris. He has received the following awards: Bronze medal, Paris Exposition, 1889; gold medal, Munich, 1892; gold medal, Philadelphia Art Club, 1892; medal, Chicago Exposition, 1893; prize, Cleveland Art Association, 1893; Webb prize, Society American Artists, 1895; prize, Boston Art Club, 1896; medal, Carnegie Institute, Pittsburgh, 1898; Temple gold medal, Pennsylvania Academy Fine Arts, 1899; silver medal, Paris Exposition, 1900; gold medal, Buffalo Exposition, 1901; gold medal, St. Louis Exposition, 1904; Thomas B. Clark prize, National Academy, 1905; gold medal, Carnegie Institute, Pittsburgh, 1905; Carnegie prize, Society American Artists, 1906; Walter Lippincott prize, Pennsylvania Academy Fine Arts, 1906; Jennie Sesnan gold medal, Pennsylvania Academy Fine Arts, 1910; Third W. A. Clark and Corcoran bronze medal, Corcoran Gallery, Washington, 1911; First W. A. Clark and gold medal, Corcoran Gallery, Washington, 1913; Hudnut prize, American Water Color Society, 1919; water-color prize, Philadelphia, 1920; gold medal of honor, Pennsylvania Academy Fine Arts, 1920; gold medal, Philadelphia Art Club, 1924.

BIOGRAPHICAL NOTE

He is represented in the following permanent collections: Pennsylvania Academy Fine Arts; Carnegie Institute, Pittsburgh; Cincinnati Museum, Buffalo Fine Arts Academy, Boston Art Club, Rhode Island School of Design, Art Club of Erie; Corcoran Gallery, Washington; Indianapolis Institute, Savannah Museum; Smith College, Northampton, Mass.; Freer Collection, Washington, D. C.; Metropolitan Museum of Art, New York; National Gallery; Walters Gallery, Baltimore; Smith College, Portland (Oregon); Art Museum, Art Institute, Chicago; Detroit Museum, Worcester Museum; City Art Museum, St. Louis; Museum Fine Arts, Boston; Brooklyn Museum; Duncan Phillips Collection, Washington, D. C.

He is a member of: Ten American Painters, New York; Société Nationale des Beaux Arts, Paris; The Secession, Munich; American Water Color Society, National Institute Arts and Letters, American Academy Art and Letters.

CATALOGUE OF THE
ETCHINGS AND DRY-POINTS OF
CHILDE HASSAM

NOTE

The plates are extant unless accounted destroyed and the number of proofs that exist is stated. Proofs of the etchings marked M. F. A. were shown in the exhibition of the artist's etched work at the Museum of Fine Arts, Boston, 1922.

Those marked C. I. were shown in the exhibitions of Mr. Hassam's etchings at the Carnegie Institute, Pittsburgh, in 1916 and 1922. Those marked A. I. C. were shown at the Art Institute, Chicago, at the time of the artist's exhibition of paintings, 1917. Those marked L. A. M. were exhibited in the Los Angeles Museum as this book went to press, 1925. Where proofs are owned by such public Museums it is so stated.

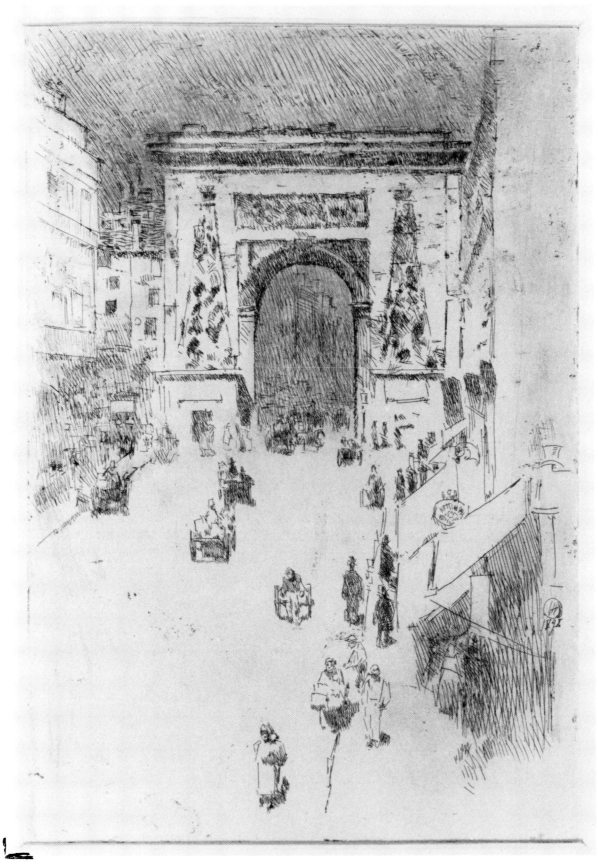

1. PORTE ST. MARTIN

CATALOGUE OF
THE ETCHINGS AND DRY-POINTS
OF CHILDE HASSAM

1. PORTE ST. MARTIN

11 by 7½ inches. Signed: C. H. 1898 near right margin. Begun in 1898, taken up and finished in 1915. Made from drawing now in collection of R. B. Moore.

Three states. Various graver additions in the arch and dry-point through the arch. 21 proofs. Plate destroyed.

C. I.

Through the arch, which is in the centre of the plate, pass a number of carriages and barrows. Shops on the right with pedestrians on the sidewalk.

2. GARDEN OF THE LUXEMBOURG

11 by 9 inches. Signed: C. H. 1898 in foliage upper left corner. Made from drawing now in collection of R. B. Moore. Begun in 1898, taken up and finished in 1915.

23 proofs. Plate destroyed.

C. I.

A scene in the park with nursemaids and children seated in the foreground. A balustrade crosses the centre of the composition. A marble statue on a pedestal is in the left centre.

3. LANNION

4 by 5 inches. Unsigned.

Childe Hassam's second continuous attempt at etching in 1915.

2 proofs only as plate was accidentally destroyed. One in the collection of John E. D. Trask. One in the collection of R. B. Moore.

C. I.

4. ST. SEPULCHRE, STRAND

7 by 4⅞ inches. Signed: C. H. 1915 in the sky, upper left corner.

Done from a drawing. Collection C. E. S. Wood. 11 proofs only as plate was destroyed in rebiting it.

C. I.

The façade of the church showing the iron fence and the sidewalk on which there are five figures lightly etched.

5. THE LAUREL WREATH

9⅛ by 4⅞ inches. Signed: C. H. 1907 in lower left corner.

Done from a drawing made in 1907. Now in collection of R. B. Moore.

20 proofs. Plate destroyed.

C. I.

Standing figure of a nude woman facing out. In left hand, which is uplifted, she holds a laurel wreath.

6. THE LILIES

6⅞ by 5⅜ inches. Signed: C. H. 1905 in lower right corner.

Done from a drawing made in 1905. In collection of C. E. S. Wood.

11 proofs. Plate destroyed.

C. I.

A nude figure of a woman faced toward the right stooping in the act of gathering lilies.

7. THE LITTLE POOL, APPLEDORE

5½ by 3 inches. Signed: C. H. 1915 in lower right corner.

Done from a drawing made at the Isles of Shoals. Collection R. B. Moore.

Various states with dry-point additions.

C. I.

Standing figure of a nude woman in the water with rocks on either side and at the back.

8. AT THE OPERA

5½ by 4 inches. Signed: C. H. 1915 near right margin.

Done from a drawing made one evening from a box at the opera. Collection Carter Harrison. Plate destroyed. 9 proofs only.

C. I.

Figure of a woman seen in profile in an opera box looking out over the audience.

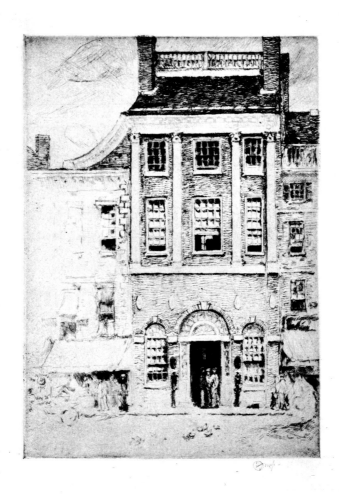

14. THE ATHENAEUM, PORTSMOUTH 8¼ by 5⅞ inches

9. CONTRE-JOUR

7 by 5½ inches. Signed: C. H. 1915 in lower left corner.

Done from model. Drawing also exists. Collection Carter Harrison. The painting (for which the drawing was made) is in the permanent collection of the Art Institute, Chicago.

C. I.

Woman in profile facing to the right, seated in a chair over which her right arm rests.

10. WEST POINT

3½ by 5⅞ inches. Signed: C. H. 1915 in the sky.

Done from nature in June, 1915.

C. I.

A view taken from the river, the famous war school buildings on a promontory in the centre. Across the back are mountains.

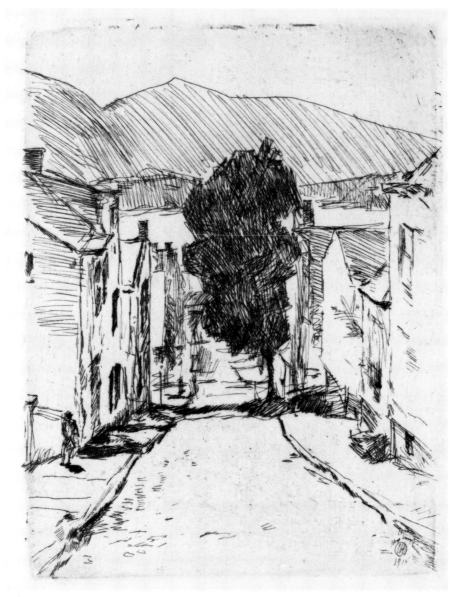

11. STREET IN NEWBURGH

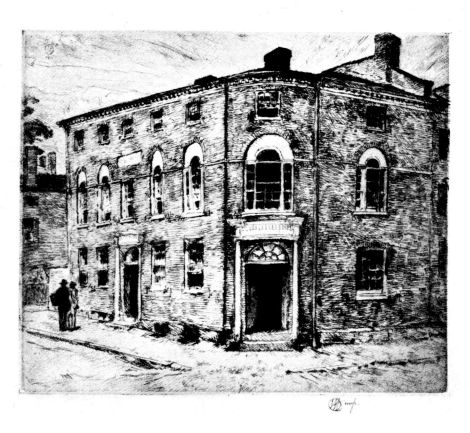

15. THE OLD CUSTOM HOUSE, PORTSMOUTH *5⅜ by 6¾ inches*

11 STREET IN NEWBURGH

> 6 by 4½ inches. Signed: June, Newburgh, C. H. 1915 in lower right corner.
>
> Done from nature in June, 1915.
>
> C. I.

A steep street with frame houses looking down to the river. To the left a large tree. Mt. Beacon and Fishkill Landing in the background.

12. LONG BEACH

> 5½ by 6½ inches. Signed: C. H. June, 1915 in lower right corner.
>
> Done from nature in June, 1915. Plate destroyed. 13 proofs only.
>
> C. I.

A view on the boardwalk crowded with people. To the left the beach with many bathers.

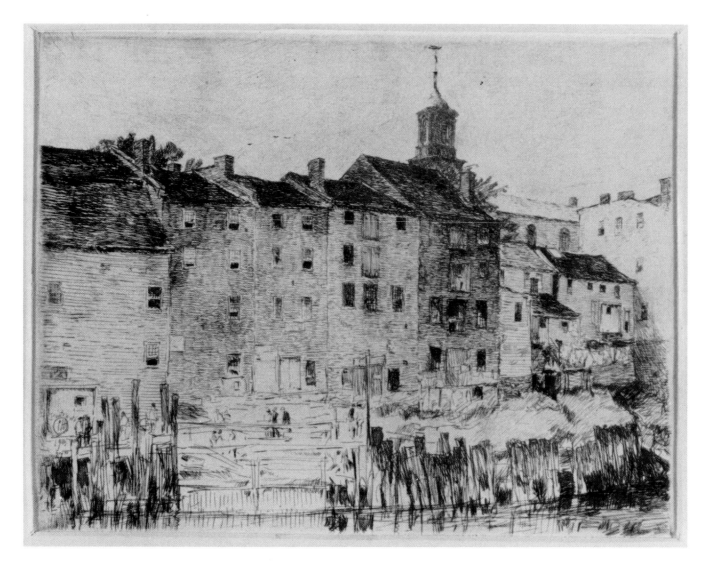

13. OLD WAREHOUSES, PORTSMOUTH

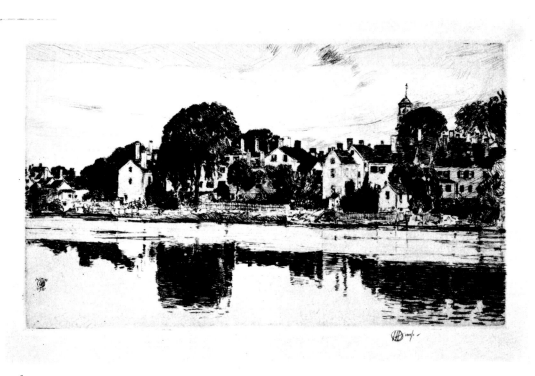

16. THE CHIMNEYS, PORTSMOUTH *5⅞ by 8 inches*

13. OLD WAREHOUSES, PORTSMOUTH

5½ by 6⅞ inches. Signed: Portsmouth, C. H. Aug. 30, 1915 in lower left corner.

Done from nature.

C. I.

The backs of a row of fine old brick buildings on the Piscataqua River. Behind the buildings is seen a church tower. In the foreground the river and old docks.

14. THE ATHENAEUM, PORTSMOUTH

8¼ by 5⅞ inches. Signed: Portsmouth, C. H. 1915 with "Dot," in lower left corner.

Done from nature in Miss Dorothy Whitcomb's car.

C. I. M. F. A.

The façade of the masterpiece by Charles Bullfinch. In the arched doorway are three figures. An arched window on either side of the door. Above the first floor are four columns supporting the cornice. This is one of the three buildings by Bullfinch in this beautiful old American town.

15. THE OLD CUSTOM HOUSE, PORTSMOUTH

5⅜ by 6¾ inches. Signed: Portsmouth, C. H. 1915 in upper left corner.

Done from nature in August, 1915.

C. I.

An old building on the corner of the street. A colonial doorway with columns in the centre. An old doorway in the same style at the left. Six windows with arched tops in second story. On the sidewalk two men conversing. This building is possibly by Bullfinch.

16. THE CHIMNEYS, PORTSMOUTH —

5⅞ by 8 inches. Signed: Portsmouth, C. H. 1915 in lower left corner.

Done from nature in August, 1915.

Proof owned by Carnegie Institute, Pittsburgh.

C. I. M. F. A.

A view of the city from across a pond showing many old houses all with fine chimneys—hence the title—and elm trees. To the left of the centre over the roofs and trees appears the tower of an old church.

17. THE OX-CART

4¾ by 7 inches. Signed: C. H. 1915 in upper left corner.

Done from a drawing made at Old Lyme. Plate destroyed. 8 proofs only.

C. I.

An ox-cart laden with wood drawn by two oxen faced to the right.

18. SUNSET, CONSTABLE'S HOOK

5 by 6⅞ inches. Signed: C. H. 1915 in lower right corner.

Done from a point drawing. In collection of Wm. Preston Harrison.

C. I. M. F. A.

A view across the lower bay at sundown with houses and very tall smoking stacks in the middle distance. To the right several boats are anchored.

19. MADISON SQUARE

4 by 5½ inches. Signed: C. H. 1892 in upper left corner.

Done from a drawing made in 1892. Collection of Wm. Preston Harrison. Plate destroyed. 8 proofs only.

C. I.

The Square on a rainy evening. In the foreground three men in long coats. In the background houses, cabs, and pedestrians.

20. RAINY DAY, ST. MARKS

7 by 4½ inches. Signed: C. H. 1915 in lower right corner.

Done from a point drawing. Collection C. H.

C. I.

The old church with its tower is seen behind a row of trees. In the foreground the wet street. A hansom cab and a woman with a pushcart in the foreground.

21. THE DANCE

11 by 7½ inches. Signed: C. H. 1915 in lower right corner.

Done from a drawing. Collection B. Dyer.

First state, before several of the figures to left and right were removed and further work added. About 6 proofs printed.

Second state, with the changes mentioned above. About 10 proofs printed.

Third state, with further work on spot to left where the woman holding the mirror had been. The figure to the right, partly covered over with additional work in the second state, now emerges with face rendered visible, and with uplifted hand and scarf in gesture of waving.

C. I.

Two draped female figures in Greek dance in the foreground. To the left a cliff and tall trees. Other dancing figures to the rear and on the right.

22. THE LAUREL DANCE

7 by 7 inches. Signed: C. H. 1915 in the foliage near lower right margin.

Done from note taken at a festival at Mt. Kisco, June, 1915.

C. I.

Two draped female figures with hands clasped dancing before a background of foliage.

23. KITTY RESTING

4 by 5½ inches. Signed: C. H. 1915 near upper margin.

Done from life between poses for a painting of Kitty Hughes, who posed for many of the artist's works.

C. I.

Nude female figure lying on a couch with arms over her head.

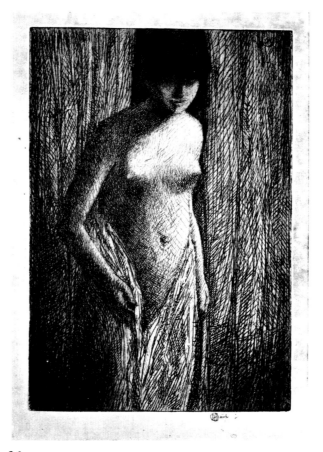

26. NUDE, HAMADRYAD

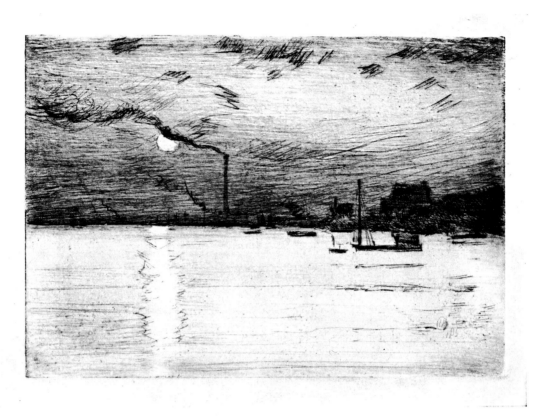

18. SUNSET, CONSTABLE'S HOOK *5 by 6⅞ inches*

24. MOONRISE AT SUNSET

> 4¾ by 6⅞ inches. Signed: C. H. near lower margin.
>
> Done from a point drawing. Collection R. B. Moore. Plate destroyed.
> 35 proofs only.
>
> C. I.

A small lake with wooded shores and mountains in the background. In first state there are three nude figures in the foreground. In the second state there are but two.

25. JUNE

> 5½ by 3 inches. Signed: C. H. 1915 in lower right corner.
>
> Done from a drawing for the painting of the same name. Collection Wm. Preston Harrison, Hassam room, Los Angeles Museum. Plate destroyed 13 proofs only.
>
> C. I.

Nude female figure in profile toward the right with mountain laurel to the right and left.

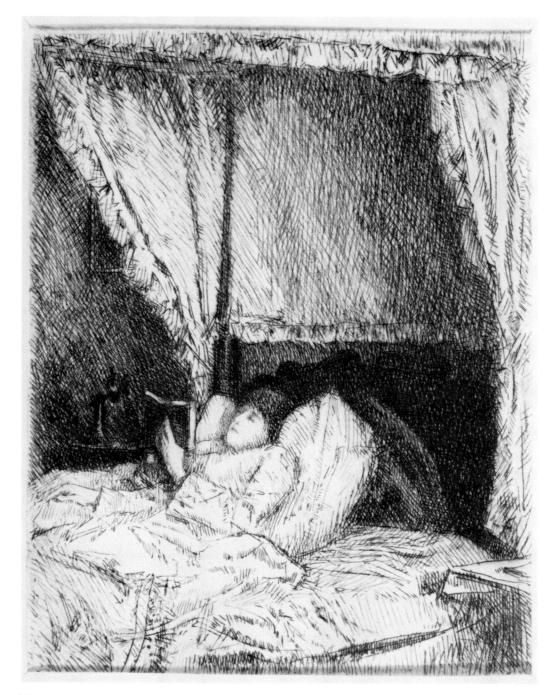

28. READING IN BED

26. NUDE, HAMADRYAD

6½ by 4½ inches. Signed: C. H. 1915 in upper right corner.

Done from life. Plate destroyed. 23 proofs only.

C. I.

Three-quarter length nude female figure standing between heavy curtains.

27. THE ETCHER

7 by 4⅞ inches. Signed: Cos Cob, C. H. 1915 near lower margin.

Done from nature.

Childe Hassam in Harold Eby's studio at Cos Cob.

Plate destroyed. 21 proofs only.

C. I.

A standing figure in painter's smock against an open door. To the left a vista into a low-ceiled room in which is a colonial armchair.

28. READING IN BED

6⅞ by 5½ inches. Signed: C. H. in lower left corner.

Done in his New York apartment from life in a half-hour sitting. A portrait of Mrs. Hassam.

C. I.

Woman reading, reclining against pillows in a four-poster bed with a high canopy.

29. THE GEORGIAN CHAIR

5 by 4 inches. Signed: C. H. 1915 in the open window.

Done from life at Exeter, New Hampshire. A portrait of Miss Dorothy Whitcomb. Plate destroyed. 16 proofs only.

C. I.

Young woman in a white dress seated in a large wing-chair looking to the left out of an open window.

30. THE LITTLE PIANO

5 by 4 inches. Signed: C. H. 1915 on music book.

Done from life (Miss Muse Costello) in an impromptu sitting at New York.

There are slight variations in the proofs due to additional work too vague to mention. Plate destroyed. 38 proofs only.

C. I.

Young woman seated at a piano. She is turned to the left.

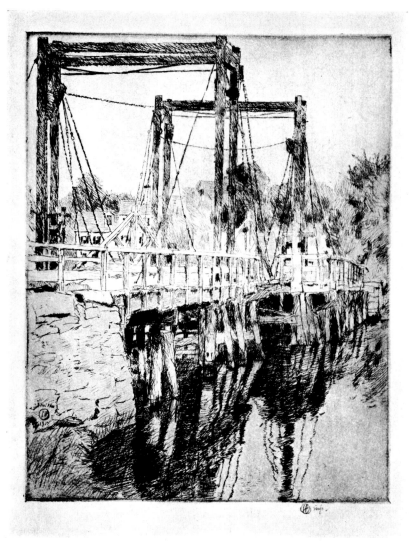

33. THE OLD TOLL BRIDGE 6⅞ by 5⅜ inches

31. THE ILLUSTRATOR

7 by 9⅞ inches. Signed: Cos Cob, C. H. 1915 in lower right corner.

Done from life in one short sitting.

A portrait of Harold Eby in his studio at Cos Cob.

First state, before the nose and contour of the neck were slightly rubbed down. About 8 proofs printed. Second state, with the changes mentioned above. Plate destroyed. 25 proofs only.

C. I.

Young man with pipe in his mouth seated in an arm chair drawing upon a table on which there are a number of artist's materials. In the background a colonial mantel.

32. COS COB

6⅞ by 5 inches. Signed: Cos Cob, C. H. 1915 in the water at lower right margin.

Done from nature.

A view of Harold Eby's studio by the waterside.

C. I. M. F. A.

The left bank of the tidal inlet on which there are several houses and sheds. In the foreground are two boats moored to the bulkhead, the larger with an awning. This is the plate that, after some dry-point work in the upper right-hand part of the composition, has been steel-faced and used as the frontispiece for this book.

33. THE OLD TOLL BRIDGE

6⅞ by 5⅜ inches. Signed: C. H. 1915 in lower left corner.

Done from nature at Stratham, N. H.

Proof owned by Carnegie Institute.

C. I. M. F. A. L. A. M.

A typical chain hoist old style toll bridge crosses a stream. In the background a wooded shore and several houses.

34. PALMER'S DOCK, COS COB

7⅞ by 5½ inches. Signed: Cos Cob, C. H. 1915 near the left margin.

Done from nature.

First state, before the dark reflections underneath the dock were slightly changed. About five proofs printed. Second state, with the changes mentioned above.

C. I.

A small dock on slender piles on which stand two men. To the left a tow boat, to the right several row boats with occupants.

35. THE BARGES

5 by 7½ inches. Signed: Cos Cob, C. H. 1915 in upper right corner.

Done from nature at Cos Cob. Plate destroyed. 13 proofs only.

C. I.

Three barges with deck houses anchored at a railroad bridge. On the barge to the right an awning. In the background towers carrying wires. To the left a wooded shore.

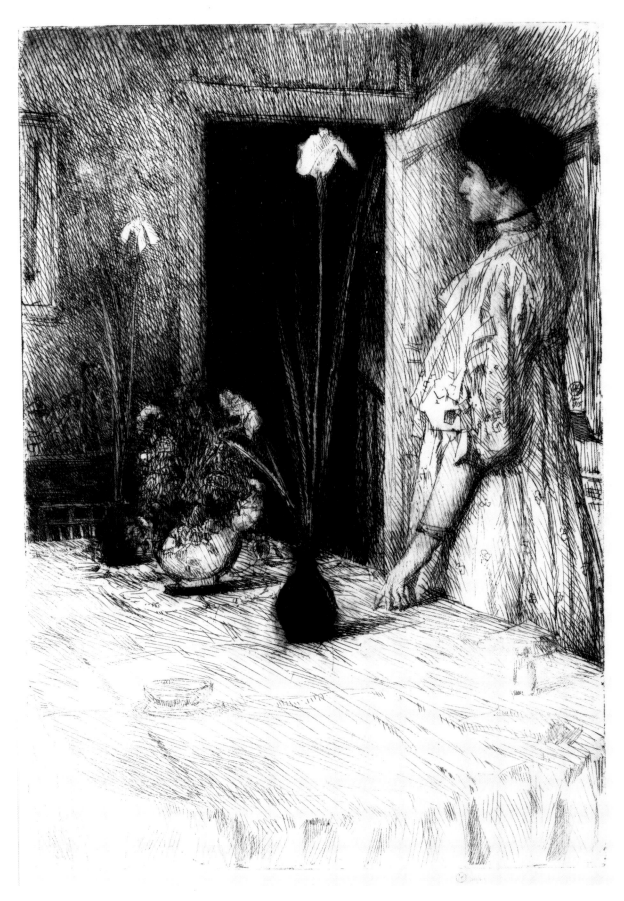

36. THE BREAKFAST ROOM

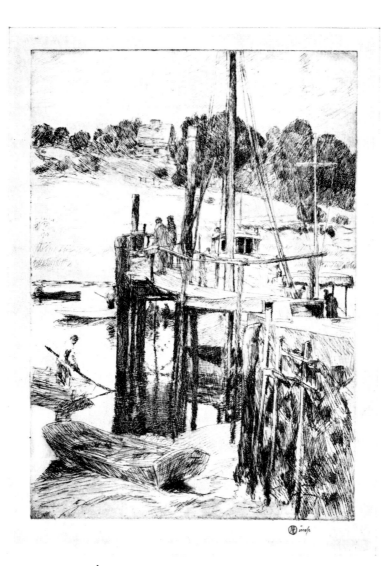

34. PALMER'S DOCK, COS COB *7⅞ by 5½ inches*

36. THE BREAKFAST ROOM

11 by 7½ inches. Signed: C. H. June, 1915 near the right margin.

Done from nature at the Holley House, Cos Cob. Plate destroyed. 12 proofs only.

C. I.

Young woman, Miss Caroline Maes (a direct descendant of Nicholas Maes), who was a talented member of the Cos Cob art colony, being a pupil of J. H. Twachtman, standing to the right at a table on which her hand rests. On the table are three vases holding flowers. In the background an open door. The dining-room in "The Old House."

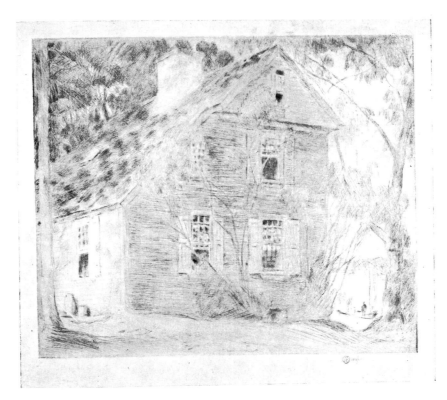

39. THE OLD HOUSE

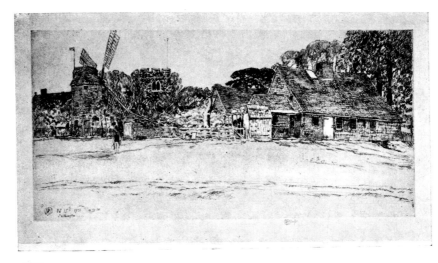

348. THE HEART OF EASTHAMPTON

37. PAINTING FANS

6⅞ by 11 inches. Signed: C. H. 1915 in lower right corner.

Done from nature in the Holley House, Cos Cob. Plate destroyed. 9 proofs printed.

C. I.

Two young women of the Cos Cob art colony seated at a round table painting fans for a fair. In the background a casement window with curtains.

38. CONNECTICUT BARNS

7 by 9⅜ inches. Signed: Cos Cob, C. H. 1915, Sept. 27 on barn to the left.

Done from nature.

The Brush barn at Cos Cob.

Plate destroyed. 17 proofs only.

C. I. M. F. A.

Three barns in the form of an L. The doors in the barn in the back are open, showing the interior with cattle and wagons. In the shadow cast by the barn in the foreground are several chickens.

39. THE OLD HOUSE

6 by 7¾ inches. Signed: Cos Cob, C. H. 1915 in lower right corner.

The old Holley House as it was one hundred years ago.

Underbitten, plate destroyed. 12 proofs only.

C. I.

The gable end of an old house by the river in which there are five windows. Tall trees on either side cast shadows on the house.

40. THE OLD HOUSE, CONNECTICUT

6½ by 7¾ inches. Signed: Cos Cob, C. H. 1915 in lower right corner.

Done from nature.

The Brush house by the waterside, Cos Cob.

Plate destroyed. 10 proofs only.

C. I. M. F. A.

The front of an old house with double piazzas. A flight of steps leads to an adjoining house in which there is a store to the upper piazza. To the left a large tree which casts a shadow on the house.

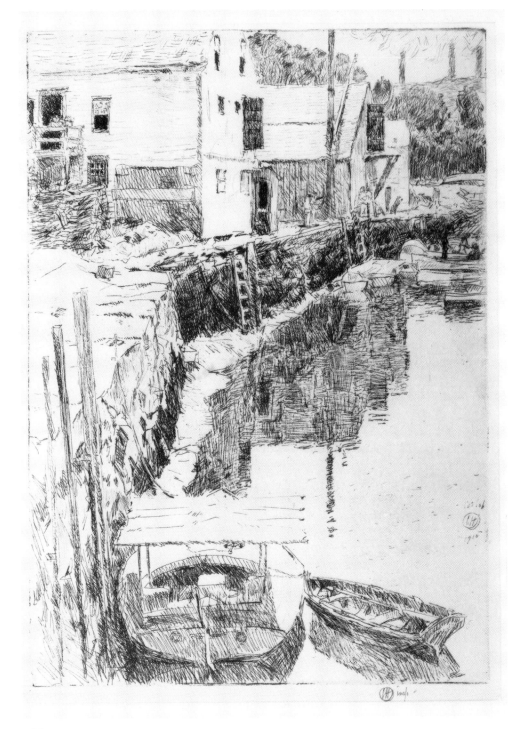

32.　cos cob

38. CONNECTICUT BARNS *7 by 9⅜ inches*

41. MOONLIGHT, THE OLD HOUSE

7⅜ by 9¾ inches. Unsigned.

Done from nature. Overbitten, plate destroyed. About 4 or 5 proofs printed.

42. LONG RIDGE

7⅜ by 8⅞ inches. Signed Sept. 28, Long Ridge, C. H. 1915 near lower margin.

Done from nature about fourteen miles inland from Cos Cob. Plate destroyed. 15 proofs only.

C. I.

A rolling landscape over which a road bordered by stone walls runs. Houses and barns to the left of the road.

43. ELMS IN MAY 6¾ by 10⅞ inches

43. ELMS IN MAY

6¾ by 10⅞ inches. Signed: Yarmouth, C. H. 1909 in lower right corner.

Done in October, 1915 from a drawing executed at Yarmouth in 1909.

Collection Wm. Preston Harrison.

The Whitcomb elms at Yarmouth, Maine. Entrance driveway to a house which had been burned down.

C. I. M. F. A.

A row of eleven elms in spring foliage. Groups of blossoming trees in the distance.

44. THE OLD CHERRY TREE

7½ by 9⅞ inches. Signed: C. H. lower left corner.

Done from nature.

The arbor and lane back of the Holley House at Cos Cob.

Plate destroyed. 19 proofs only.

C. I.

An old cherry tree against which leans a ladder is at the right of the entrance to a garden. A house in the background.

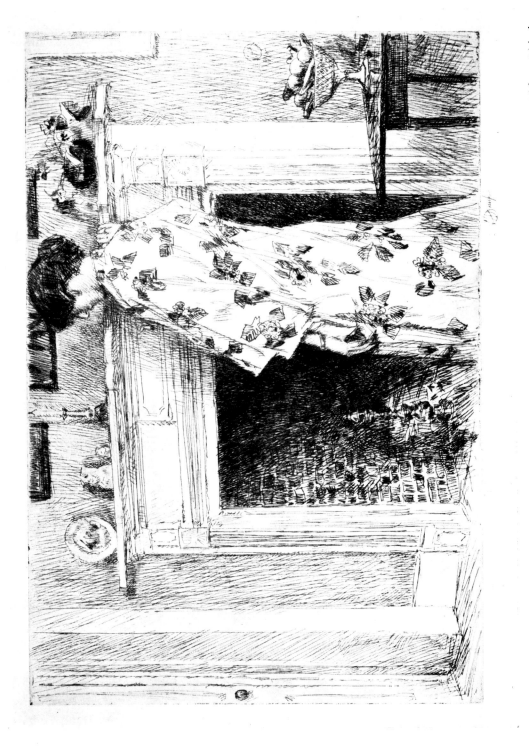

47. THE WHITE KIMONO

7⅜ by 10⅞ inches

45. LOW TIDE, COS COB BRIDGE

7¾ by 10⅞ inches. Signed: Cos Cob, C. H. 1915 in upper left corner.

Done from nature in October, 1915.

First state, before the river bed was darkened and the pile of stones in front covered with light lines. About 15 proofs printed. Second state, with changes mentioned above. Additions in January, 1916. Plate destroyed. 29 proofs only.

C. I.

A view of the river at low tide. A barn to the left. Across the river in the middle distance is the great steel N. Y., N. H. & H. railroad bridge over which passes a train of freight cars.

46. THE BIRD BOOK

10 by 8½ inches. Signed: C. H. 1915 near left margin.

Done from nature at Cos Cob.

First state, before the figure of the girl was replaced by flowers and still life. 3 proofs printed. Second state.

Childe Hassam started to burnish down the waist of the figure and the plate went to pieces, being a bad piece of copper, so he put in the vase and flowers and experimented with the plate, using the burin, dry-point, burnisher and all the various devices for etching on copper—or rather changing an etching on copper into an entirely different state. Plate destroyed. 17 proofs only.

C. I.

47. THE WHITE KIMONO

7⅜ by 10⅞ inches. Signed: C. H. 1915 near right margin.

Done from nature.

A fireplace in the Holley House at Cos Cob.

The model was Miss Helen Burke.

Proof owned by Metropolitan Museum of Art, New York.
C. I. M. A. M.

An interior in which is a colonial mantel against which rests a girl in a white figured kimono. A number of articles on the mantel and to the right a table on which there is a dish of fruit.

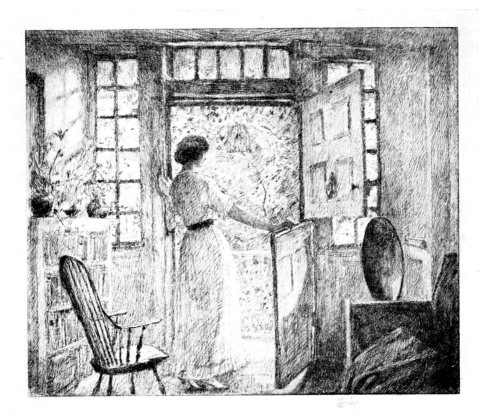

49. THE DUTCH DOOR *8⅜ by 9⅞ inches*

48. THE LUCINDA OF NEW YORK

6¾ by 6⅞ inches. Signed: Cos Cob, C. H. 1915 under roof of house.

Done from nature at Cos Cob. Plate destroyed. 22 proofs only.

C. I.

A view of the river bank, to the left a barn and dock, against which is moored a coal barge. The railroad bridge in the distance.

49. THE DUTCH DOOR

8⅜ by 9⅞ inches. Signed: C. H. 1915 in left margin by the flowers in jar.

Done from nature.

One of the doors of the Holley House at Cos Cob.

The model was Miss Helen Burke, daughter of Toby Burke.

C. I. M. F. A. L. A. M.

An interior of a colonial room flooded with sunlight from windows and an open Dutch door. In the doorway a girl in a light dress. A bird cage hangs outside suspended from the roof of the veranda.

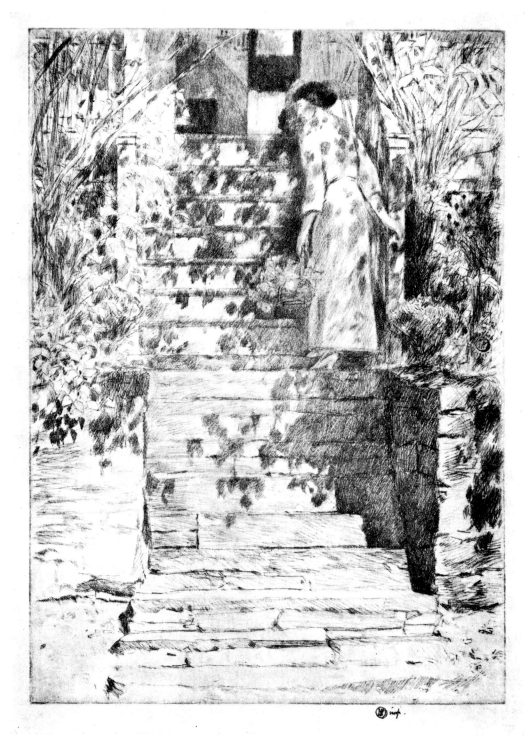

52. THE STEPS 10½ by 7½ inches

50. THE WHITE MANTEL

6⅞ by 9⅞ inches. Unsigned.

Done from nature.

The fireplace in the dining-room of the Holley House at Cos Cob.

The model was Miss Helen Burke.

C. I. L. A. M.

An interior with a colonial mantel on which are a clock, candle sticks, and several other articles. To the left of the mantel is a seated figure of a girl in a white figured kimono.

51. THE COLONIAL TABLE

6⅞ by 9⅞ inches. Signed: C. H. 1915 in upper left corner.

Done from nature.

A room in the Holley House, Cos Cob.

Plate destroyed. 20 proofs only.

C. I. L. A. M.

A young woman in white seated to the right of a colonial table on which are globe with fish and a vase of blossoms.

52. THE STEPS

10½ by 7½ inches. Signed: Sept. 19, 1915, Cos Cob, C. H. near right margin.

Done from nature.

A portrait of Mrs. Elmer Livingston MacRae, on the steps of the Holley House at Cos Cob.

C. I. M. F. A. L. A. M.

Proof owned by Metropolitan Museum, New York.

A flight of stone steps leading to an open door. A young woman with a basket of flowers ascending a flight of stone steps.

53. THE OLD HOUSE, COS COB

6⅜ by 8⅜ inches. Signed: Cos Cob, C. H. Oct. 27, 1915 in lower right corner.

Done from nature.

A view of the Holley House at Cos Cob.

C. I. L. A. M.

An old house with double piazzas standing on a terrace. To the right a large tree whose branches overhang the house.

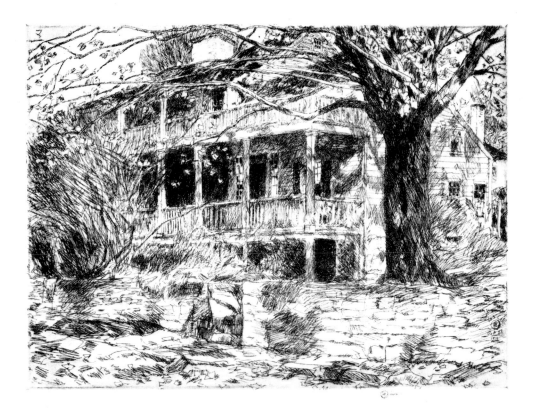

53. THE OLD HOUSE, COS COB 6⅜ by 8⅜ *inches*

54. THE WRITING DESK

10 by 7 inches. Signed: Cos Cob, C. H. 1915 upper right corner.

Done from nature.

A portrait of Mrs. Hassam at the Holley House.

C. I. M. F. A. L. A. M.

A lady facing to the right is seated at an open writing desk placed beside a window.

55. TOBY'S, COS COB

6⅞ by 8⅞ inches. Signed: Cos Cob, C. H. 1915, Oct. 31 in lower left corner.

Done from nature.

Toby Burke's public house at Cos Cob.

C. I. M. F. A. L. A. M.

An old house, the lower part of which is a country bar; on a veranda above and behind the open-work railing is a seated figure. In the foreground are two Italians with a hand organ.

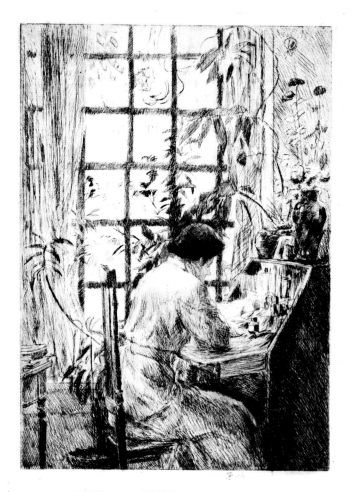

54. THE WRITING-DESK 10 *by* 7 *inches*

56. OLD LACE

7 by 7 inches. Signed: Cos Cob, C. H. 1915 in lower right corner.

Done from nature, October, 1915.

A view of the bridge and Cos Cob inlet at low tide. The delicate pattern
and tracery of the design suggested to Mr. Hassam the title, Old Lace.

One of the most delicately bitten plates, technically, in the etched work of
the world.

C. I. M. F. A.

Proofs in the Carnegie Institute, Pittsburgh; and the Los Angeles Museum.

In the foreground are several boats left dry by the receding tide. Back of the bridge,
which crosses the composition, are a number of houses and many trees.

{ 24 }

57. OLD DUTCH CHURCH, FISHKILL VILLAGE

[48]

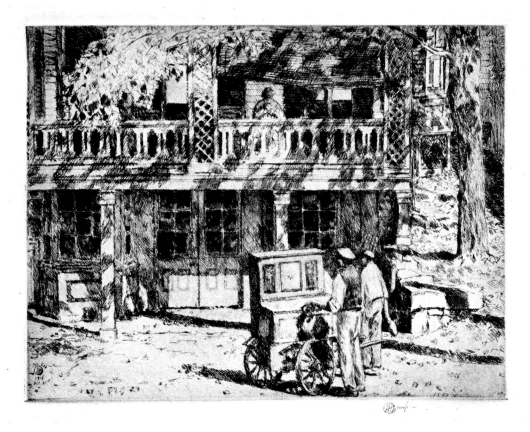

55. TOBY'S, COS COB 6⅞ by 8⅞ inches

57. OLD DUTCH CHURCH, FISHKILL VILLAGE

7⅜ by 10⅜ inches. Signed: Fishkill, June 4, C. H. 1915 in lower right corner.

Done in November after a drawing executed in Fishkill early in June.

Collection R. B. Moore.

Harvey Birch, hero of James Fenimore Cooper's novel "The Spy," is supposed to have sought refuge in this church.

First state, before the bare spaces in lower clumps of foliage were covered with cross lines and other bare spaces on the trunks covered with fine lines. About 8 proofs printed. Second state, with changes mentioned above. Plate destroyed. 29 proofs only.

C. I.

The façade of the old church. In the foreground are two large trees.

58. COS COB DOCK

8⅜ by 6¼ inches. Signed: Cos Cob, C. H. 1915 near left margin.

Done from nature in November, 1915.

Another view of Harold Eby's studio by the waterside.

C. I. M. F. A. L. A. M.

Proofs in the Metropolitan Museum of Art, New York; and the Los Angeles Museum.

A view of the tidal river bank, at low tide. On the bank to the left is a row of sheds, and in the foreground a number of boats which have been left dry by the receding tide.

59. PORTRAIT

5½ by 4⅜ inches. Signed: C. H. New York, 1915 near the left margin.

Done from life in November, 1915.

First state, before fine dry-point lines were added on neck, breast, and face. About 15 proofs printed. Second state, with the changes mentioned above. There are no blank spots on the model's right cheek and the right side of the nose. Plate destroyed. 26 proofs only.

C. I.

Head of a young girl three-quarters to the right with hair unbound.

60. MRS. R.

11 by 7 inches. Signed: C. H. 1915 in upper right corner.

Done from life one day in December, 1915, in two short sittings broken into by lunch. Plate destroyed. 20 proofs only.

A portrait of Mrs. Hugo Reisinger, then the wife of the well-known collector, now Mrs. Charles Greenough.

C. I.

A portrait of a lady full length in a light dress seated in a large chair looking to the left.

61. YOUNG PAN PIPING

6⅜ by 7½ inches. Signed: Christmas, C. H. 1915 in lower left corner.

Done from a pastel drawing in the collection of Mrs. C. E. S. Wood. Plate destroyed. 12 proofs only.

A rocky landscape in which are a number of small trees. In the foreground, seated, facing to the right is a young Pan piping.

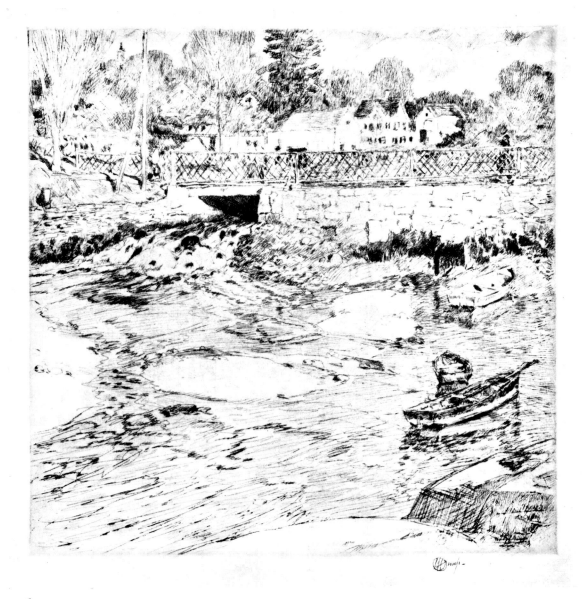

56. OLD LACE *7 by 7 inches*

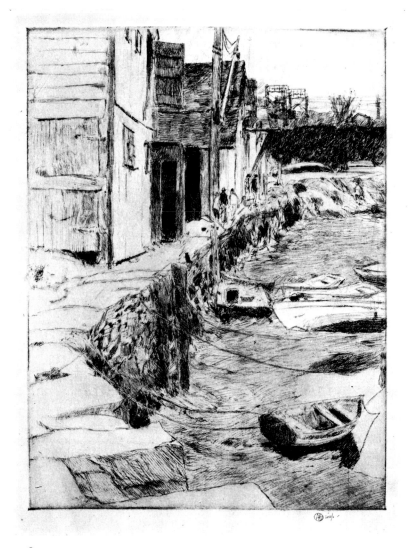

58. COS COB DOCK 8⅜ by 6¼ *inches*

62. CALVARY CHURCH IN SNOW

7 by 4⅞ inches. Signed, December 27, C. H. 1915 in lower left margin.
From a drawing made in New York in 1904. Collection C. H.
C. I. M. F. A. L. A. M.

A view of the church at Fourth Avenue and 22d Street covered with snow. In the
street are several pedestrians and a horse and carriage.

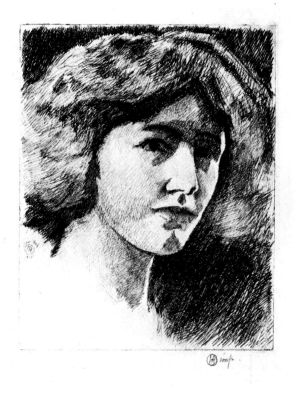

59. PORTRAIT *5½ by 4⅜ inches*

63. THE THREE LITTLE GIRLS

5⅞ by 3½ inches. Signed: C. H. 1916 in lower right margin.

Done in January, 1916, from a drawing executed out-of-doors at Cos Cob the previous summer. The young daughters of Cos Cob artists who were always allowed to run around nude on the various picnics of their parents and friends. Collection C. H. Plate destroyed. 8 proofs only.

Three nude figures on the beach.

64. THE SCARF DANCE—FOUR FIGURES

6⅞ by 6⅞ inches. Signed: C. H. 1916 in lower right margin.

Done in the studio in January, 1916, from posed models and the background taken from notes made at Mt. Kisco. Plate destroyed. 21 proofs only.

65. THE BUTTERFLY DANCE—ONE FIGURE

5¾ by 3⅜ inches. Signed: C. H. 1916 in lower right margin.

Done in the studio January, 1916, from Kitty Hughes and with background made from notes taken at Mt. Kisco.

{ 30 }

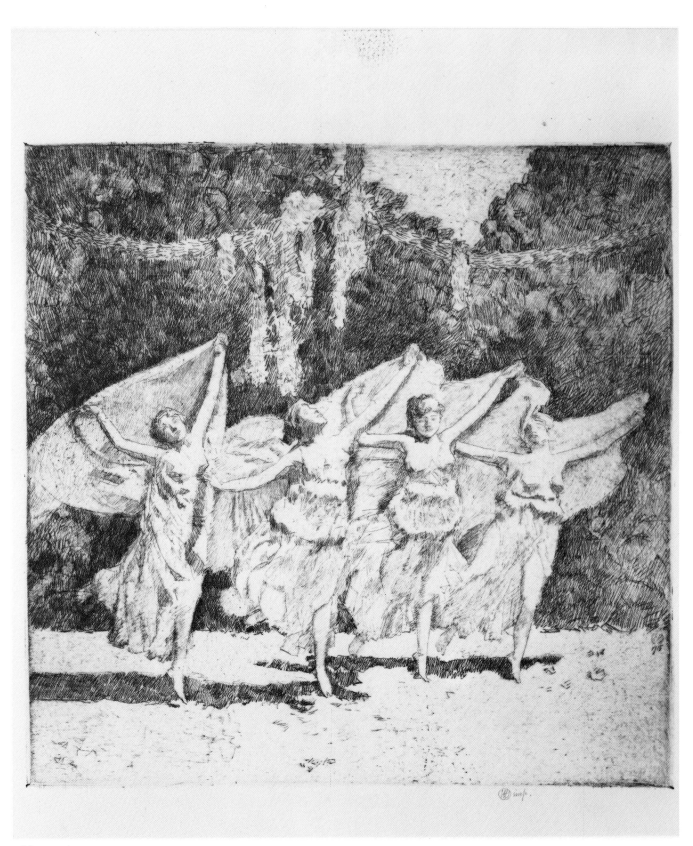

64. THE SCARF DANCE—FOUR FIGURES

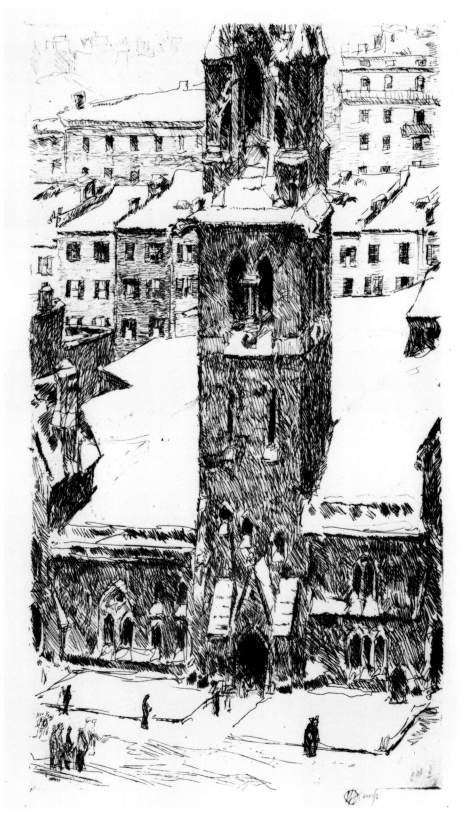

66. THE CHURCH ACROSS THE WAY

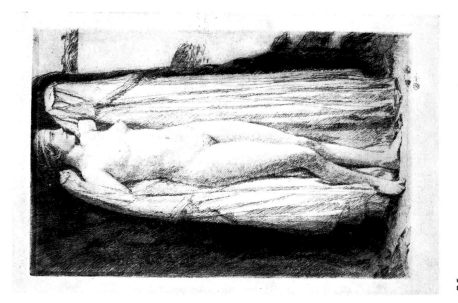

75. THE GODDESS

67. BATTERY PARK

66. THE CHURCH ACROSS THE WAY

8⅛ by 4⅜ inches. Signed: New York, C. H. 1916 in lower left corner.

Done from nature from the studio window in January, 1916.

Calvary Baptist Church in 57th Street, the roof of which covered with snow is seen from an elevation. On the sidewalk in front of the church are a number of pedestrians.

67. BATTERY PARK

12¾ by 7 inches. Signed: New York, C. H. Jan. 18, 1916 in lower left corner.

Done from nature on the plate. The print therefore appears reversed.

First state, before the shadows on the panes of the building to the left and on the Singer Building were rubbed down. About 10 proofs printed.

Second state, with the changes mentioned above. The cast shadows on the building directly below the Woolworth Building have been rubbed down and altered in shape, continuing the eye still further down underneath the elevated railroad. There are now two light spots where there was only one before.

A view of the park looking up Broadway with the Woolworth Building in the background. In the foreground benches, on which are seated figures, and across the middle distance the elevated railroad.

68. WASHINGTON'S BIRTHDAY— FIFTH AVENUE & 23d STREET

12¾ by 7 inches. Signed: C. H. New York, Feb. 22, 1916 on the flag near left margin.

Done from nature with the aid of hasty notes.

First state, before the cast shadows of the Metropolitan Tower were added on the lower part of the Flatiron Building. About 10 proofs printed.
Second state, with the changes mentioned above.

A view down Fifth Avenue, which is decorated with flags and crowded with automobiles. In the background the Flatiron Building.

69. MANHATTAN

5½ by 10 inches. Signed: C. H. Brooklyn in lower left corner.

Done in February, 1916, from a drawing made from the Hotel Touraine, Brooklyn, in September, 1911.

A view of the skyline of Manhattan behind which is the setting sun.

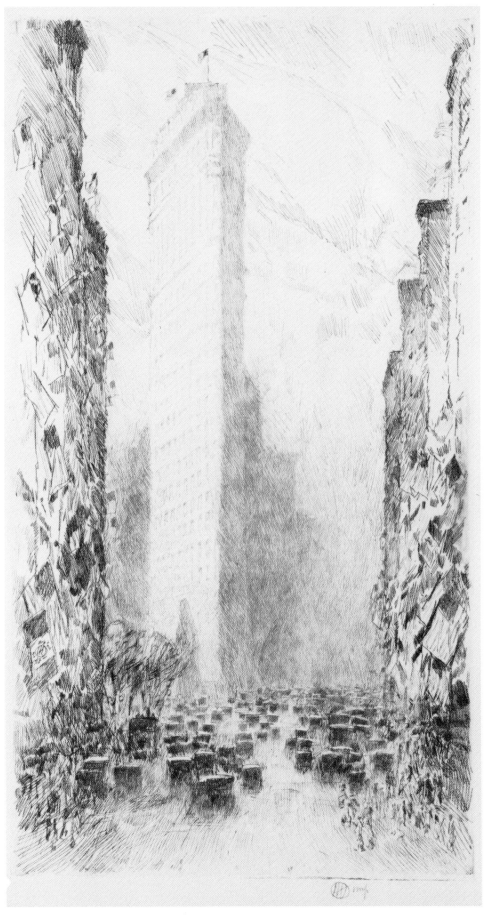

68. WASHINGTON'S BIRTHDAY—FIFTH AVENUE & 23D STREET

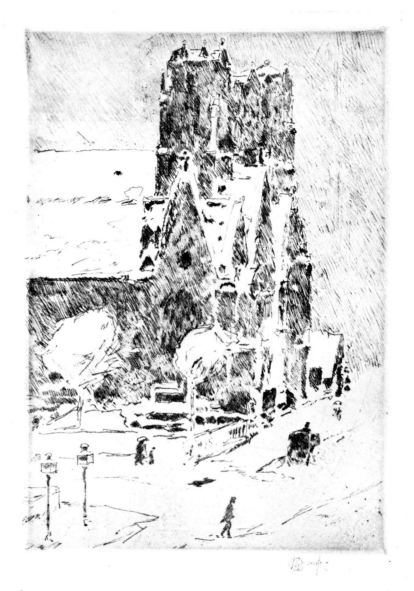

62. CALVARY CHURCH IN SNOW *7 by 4⅞ inches*

70. THE ROOFS, SOUTH FROM 57th STREET

7 by 5⅜ inches. Signed C. H. New York, 1916 in lower left corner.
Done from nature in March, 1916, from the artist's apartment window.

71. THE DRESSING-TABLE

5½ by 4 inches. Signed: March 7, C. H. 1916 near upper margin.
Done from life.

A slightly draped figure of a young woman standing before a dressing-table. Over
the table an oval mirror in which the figure is reflected.

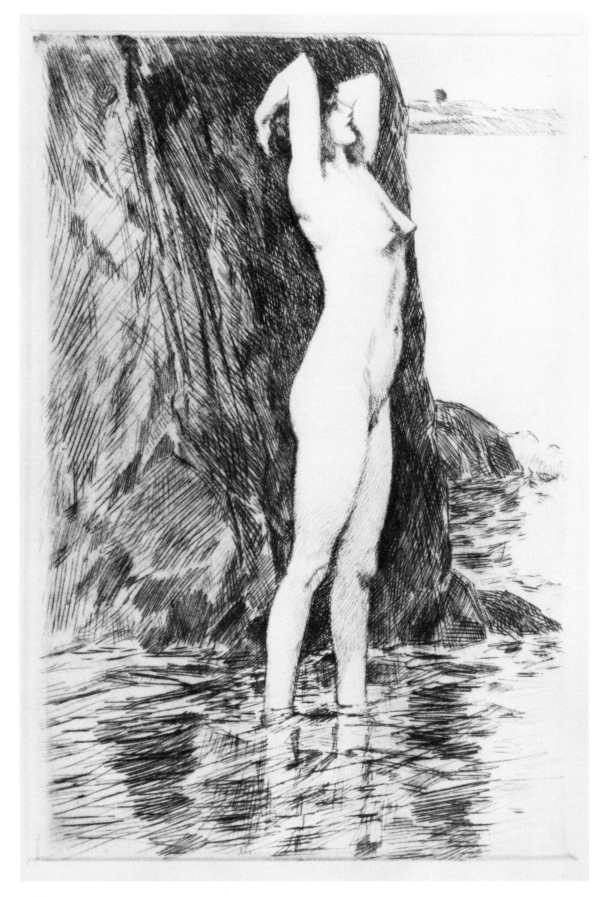

73. THE SWIMMER, MORNING—FACING WATER

72. CHURCH DOORWAY, SNOW

7 by 5⅜ inches. Signed: C. H. New York, 1916 in lower right corner.

Done from nature in March, 1916.

A doorway of the Calvary Baptist Church in 57th Street.

C. I.

A gothic stone doorway, partly covered by snow, in the centre of the composition. On the steps leading to the door stands a man with a broom.

73. THE SWIMMER, MORNING—FACING WATER

9 by 5⅞ inches. Signed: C. H. 1916 in upper left corner.

Done in March, 1916, from posed model in studio, with background added from paintings made at the Isles of Shoals.

A nude figure of a young woman standing in shallow water is faced to the right. A large rock behind the figure. To the right water and distant shore.

74. THE SWIMMER, EVENING—FACING LAND

9 by 5⅞ inches. Signed: C. H. 1916 in lower right corner.

Done in March, 1916, from posed model in studio, with background added from paintings made at the Isles of Shoals.

A nude figure of a young woman standing in shallow water with arms raised over her head is faced to the right. A large rock behind the figure and to the left water and distant shore.

75. THE GODDESS

9 by 5¾ inches. Signed: C. H. 1916 on upper fold of drapery.

Done in March, 1916 from posed model in studio, with background added from paintings made at the Isles of Shoals. Plate destroyed. 12 proofs only.

A nude figure of a young woman with a band around her head is standing against a large rock. In her hands, which are upheld, are draperies which fall to the ground. To the right water and the distant shore.

76. THE AUTO SCHOOL

4 by 7⅛ inches. Signed: New York, C. H. 1916 near right margin.

Done in March, 1916, from a drawing executed on Seventh Avenue in 1910.

A row of small shops and doorways. Over the centre doorway is lettered "Alwyn Auto School." Before the same are two figures, the one to the right holding an umbrella under his arm.

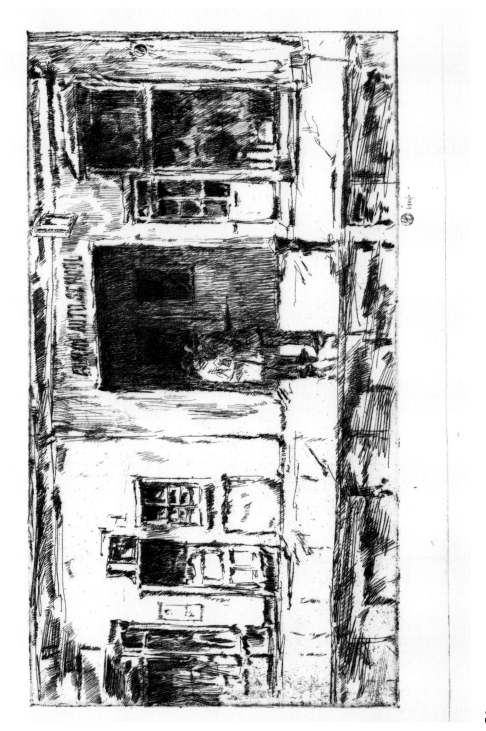

76. THE AUTO SCHOOL

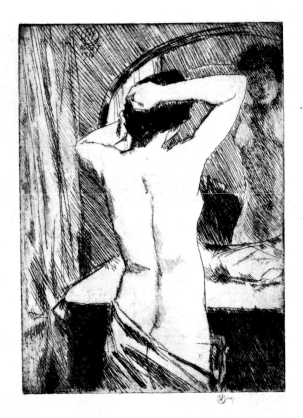

71. THE DRESSING-TABLE *5½ by 4 inches*

77. FIFTH AVENUE, NOON

9⅞ by 7½ inches. Signed C. H. April 1, 1916 on base of building to left.

Done from nature from a window at Fifth Avenue and 34th Street.

First state, before the plate was cut down on the left to 7¼ inches, leaving the unbroken contour of the wall of the Altman Building. About 20 proofs printed. Second state, with the changes mentioned above.

C. I. M. F. A.

A view of Fifth Avenue in sunlight looking north from 34th Street. The roadway crowded with buses, cabs, and automobiles, and the sidewalks with pedestrians.

78. THE WANING MOON

2½ by 2½ inches. Signed: May, C. H. 1916 in lower left corner.

Done from a sketch made at the Isles of Shoals.

A small nocturne. In the centre the waning moon shows over a hill.

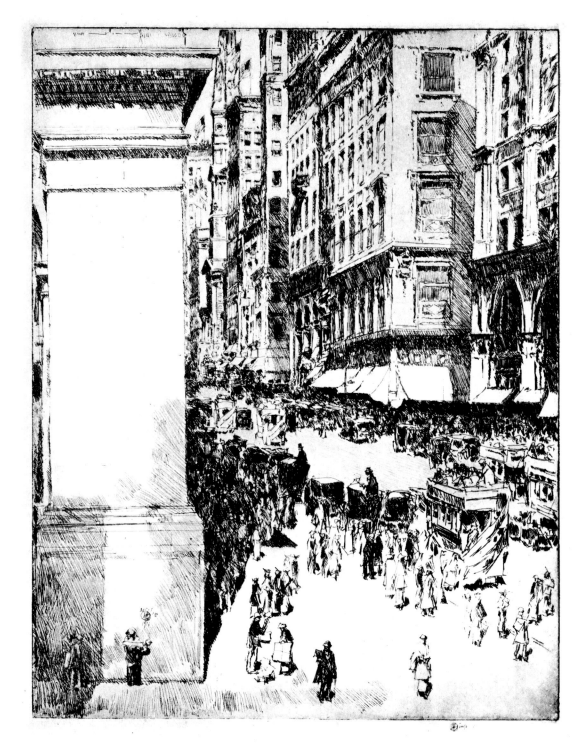

77. FIFTH AVENUE AT NOON 9⅞ by 7½ inches

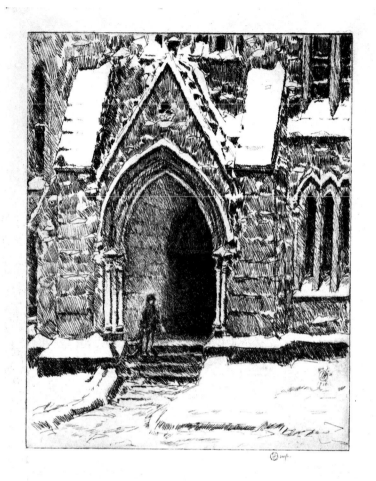

72. CHURCH DOORWAY, SNOW *7 by 5⅜ inches*

79. NOCTURNE, COS COB

3¼ by 4 inches. Unsigned.

Done from a sketch at Cos Cob.

A small nocturne with a full moon near upper left corner. To the left centre are several houses. Water with reflections in the foreground.

80. WINTER, CENTRAL PARK

7 by 7 inches. Signed: March 17, C. H. 1916 near right margin.

Done from a drawing made in March, 1916. Plate destroyed. 2 proofs only.

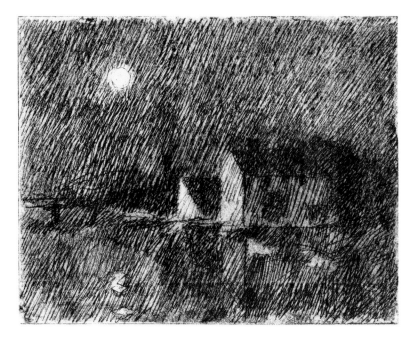

79. NOCTURNE, COS COB

81. SPRING, CENTRAL PARK

3½ by 3⅜ inches. Signed: C. H. 1916 in lower left corner.

Done from nature. Plate destroyed. 14 proofs only.

A group of trees in the foreground. In the middle distance to the right a bridge spans a roadway on which is an equestrian.

82. RUE DE NEVERS

7⅜ by 3½ inches. Signed: Paris, C. H. 1910 on farthest building.

Done from a drawing made in Paris, 1910. Collection R. B. Moore.

Plate destroyed. 28 proofs only.

A narrow street between tall buildings. From the centre building on the left projects a lantern. In the street stand a team of horses and a man.

83. RUE DU CHAT QUI PECHE, PARIS

5 by 3⅞ inches. Signed: C. H. 1910 on centre wall.

Done from a drawing made in Paris, 1910. Collection R. B. Moore.

Plate destroyed. 1 proof only.

84. ZOLA'S HOUSE, PARIS

5⅜ by 4 inches. Signed: Paris, C. H. 1887 near lower left margin.

Done from a drawing made in Paris, 1887. Plate destroyed. 5 proofs only. Collection R. B. Moore.

A street corner with a number of pedestrians, in the rain the two in the foreground holding an open umbrella. Across the plate a row of four tree trunks.

85. MONTMARTRE

4⅝ by 6¼ inches. Signed: Paris, C. H. 1887 near left margin.

Done from a drawing made in Paris, 1887. Collection R. B. Moore.

A small shop at the entrance of which stands a woman cooking French-fried potatoes over a brasier. In the front stands a small boy holding a pan.

86. FISH SHOP, JERMYN STREET, LONDON

3½ by 6 inches. Signed: London, C. H. 1910 in lower right corner.

Done from a drawing made in London, 1910.

A small fish shop in which are displayed many fish. On a beam between two doors is suspended a row of six soles.

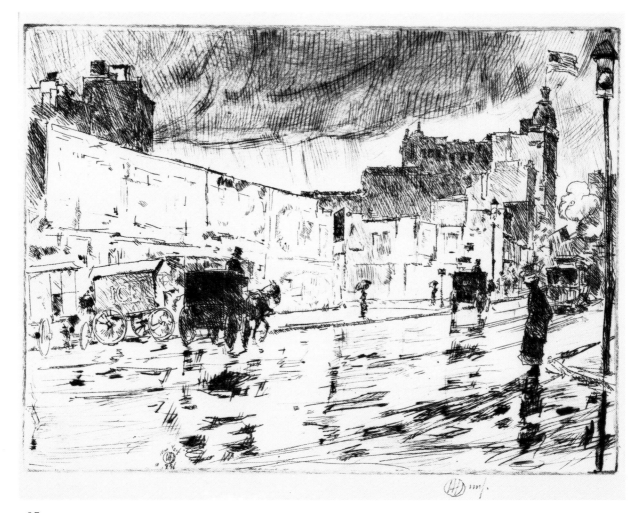

87. THE BILLBOARDS, NEW YORK

87. THE BILLBOARDS, NEW YORK

4⅝ by 6¼ inches. Signed: New York, C. H. 1896 near lower margin.

Done from a drawing made in New York, 1896. Broadway and 55th and 56th Streets.

Several states with dry-point additions. Proof owned by Los Angeles Museum.

A street crossing. In the street several cabs and an ice wagon. To the left a row of billboards and in the distance a tall building on which flies a flag.

88. OLD SHOPS, NEW YORK

3½ by 6 inches. Signed: New York, C. H. 1902 in lower left corner.

Done from a drawing made in New York, 1902. Collection C. H.

A row of small shops, partly covered with snow. The second shop from the left is occupied by a shoemaker who displays his signs. On the sidewalk, which is covered with snow, are a pedestrian and a large barrel. The painting for which the drawing was made is owned by the Rhode Island School of Design.

89. UNION SQUARE

4¼ by 5¾ inches. Signed: New York, C. H. 1896 near lower right margin.

Done from a drawing made in New York, 1896. Collection C. H.

A street scene. On the sidewalk to the right are six pedestrians, the nearest being a woman carrying a box. At the curb are a cab and a hansom, and in the background a view of the park and distant buildings.

90. THE LINDEN TREE

6⅞ by 4⅞ inches. Signed: C. H. 1916 in water.

Done from a drawing made at Old Lyme, similar to the decorative panel in Miss Florence Griswold's house at Old Lyme. Plate destroyed. 8 proofs.

Two nude figures are seated on a grassy bank, one other standing in the water. A small Linden tree almost fills the upper half of the composition. In the foreground water with many reflections.

91. THE GREEK DANCE

8¼ by 10 inches. Signed: C. H. 1916 near left margin.

Done from posed models in studio with background from paintings made at the Isles of Shoals. Plate destroyed. 15 proofs.

Three draped figures with arms outstretched and hands touching standing on the shore between two large rocks. In the centre the sea and the distant shore.

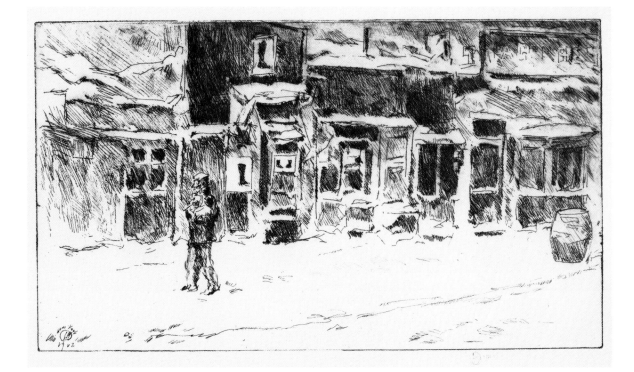

88. OLD SHOPS, NEW YORK

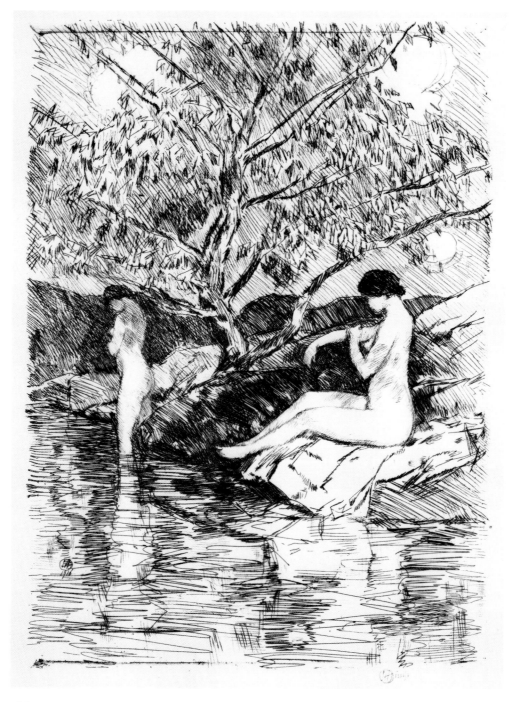

90. THE LINDEN TREE

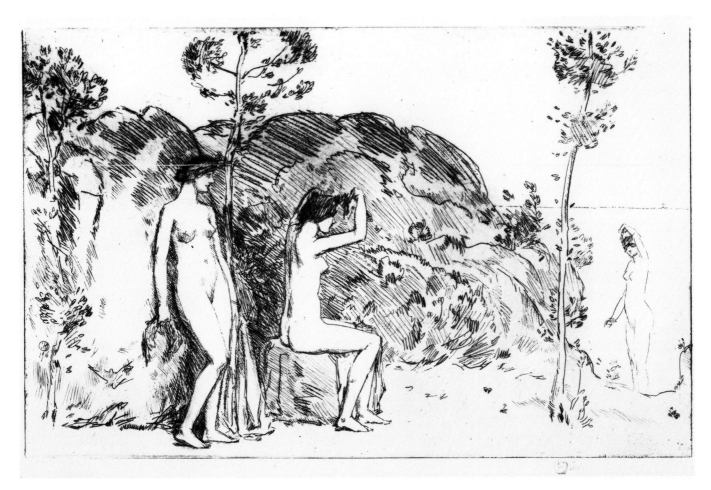

93. FRESCO

92. THE OLD ELM

4½ by 6⅜ inches. Signed: Old Lyme, C. H. 1909 in lower left corner.

Done from a drawing made in Old Lyme, 1909. Collection C. H.

93. FRESCO

4½ by 6⅞ inches. Signed: C. H. 1916 near lower right margin.

Done from a pen drawing made as a study for a panel in the library of C. E. S. Wood, Portland, Oregon. Plate destroyed. 8 proofs.

Three nude figures, the one in the centre seated; the figure to the left holds a wreath, the figure to the right stands in shallow water. Two small trees divide the composition. Large rocks in the background.

94. TOLEDO

6⅛ by 9⅝ inches. Signed: Toledo, C. H. 1910 on wall, upper right corner.

Done from a water-color drawing made in Toledo, Spain, 1910. Proof owned by the Hispanic Museum.

A street scene with three houses on the right. To the left from a wall projects a lantern. In the street two donkeys and a number of figures. The background a rocky hillside.

95. OLD CHINATOWN, SAN FRANCISCO

5¼ by 5 inches. Signed: C. H. 1904 near right margin.

Done from a drawing made in San Francisco, 1904.

A bit of old Chinatown before the earthquake.

M. F. A.

A subterranean chamber—old Chinatown was largely underground—into which from the back projects a flight of stairs on which is a Chinaman. Another Chinaman stands at the right. Across the courtyard are a number of beams from which hang draperies.

96. THE SUMMER SOFA

7½ by 5½ inches. Signed: June 10, C. H. 1916 in upper right corner.

Done from a model at the Studio, New York. Plate destroyed. 15 proofs.

A nude figure of a young woman seated, faced to the right, with legs drawn under her, upon a sofa. Her right arm, which supports her head, rests on a cushion.

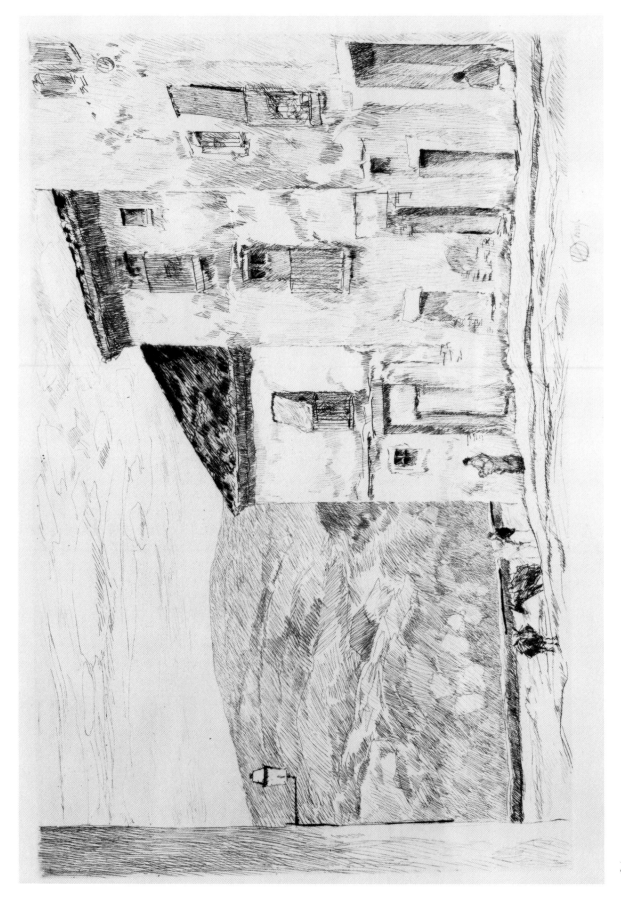

94. TOLEDO

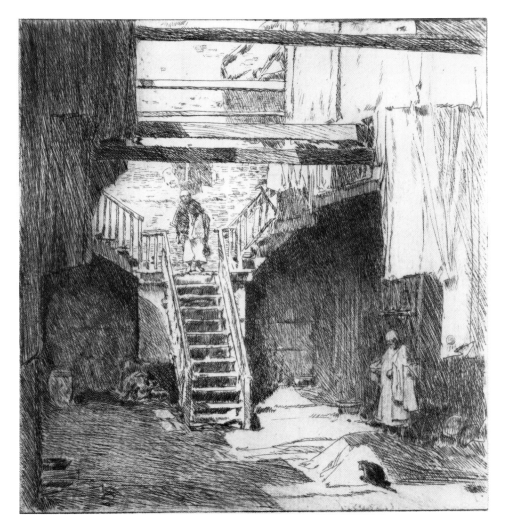

95. OLD CHINATOWN, SAN FRANCISCO

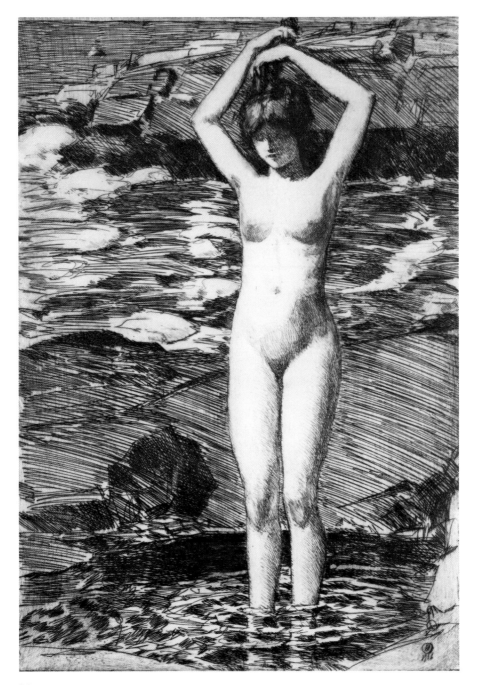

98. DIANA'S POOL, APPLEDORE

97. THE FAR HORIZON

10⅞ by 8⅜ inches.　Signed: C. H. 1916 in lower right corner.

Done out-of-doors with a posed model.　Plate destroyed.　10 proofs.

Symbolic of the forward vision—the hope of a better future for the world.

The back of a nude figure of a young woman standing with arms outstretched looking toward right.　In the background trees, bushes, and a rolling landscape.

98. DIANA'S POOL, APPLEDORE

10⅞ by 7⅜ inches.　Signed: C. H. 1916 in lower right corner.

Done from nature, Isles of Shoals.

A nude figure of a young woman standing in shallow water, facing front.　Her arms are upraised arranging her hair.　In the background rocks and rapidly moving heavy ocean surges.　Proof owned by the Los Angeles Museum.

99. THE HIGH POOL

4½ by 3 inches.　Signed: C. H. 1916 near right margin.

Done from a drawing made at the Isles of Shoals.

In the foreground a nude figure of a young woman seated on a ledge of rocks with her left foot in the water.　The background a rocky shore with a view of the sea in the centre.

100. MADONNA OF THE NORTH END

6½ by 4½ inches.　Signed: C. H. 1916 upper left corner.

Done from a drawing made in that part of Boston known as the "North End" where there were once fine old houses.　Drawing in the Collection Wm. Preston Harrison.　Hassam Room, Los Angeles Museum.

The façade of an old house showing a door and four windows.　From the windows are hand lines of clothes.　In the upper window to the right are a mother and child. There are also two figures in the doorway which is in shadow.

101. PORTSMOUTH, EVENING

2⅞ by 4⅜ inches.　Signed: Portsmouth, C. H. 1916 near lower left margin.

Done from nature in August, 1916.

A row of buildings on the river bank.　In the centre a church steeple.　To the right two tall smoking chimney-stacks.

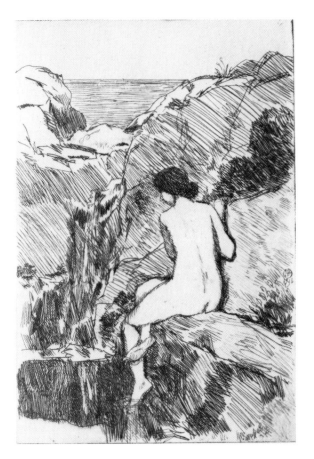

99. THE HIGH POOL

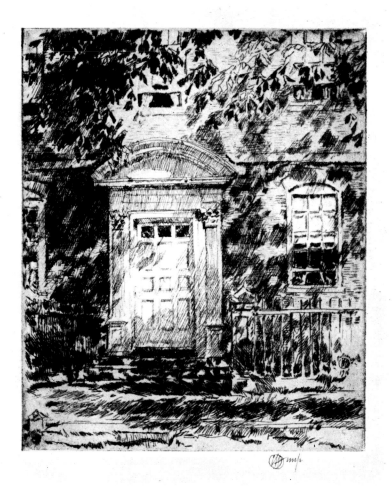

104. PORTSMOUTH DOORWAY 5½ by 4½ inches

102. FIRE DANCE

6½ by 4 inches. Signed: August 28, C. H. 1916 in lower left margin.

Done from life at Portsmouth, in August, 1916. Plate destroyed. 4 proofs.

A draped figure of a young girl facing to the right with left arm raised above her head.

103. DANCE IN THE GARDEN (TWO FIGURES)

5½ by 4½ inches. Signed: August 23, Portsmouth, C. H. 1916 in lower left corner.

Done from life.

Two draped figures seen against a background of bushes and garlands. The figure at the left faced to the right, the other figure facing out.

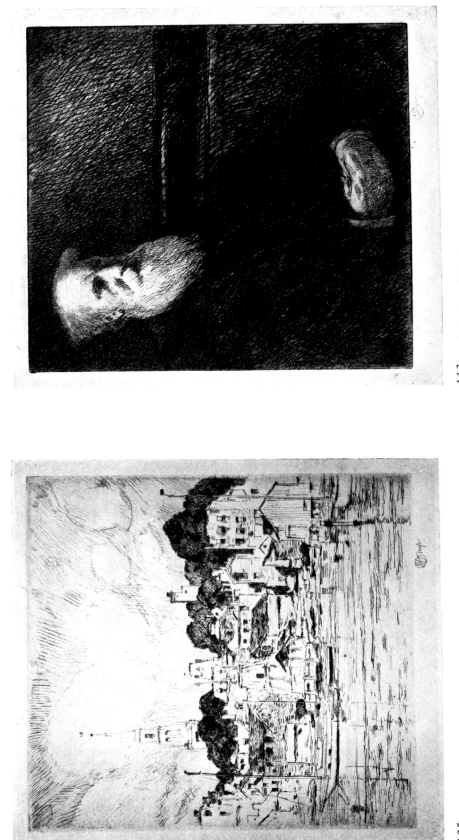

113. JOHN BURROUGHS

105. NEWPORT HARBOR

104. PORTSMOUTH DOORWAY

5½ by 4½ inches. Signed: Portsmouth, C. H. 1916 near lower right margin.

Done from nature in August, 1916.

Front doorway of the Warner House at Portsmouth, N. H.

C. I. M. F. A. L. A. M.

The façade of the old house showing the colonial doorway with an arched top, the whole in flickering light, with shadows cast by a horse-chestnut-tree whose branches fill the upper part of the composition.

105. NEWPORT HARBOR

6⅞ by 6¼ inches. Signed: C. H. 1916 in sky.

Done from nature in August, 1916.

Second state dry-point additions.

A view of the town from the river on which are several boats. Buildings and trees in the middle distance. A tall church steeple to the left of the centre. Trinity Church.

106. NEWFIELDS, N. H.

9⅜ by 11⅜ inches. Signed: C. H. 1916 in lower right corner.

Done from nature in September, 1916, at the Whitcomb Farm, Stratham, New Hampshire.

A rolling landscape. The foreground is meadows, among trees in which are several small houses. In the background is the small village of Newfields, N. H., near the famous boys' school of Phillips Exeter Academy on the tidal river Squamscot. The sky, which occupies about two-thirds of the composition, is full of rolling clouds— a thunderstorm. L. A. M.

107. HALCYON HILL

8⅞ by 11¼ inches. Signed: C. H. 1916 near lower left margin.

Done after studies for a painting of the same name, in September, 1916.

First state, before left cloud was slightly reduced and additional work in the reflections of the water to the left. About 4 or 5 proofs printed.

Second state, with the changes mentioned above. There are now no large spaces in the water. Plate destroyed. 16 proofs.

A large, round hill on which are a number of trees in the foreground, a small stream and three nude figures.

107. HALCYON HILL

106. NEWFIELDS, N. H. 9⅜ by 11⅜ inches

108. THE SURF
6⅜ by 4⅜ inches. Signed: C. H. 1916 in upper right corner.

Done about September 15, from a drawing. Plate destroyed. 8 proofs.

A nude figure of a young girl reclining against a large rock looking out over the sea. Rocks and surf in the middle distance.

109. ALBERT ROULLIER
6 by 4 inches. Signed: Chicago, C. H. Oct. 29, 1916 in upper left margin.

Done from life at a half-hour sitting.

A portrait of the print-seller, Albert Roullier, seated in his print cabinet.

Half-length portrait of a man in a dark coat, wearing glasses and with very thick, white hair, who looks like a French abbé.

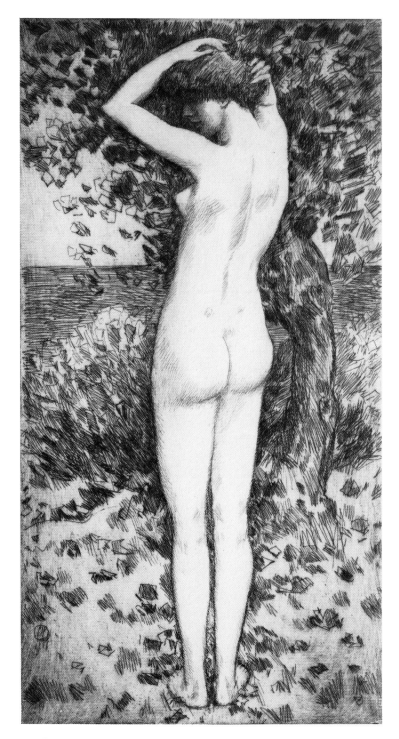

112. THE ALMOND TREE

110. THE LITTLE MODEL RESTING

5 by 5 inches. Signed: New York, C. H. 1916 in upper left corner.

Done from life in the studio, November, 1916. Plate destroyed. 10 proofs.

A nude figure of a young girl seated against draperies on a sofa facing to the left.

111. STOCK BROKER'S OFFICE, WALL STREET

4 by 5¾ inches. Signed: New York, C. H. Nov. 8, 1916 in lower right corner.

Done from nature. Plate destroyed. 13 proofs.

In the centre a man stands arranging cards in a large score-board. To the left four figures grouped about a stock-ticker over which is an electric light. Then office of Post Bros., Wall Street.

112. THE ALMOND TREE

11 by 5¾ inches. Signed: C. H. 1916 in lower left corner.

Done from posed model and from the painting of the same name at the studio, November 11, 1916.

Nude back figure, full length, of a young woman with hands arranging hair, head turned to the left, is seen standing against an almond-tree. Proof owned by the Los Angeles Museum.

113. JOHN BURROUGHS

5 by 4½ inches. Signed: New York C. H. Nov. 17, 1916 in upper right corner.

Done from life in a short sitting.

A portrait of the celebrated naturalist.

M. F. A.

Three-quarter-length portrait of an old man with a white beard and with hands clasped in lap, seated upon a sofa, facing to the right.

114. SELF-PORTRAIT

11 by 7 inches. Signed with full name on the screen.

Done from life and from a similar painting in November, 1916. Plate destroyed. 26 proofs.

Half-length portrait of the artist with brushes and palette in hands faced to the right, looking out. Stands against a panelled screen. Proof owned by the Los Angeles Museum.

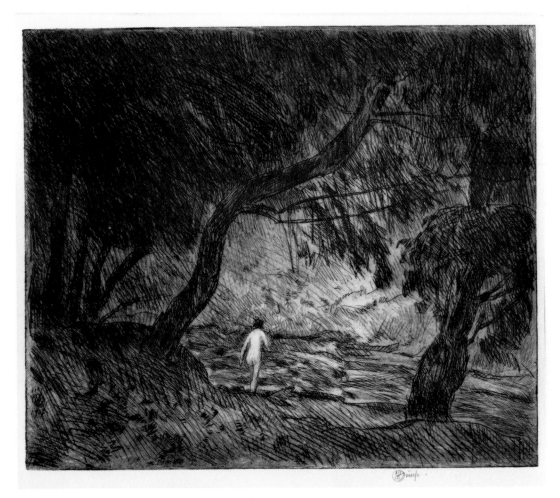

118. WOODLAND STREAM IN JUNE

115. C. H. ETCHING

5½ by 3⅞ inches. Signed: C. H. 1916 near centre at the top.

Plate destroyed. 19 proofs.

A half length full face portrait of the artist with needle and copper-plate in hands.

116. THE WILLOW POOL

7½ by 9 inches. Unsigned.

A nude figure of a young woman stands in a shallow woodland pool facing to the right with hands holding the branch of a willow-tree.

117. THE WHITE HOUSE

5 by 8 inches. Signed: C. H. Washington, Dec. 7, 1916 in lower left corner.

Made from nature when serving as a juror for paintings at the Corcoran Gallery.

A view of the White House from the park, trees and bushes on either side. A flag flies from the flagstaff.

118. WOODLAND STREAM IN JUNE

4⅝ by 5½ inches. Signed: 10 June, C. H. 1916 in lower left corner.

Plate destroyed. 26 proofs.

Second state with dry-point additions.

A nude figure of a young girl about to enter a woodland stream. Two large willow trees in the foreground, several others to the left. Los Angeles Museum.

119. BOULDER IN SNOW

4¼ by 5⅞ inches. Signed: New York, C. H. 1916 in lower margin at the centre.

Made in Central Park. Plate destroyed. 9 proofs.

A large boulder covered with snow is at the right, two large trees in foreground, others at the left and behind the boulder.

120. ST. PATRICK'S CATHEDRAL

8⅞ by 10⅞ inches. Signed: New York, C. H. 1917 in upper right corner.

Made from nature at the window of a friend's Fifth Avenue house.

The west front of the cathedral. The steps and sidewalk are covered with snow, and a few figures. The building of the Union Club is seen at the right. Los Angeles Museum.

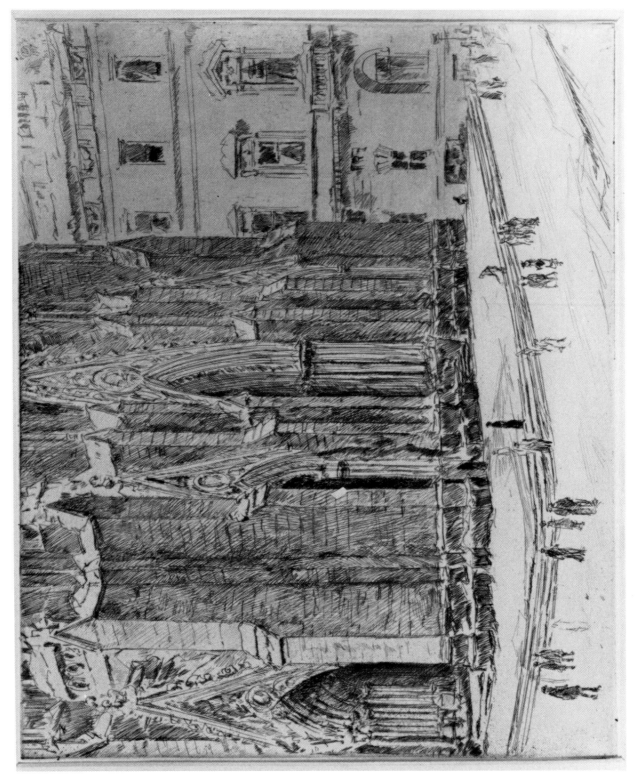

120. ST. PATRICK'S CATHEDRAL

121. MRS. H.

5¼ by 3¾ inches. Signed: New York, C. H. 1917 to the left and centre.

Portrait of a lady with fur scarf and hat with wide brim, facing to the left.

122. UNDER THE CLIFFS

5⅜ by 3⅞ inches. Signed: C. H. 1917 to the right at centre.

Plate destroyed. 13 proofs.

A nude figure of a young girl seated on the sand at the foot of a cliff, facing to the left. The sea at the left.

123. THE ABELONE SHELL

8⅞ by 6⅞ inches. Signed: C. H. 1917 in lower right corner.

Plate destroyed. 26 proofs.

Nude figure of a young girl kneeling on the shore. In her right hand she holds to her ear an Abelone shell. Rocks and bushes in the background to the left, while on the right a view of the sea and the distant shore. Los Angeles Museum.

124. A NEW ENGLAND BARROOM

5 by 5⅛ inches. Signed: C. H. 1917 in lower right corner.

An old-fashioned barroom. Before the bar stands a man in a dark suit of clothes and a light hat. A man behind the bar is seen in profile. On the walls a number of framed advertisements.

125. STORM IN THE CATSKILLS

6½ by 9⅜ inches. Signed: June, C. H. 1917 in upper left corner.

Plate destroyed. 21 proofs.

A view across the river to the mountains where a storm gathers. In the foreground two fishing-boats with nets.

126. NEW YORK PUBLIC LIBRARY

6½ by 5½ inches. Signed: C. H. 1917 in upper left corner.

Made from nature. Reversed.

A view of the library from 42nd Street. Many automobiles and busses in the street in front and many pedestrians on the walks. Two flags fly from poles in front of the library, and at the right are two tall buildings.

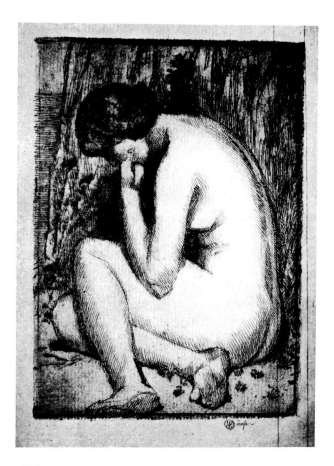

122. UNDER THE CLIFFS

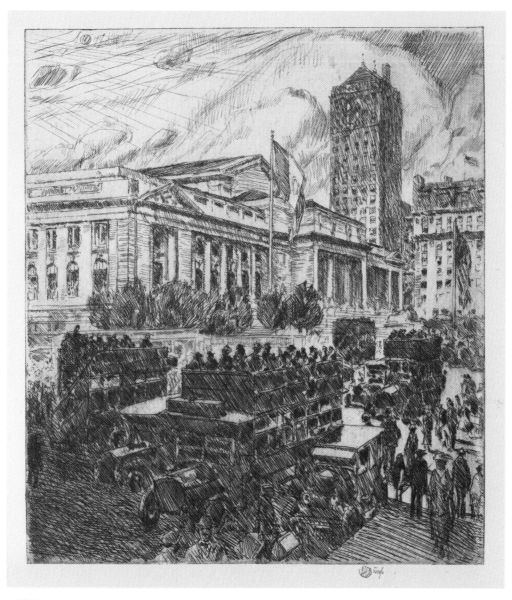

126. NEW YORK PUBLIC LIBRARY

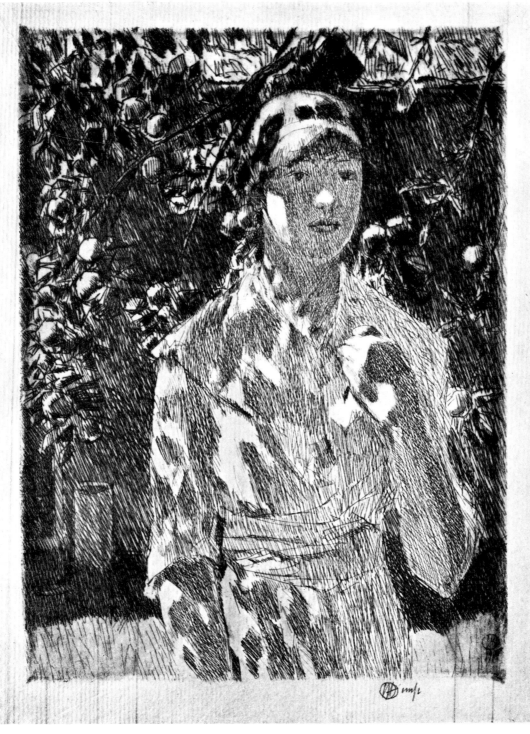

128. HELEN BURKE 7⅜ by 5⅜ inches

127. LITTLE BRIDGE, MOONRISE

3¾ by 6 inches. Signed: C. H. 1917 in lower left corner.

A wooden bridge over which a man is walking crosses a small stream in the foreground. Several dark trees in the middle distance. In the background a hill over which is seen the rising moon.

128. HELEN BURKE

7⅜ by 5⅜ inches. Signed: C. H. 1917 in lower left corner.

Made at Cos Cob of the young girl who posed for the artist at the time.
M. F. A.

Three-quarter portrait full-faced, of a young girl in a white dress, standing under an apple-tree, the branches of which, with its fruit, form a background. The whole flecked with light and shadow, perhaps the only plate ever attempted of this effect.

129 POLLY KANE

6 by 8⅜ inches. Signed: C. H. 1917 in lower right corner.

Plate destroyed. 20 proofs.

The draped figure of a young girl, half-length, full-faced, with arms extended, is seen against the background of a laden peach-tree. Portrait of the young girl who posed for it.

130. UPPER MANHATTAN

5¾ by 8¾ inches. Signed: Coytesville, C. H. 1917, June in lower left corner.

Dry-point.

The skyline of Upper Manhattan is seen across the Hudson River. In the foreground a row of barges. This was etched on the plate from nature from Richards's restaurant overhanging the Palisades.

131. THE FLAG

5¼ by 4¼ inches. Signed: New York, C. H. May 2, 1917 in lower left corner.

Plate destroyed. 7 proofs.

A scene at Fifth Avenue near 59th Street. A large American flag hangs over the walk, on which are many pedestrians. In the distance are seen the trees of Central Park.

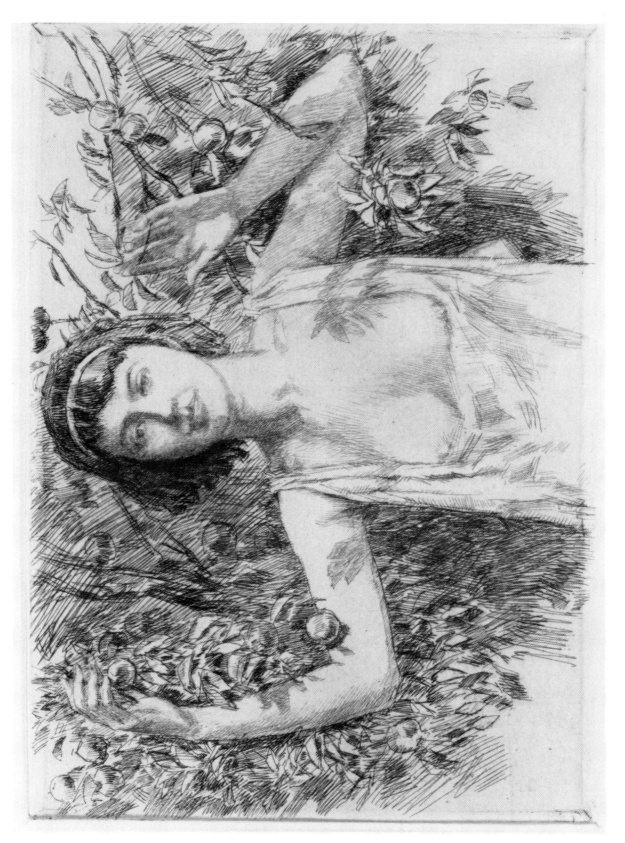

129. POLLY KANE

132. EGYPT LANE

3¾ by 6 inches. Signed: July, C. H. 1917 in lower right corner.

Dry-point.

A winding road runs across the country to the sand dunes at the left. At the right a bank on which is an old, dead tree.

133. TREES OF HEAVEN

6¼ by 6⅞ inches. Signed: July, C. H. 1917 at left side near centre.

Dry-point.

In the foreground two large Ailanthus trees, the tree of Heaven, sacred tree of China, behind which are many smaller ones and bushes. Etched in dry-point in the garden of Mrs. Ruger Donoho at Easthampton.

134. EASTHAMPTON

7½ by 11¼ inches. Signed: C. H. 1917 in lower left corner.

C. I. M. F. A. L. A. M.

The village street bordered on both sides by large elm-trees. In the centre of the street are two dogs. At the left of the composition a picket fence, behind which is a colonial house. The Lion Gardiner House.

135. THIS HOUSE

7½ by 10⅞ inches. Signed: C. H. 1917 at bottom to right.

First state, with sky. 14 proofs. Second state, with sky removed.

The gable end of a little old house on Egypt Lane, Easthampton. There are two windows and a door. On the door of the house is fastened a Government proclamation stating that "A man from this house is fighting in France." Seated on the grass in the foreground is a young baby.

136. THE FITHIAN FARM, EASTHAMPTON

7 by 10⅞ inches. Signed: Easthampton, C. H. 1917 near the right margin of the centre.

In the foreground a barn and three trees behind a rail fence. To the right a horse is grazing. In the distance a house and many barns and sheds, with a large grove of trees behind the same. This fine old farm has been cut up into building lots and the old house has been moved and the barns torn down.

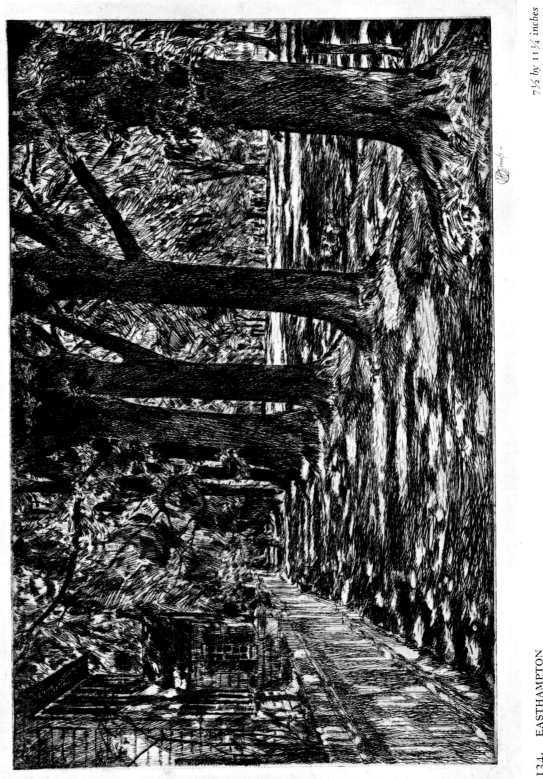

134. EASTHAMPTON

7½ by 11¼ inches

130. UPPER MANHATTAN

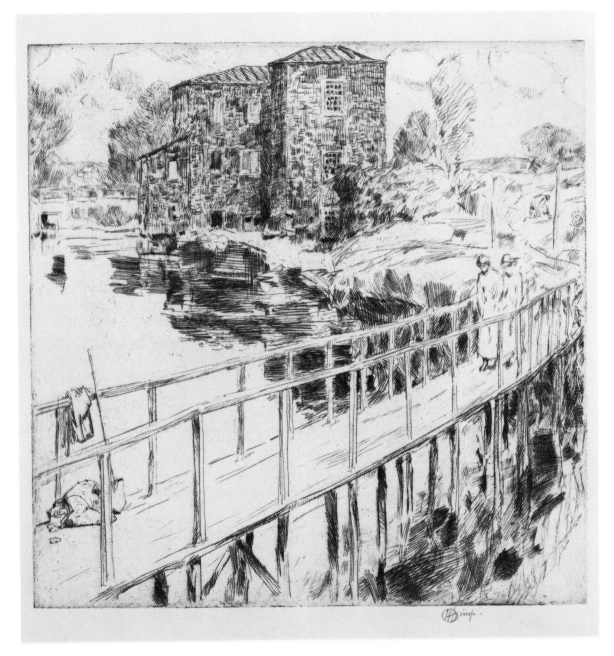

137. WATER MILL

137. WATER MILL

6 by 5⅞ inches. Signed: July 11, C. H. 1917 at right margin near centre.

Made from nature at the place of this name near Easthampton.

M. F. A. L. A. M.

In the foreground a wooden foot-bridge over which pass three figures. In the background an old mill and in the extreme distance to the left a second bridge or viaduct.

138. NEWMARKET ROAD

3⅞ by 6 inches. Signed: July 26, C. H. 1917 near lower left margin.

Dry-point.

In the centre a large elm-tree casts its shadow across a road which runs through the composition. To the left of the road behind the tree are several small houses and barns.

139. WINNICUTT POND

3½ by 5⅝ inches. Signed: June 23, C. H. 1917 in lower right corner.

M. F. A. L. A. M.

A small pond near Exeter, N. H., in the foreground, on the shore of which are willows and a large elm-tree. On the far side of a hayfield, which is across the pond, are a number of trees and bushes.

140. ELM ARCH

4 by 4⅜ inches. Signed C. H. 1917.

Dry-point.

The driveway entrance to the Whitcomb Farm, Stratham, N. H.

141. THE WATERING PLACE

4 by 5⅞ inches. Signed: July 17, C. H. 1917 in lower left corner.

Dry-point.

A large elm-tree overshadows a water pool beside a road which is on the right. On the road in the distance is a carriage.

142. HICKORIES—DRY-POINT

4 by 6½ inches. Signed: Aug. 24, C. H. 1917 in lower left corner.

M. F. A.

A row of seven hickories in a hayfield crosses the composition in the foreground. Many other trees and bushes suggested in the distance.

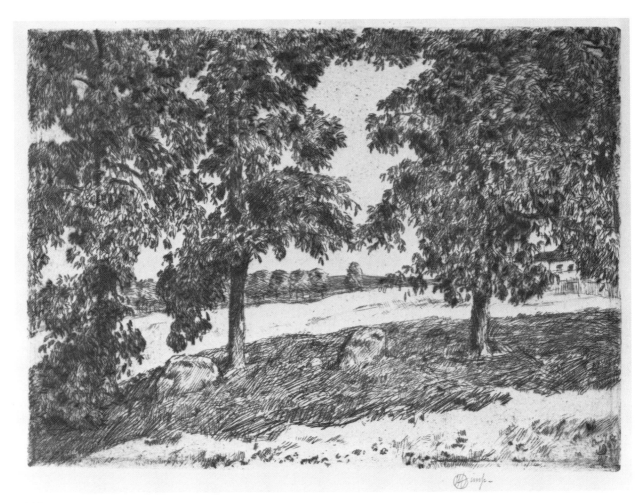

143. THREE HICKORIES

143. THREE HICKORIES

5½ by 7⅜ inches. Signed: C. H. 1917 in lower right corner.

First state 20 proofs. Second state, a young Pan piping has been added near the rocks.

Three large hickory-trees in the foreground cast heavy shadows on the ground under-neath. In the shadow are two large rocks. In the distance across a sunlit field are many other trees, and to the right a small house. Made on the Whitcomb Farm, Stratham, N. H.

144. HICKORIES IN A HAYFIELD

7 by 9⅜ inches. Signed: Aug. 23, C. H. 1917 in lower right corner. M. F. A.

A row of five large hickory-trees stand in a hay field. In the foreground the hay has been cut and lies in rows. In the distance a large, dark hill and other smaller trees. Etched from nature at the Whitcomb Farm.

145. THE OPEN WINDOW

8 by 6¼ inches. Signed: C. H. 1917 in the picture on the wall to the right.

Plate destroyed. 17 proofs.

A young woman in a white dress seated on a sofa faced to the left, beside an open window. Beside the sofa stands a rush-bottomed chair.

146. THE RED CROSS GIRL

7 by 4⅞ inches. Signed: C. H., Heroland, 1917 in upper left corner.

Plate destroyed. 41 proofs.

Made at one of the fairs for Heroland to help the soldiers.

Full-face portrait of a young woman in the uniform of a Red Cross worker.

147. THE AVENUE OF THE ALLIES

14¾ by 9¾ inches. Signed: C. H. 1918 in lower left corner.

Dry-point.

A view on Fifth Avenue near 59th Street. Many flags flying from the houses on either side and a great number of pedestrians on the street. In the distance the trees of Central Park. The drawing was reversed on the plate, so the view is seen as it is.

148. NYMPH WITH RABBIT

7½ by 8⅞ inches. Signed: C. H. 1917 in lower left corner.

The nude figure of a young girl faced to the right and beside her stands a rabbit by the shore of a stream with a large group of bushes.

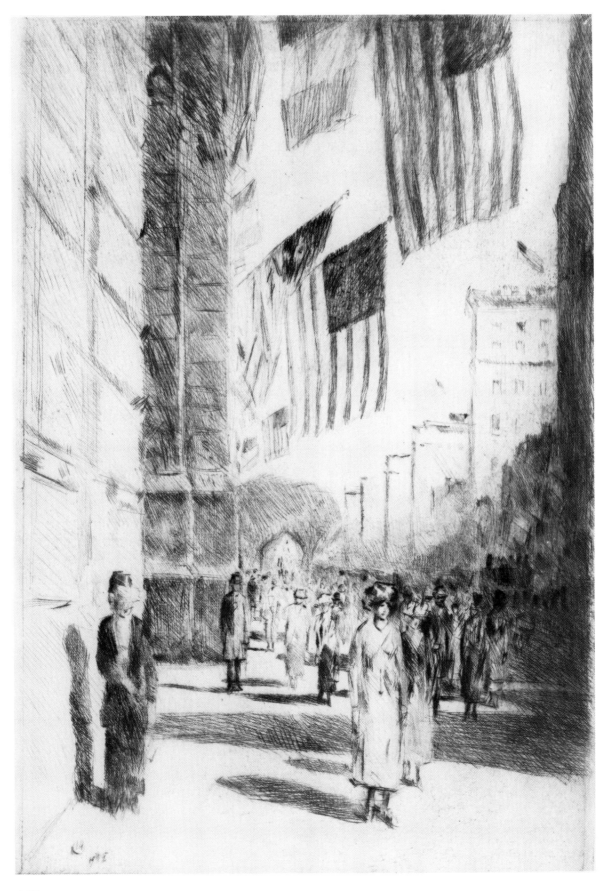

147. THE AVENUE OF THE ALLIES

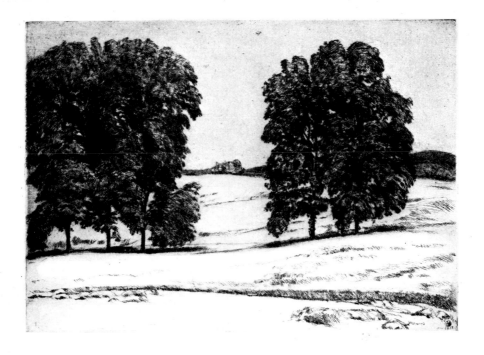

144. HICKORIES IN A HAYFIELD *7 by 9⅜ inches*

149. THE GREEK PAGEANT DANCE

5⅜ by 6⅞ inches. Signed: C. H. 1920 in lower left corner.

A group of six young women in Greek costume with hands clasped are dancing on the grass. From drawings made at a war pageant in 1918.

150. MIDSUMMER

9 by 6⅞ inches. Signed: C. H. 1919 in lower right corner.

Three-quarter length nude figure of a young woman, faced to the right, stands on the shore with hands arranging her hair. Around her waist is a girdle. Made at Gloucester, Cape Ann. L. A. M.

151. EVENING LIGHT, APPLEDORE

8⅞ by 5⅞ inches. Signed: C. H. in lower right corner.

Three states of the plate, graver and dry-point additions.

The nude figure of a young woman seated on a large rock, faced to the left. In the background the sea, on which is a boat with one sail.

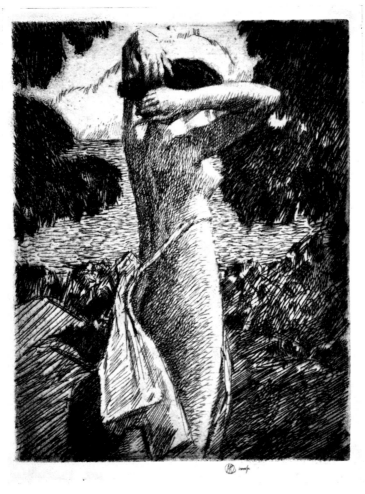

150. MIDSUMMER *9 by 6⅞ inches*

152. GREEK DRESS

6 by 3½ inches. Signed: C. H. July 11, 1919 near left margin.

The draped figure of a young woman in Greek dress and sandals stands at the foot of a cliff. She is looking toward the left. In the distance between cliffs is the sea.

153. NEW YORK AND THE HUDSON

9⅝ by 11¾ inches. Signed: Studio, C. H. 14 March 1920 in lower right corner.

A view of New York from the Palisades. In the river are many steamships and barges, and in the foreground two boys are flying a kite. The domelike structure on the left is the Hell Gate bridge. The drawing was reversed on the plate, the print is seen as it is in natural arrangement.

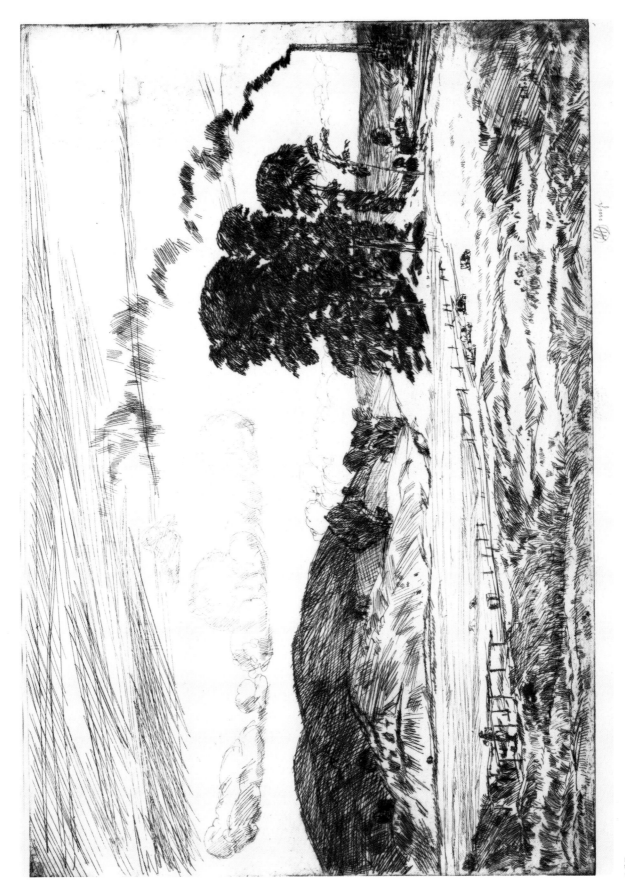

157. THE DANBURY HILLS

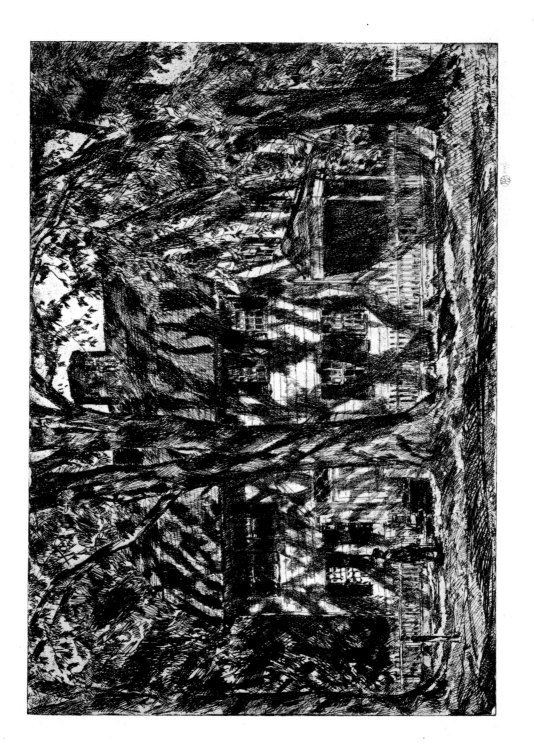

159. THE LION GARDINER HOUSE, EASTHAMPTON

9¾ by 14 inches

154. THE DEEP SEA BATHERS

5⅜ by 7⅝ inches. Signed: C. H. 1920 in lower right corner.

M. F. A.

Three nude figures of young girls standing on a rock facing to the right. Beyond is the sea and ocean surges.

Souvenir of the Isles of Shoals.

155. C H. 1920

3¾ by 3 inches. Signed: N. Y. C. H. 1920 near lower left corner.

C. I.

A portrait bust of the artist, full-faced, looking toward the right.

156. ANNA

5 by 5⅜ inches. Signed: New York, C. H. 1920 near margin to the right.

Portrait bust of a young woman with a large dark hat. In her hands are seen the handle of a parasol.

157. THE DANBURY HILLS

8 by 12 inches. Signed: C. H. 1920, Bethel, Conn. near lower right corner.

In the foreground are meadows in which are four cows. An elevated roadway, on which there is a man, crosses the meadow. To the left are hills and to the right a factory with a large smoking chimney stack.

158. CHILDE HASSAM—CONTRE JOUR

4¾ by 2⅞ inches. Signed: C. H. N. Y. May 2, 1920 in lower left corner.

A full-faced portrait of the artist in his painting smock. At the back to the left an open window.

159. THE LION GARDINER HOUSE, EASTHAMPTON

9¾ by 14 inches. Signed: Oct. 8, C. H. 1920, Easthampton, in lower right corner.

C. I. M. F. A.

An old house with a picket fence stands behind a row of large elm-trees. On the walk a figure of a man. Uncle David Gardiner, a descendant of Lion Gardiner, lives in the old house.

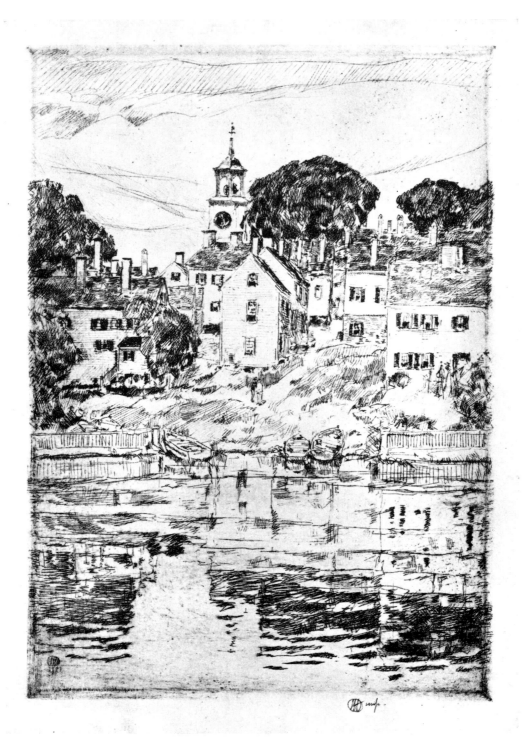

161.　THE CHURCH TOWER, PORTSMOUTH　　　　　　　　*8½ by 6 inches*

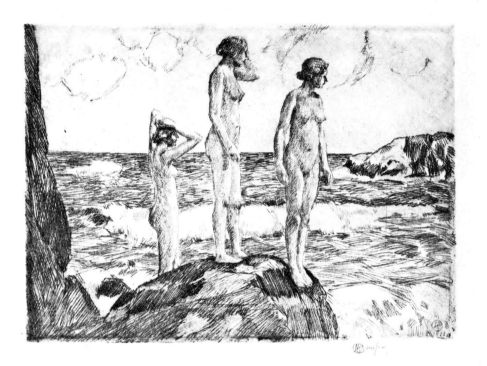

154. THE DEEP SEA BATHERS 5⅜ by 7⅝ inches

160. THE HAY BARN

10⅜ by 14¼ inches. Signed: C. H. 1920 in lower right corner.

Drawing in collection of Geo. J. Dyer.

An old barn, the doors of which are open. On the floor of the barn a wagon loaded with hay on which stands a man tossing hay. Made from drawing done at the Whitcomb Farm. This real New England Farm was the summer residence of Mr. and Mrs. Charles H. Whitcomb and their family, life-long friends of the artist.

161 THE CHURCH TOWER, PORTSMOUTH

8½ by 6 inches. Signed: C. H. 1921 in lower left corner.

C. I. M. F. A.

A view of the town from the river. Behind many houses are elm-trees and a church tower. On the shore are three boats.

162. OLD DOORWAY, EASTHAMPTON

10 by 11⅞ inches. Signed: Easthampton, C. H. July 28, 1920 in lower right corner.

C. I. M. F. A.

The doorway of an old house, The Nathaniel Dominy house at Easthampton, on either side of which are wistaria vines. In front of the door are two old millstones.

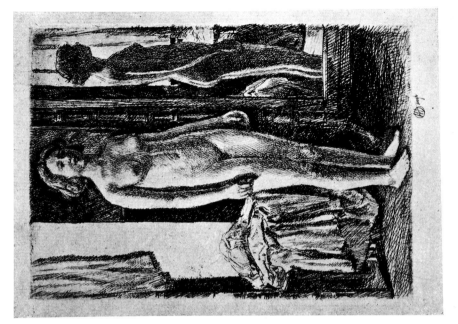

167. THE SWIMMER—MODEL

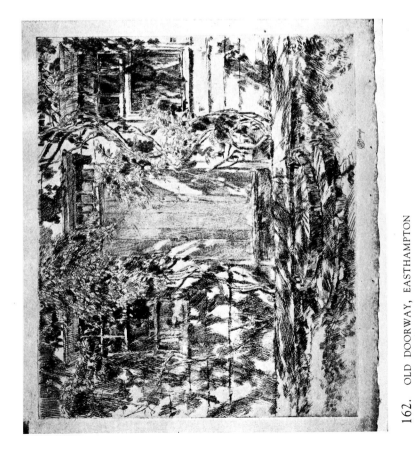

162. OLD DOORWAY, EASTHAMPTON

[110]

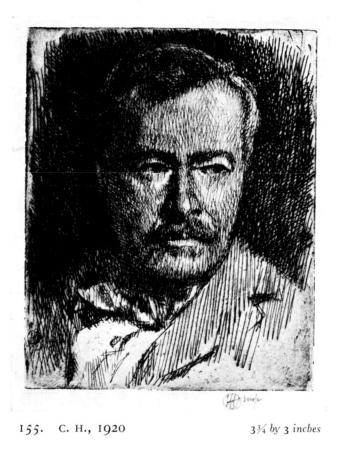

155. C. H., 1920 3¾ by 3 inches

163. HEAVY SURF, HIGH TIDE, EASTHAMPTON

8 by 12 inches. Signed: Oct. 1st 1920, C. H. Easthampton.

A view of the surf from the shore. Heavy clouds and strong rays of light in the distance.

164. THE LITTLE WILLOWS

13⅞ by 10 inches. Signed: C. H. 1921 in lower right corner.

Nude figure of a young woman faced to the left is walking between two rows of willows.

165. THE BEACH, EASTHAMPTON

9 by 14 inches. Signed: Studio, C. H. 1921 in lower left corner.

On the beach, on which is breaking a heavy surf, stand three nude figures in the shallow water that comes over the crest of the beach at high tide forming curving rythmic patterns. The two to the left have their hands upraised.

[111]

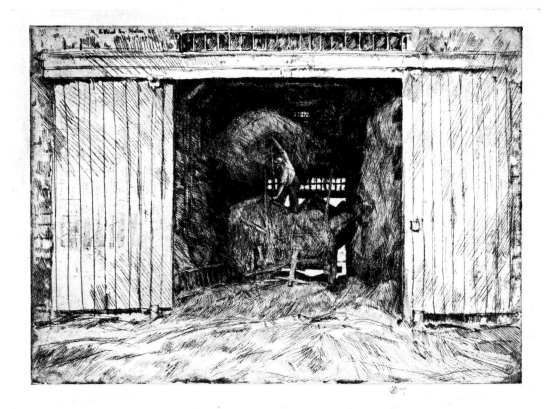

160. THE HAY BARN 10⅜ by 14¼ inches

166. THE SWIMMER, BASS ROCK

7½ by 3½ inches. Signed: Studio, C. H. 1921 in lower left corner.

Nude figure of a young girl standing in shallow water at the foot of a cliff. She is looking toward the right. In the background the sea and a distant shore.

167. THE SWIMMER—MODEL

6⅞ by 4⅞ inches. Signed: C. H. in shadow behind the model's left shoulder.

Nude figure of a young girl standing before a mirror facing to the right. Made from the model, etched directly on the plate.

168. LONG ISLAND SURF

9 by 5⅞ inches. Signed: July 2, C. H. 1921 in lower right corner.

Nude figure of a young woman standing on the shore and facing to the left. Behind the figure the sea and a heavy surf.

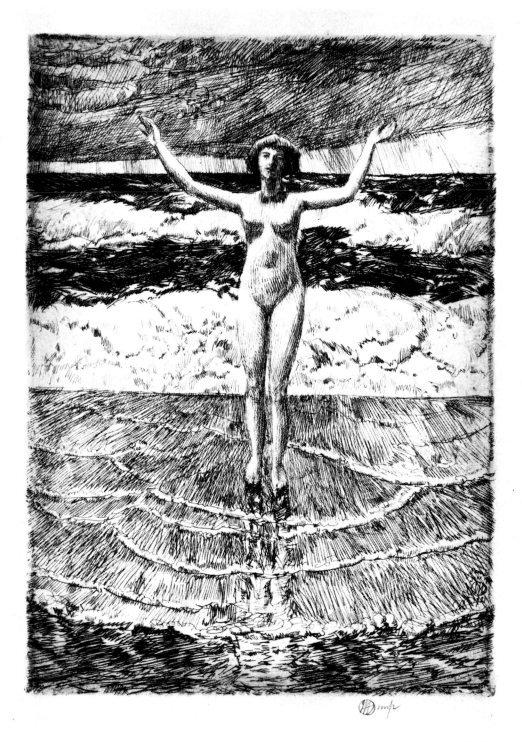

170. RAIN DROPS AND SURF $8\frac{3}{8}$ *by 6 inches*

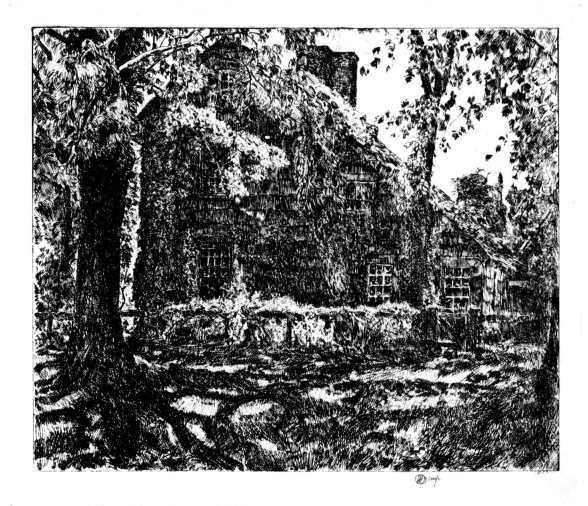
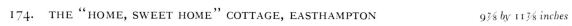

174. THE "HOME, SWEET HOME" COTTAGE, EASTHAMPTON 9⅞ by 11⅞ inches

169. WALKING INTO THE SURF

8⅞ by 5¾ inches. Signed: Easthampton, July 18, C. H. 1921 in lower right corner.

C. I. M. F. A. L. A. M.

The nude figure of a young woman standing on the shore facing to the right. In the background are sand dunes.

170. RAIN DROPS AND SURF

8⅜ by 6 inches. Signed: Easthampton, June, C. H. 1921 in lower right corner. L. A. M.

The nude figure of a young woman standing on the shore with arms raised over her head. In the background the sea and a heavy surf.

171. IN THE SURF, EASTHAMPTON

8¾ by 6 inches. Signed: June 26, Easthampton, C. H. 1921 in lower left corner.

The nude figure of a young woman going into the surf with arms extended and looking to the left.

172. IN THE SURF IN A STORM

8¾ by 6 inches. Signed: Easthampton, C. H. July 7, 1921 in lower left corner.

C. I. L. A. M.

The back view of the nude figure of a young woman standing in the surf with arms extended.

173. PORTRAIT OF MRS. K. VAN R.

8⅞ by 5⅞ inches. Signed: July 15, C. H. 1921 in left margin near centre.
Portrait of a lady in light dress and large hat seated before and with arm resting upon an open piano on which is a bowl of flowers. Etched at a short sitting from Mrs. Kiliaen Van Rensselaer in her cottage at Easthampton.

174. THE "HOME SWEET HOME" COTTAGE, EASTHAMPTON

9⅞ by 11⅞ inches. Signed: June C. H. 1921 in lower right corner.

Made from nature directly on the plate. Consequently subject is reversed.

The gabled end of the famous old house covered with vines stands behind a fence, which is also covered with vines. In the foreground to the left a large elm-tree which casts its shadow over the roadway. This is where the author of the world-wide known lyric passed his boyhood—and this old house was the motif of the celebrated song. First sung in London a century ago.

[115]

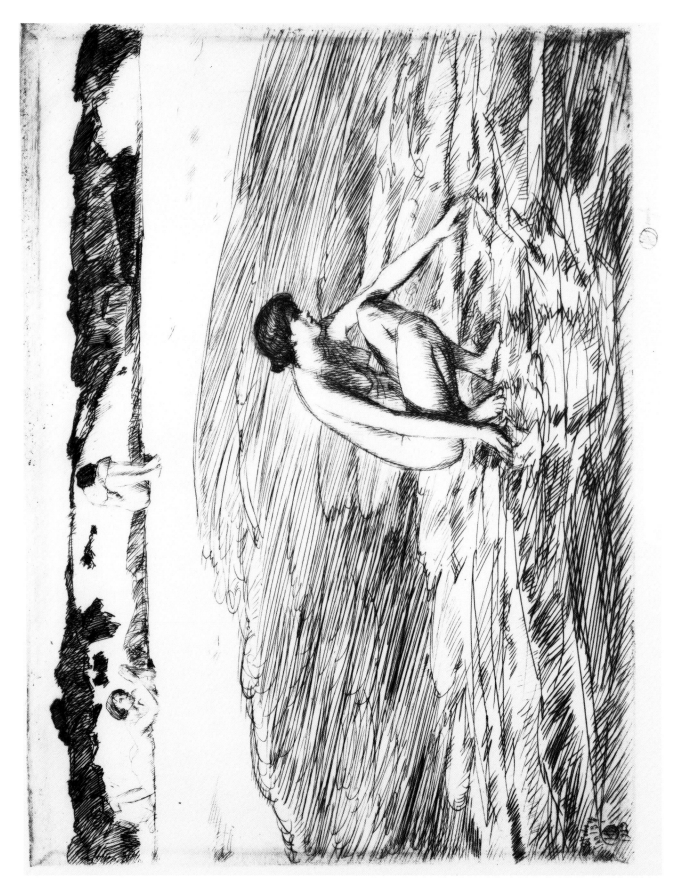

217. HIGH TIDE, MONTAUK

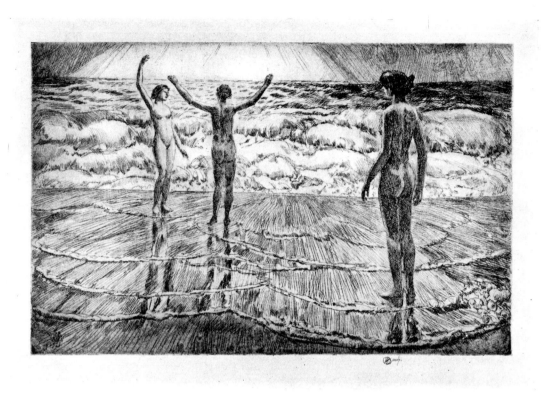

165. THE BEACH, EASTHAMPTON *9 by 14 inches*

175. EVENING, EASTHAMPTON

10¼ by 11⅞ inches. Signed: Aug. 3, C. H. 1921 in lower right corner.

Before a large group of dark trees stand two nude figures of women with arms extended over their heads.

176. OLLIE

5½ by 4 inches. Signed: C. H. 1921 in upper left corner.

A half-length figure of a young girl with short hair. She is facing to the right. Portrait of a model etched from life at a sitting.

177. MY NEW YORK WINTER WINDOW

8⅞ by 6⅞ inches. Signed: C. H. New York, Feb. 15, 1922 at the top near centre.

Plate destroyed. 24 proofs.

A half-length portrait of the artist in a dark coat seated at a table. He is etching the plate by looking into a mirror. In the background a window through which are seen many snow-covered roofs.

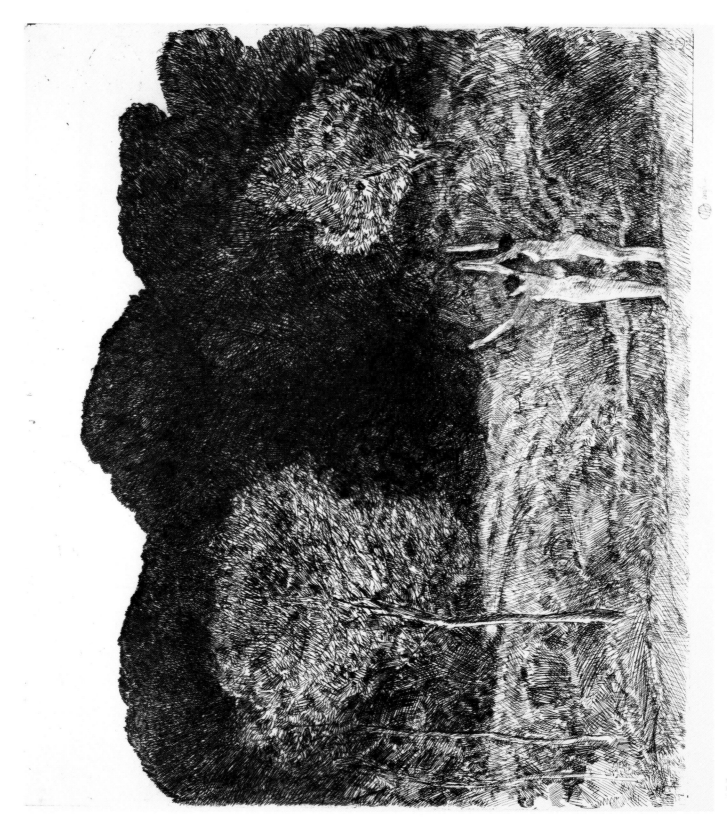

175. EVENING, EASTHAMPTON

178. SURF SWIMMER IN THE SUNLIGHT

8⅝ by 6⅛ inches. Signed: C. H. 1922 in lower left corner.

The nude figure of a young woman on the shore seen in bright sunlight. She is faced to the right and behind her are the sea and a heavy surf.

179. CLAIRE MARTEL

6⅜ by 4½ inches. Signed: New York, C. H. 1922 in right margin near centre.

Done from the model.

C. I. L. A. M.

A full-faced portrait of a young woman with dark hair and wearing a fur coat. A string of pearls around her neck.

180. THE SURF SWIMMER

7⅛ by 9⅞ inches. Signed: C. H. Easthampton, Sept. 7, 1920 in lower right corner.

The nude figure of a young woman going into the surf with water above her knees is about to plunge into an incoming breaker.

181. STOCKBRIDGE BOWL

4¼ by 8⅜ inches. Signed: Studio, C. H. 1922 in lower right corner.

The lake in the middle distance is seen through a group of trees. In the background are rolling hills.

182. COURT STREET, PORTSMOUTH

6½ by 7⅝ inches. Signed: C. H. 1922 in lower left corner.

A colonial house with a hipped roof stands behind a board fence at the corner of a street. In the foreground two large trees, and to the right another house.

183. C. H.—DRY-POINT

7⅛ by 5 inches. Signed: Feb. 14, C. H. 1922 near upper margin to the right.

A half-length portrait of the artist seated at a table etching a plate. He is in a dark coat and wears a pair of large horn-rimmed glasses.

184. POSEY ROOK

5½ by 4 inches. Signed: C. H. 1922 in upper right corner.

The bust portrait of a young girl with bobbed hair wearing a light dress with a large collar. She is faced to the right. The artist's niece.

185. PLAY OF LIGHT

5 by 4 inches. Signed: C. H. 1922 in upper left corner.

The half-length portrait of a young woman standing and faced to the left. Fragment of the painting, same title.

186. MY MODEL IN A FUR COAT

6 by 4½ inches. Signed: 1922, New York, C. H. March 15 in lower left corner.

Made from the model.

Half-length portrait of a young woman in a fur coat and a dark hat with a white band. She is faced to the right.

187. WAY UPTOWN, (AUDUBON AVENUE AND 193RD STREET)

4¼ by 9½ inches. Signed: C. H. 1921 and April, 1922 in lower right corner.

A view of upper New York from a rocky hill, on which is a group of five figures.

188. SUNSET, EASTHAMPTON

4¼ by 8⅜ inches. Signed: C. H. 1922 in lower left corner.

A hillside in front of which are five trees and over which is the setting sun.

189. MONTAUK POINT

6 by 10½ inches. Signed: Studio, C. H. 1922 in lower left corner.

In the foreground the nude figure of a young woman with left arm extended. To the left a row of cliffs and in the distance to the right a lighthouse. Montauk Light.

190. MLLE. ERMINIE GAGNON

9½ by 7 inches. Signed: New York, April 1, C. H. 1922 near right margin at centre.

Made from the model.

Half-length portrait, full faced, of a young lady wearing a fur coat and a large black hat.

191. C. H. IN HIS STUDIO

7 by 5⅜ inches. Signed: April 3, C. H. 1922 in upper left corner.

Three-quarter-length portrait of the artist in white shirt and light trousers standing before a paint-stand on which is an artist's palette. In his left hand he holds a number of brushes.

192. THE NAPOLEON GIRL

13 by 9⅛ inches. Signed: New York, April 1, C. H. 1922 in right margin near centre.

Made from the model.

Three-quarter-length portrait, full faced, of a young girl seated. She wears an ermine cape and a dark Napoleon hat with feathers.

193. THE PORTRAIT PAINTER

10 by 7⅞ inches. Signed: New York, C. H. March 5, 1922.

Made from Albert Smith, who was painting a portrait of C. H.

Half-length portrait of a man painting a portrait on a large canvas.

194. APPLEDORE

10⅞ by 7 inches. Signed: C. H. 1922 in lower left corner.

Nude figure of a young woman standing on the shore at the foot of a cliff facing to the left. Between cliffs are seen the sea and the distant shore.

195. PHYLLIS DEANE

5⅜ by 3⅞ inches. Unsigned.

Made from the model.

Half-length figure of a young girl. Her arms, which are held at her waist, support drapery.

196. ALONG THE SHORE, EASTHAMPTON

4⅞ by 7 inches. Signed: New York, C. H. 1922 in lower right corner.

The nude figure of a young woman standing on the shore with arms extended facing to the left. In the background the sea and surf.

197. STREET IN BUFFALO

5⅜ by 4⅞ inches. Signed: C. H. 1916.

Made from nature, while on a visit in Buffalo, from the window of the hotel. 1 proof was pulled. Collection of C. H.

Plate was lost.

198. MY MODEL RESTING

6⅞ by 5⅜ inches. Signed: April 10, C. H. 1922 in upper left corner.

Portrait of a young girl with light drapery, full faced, seated on a sofa. Made from the model directly on the plate.

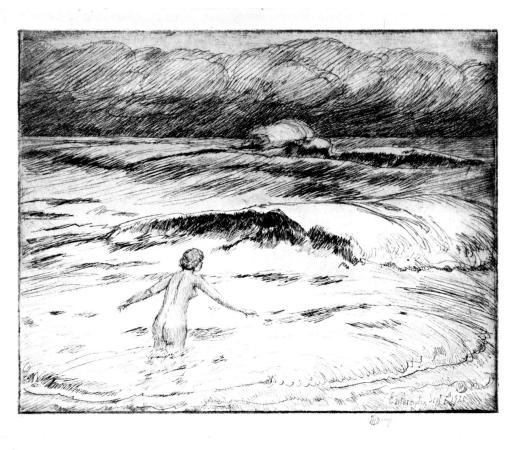

180. THE SURF SWIMMER 7⅞ by 9⅞ inches

199. MONTAUK BEACH

13¼ by 9⅛ inches. Signed: C. H. 1922 in lower left corner.

The nude figure of a young woman on the shore at the edge of the water. She is looking toward the left.

200. IN THE SUN, CAPE ANN

8¾ by 11⅜ inches. Signed: C. H. 1922 in lower left corner.

Nude figure of a young woman seated on the grass arranging her hair. She is almost surrounded by rocks and small bushes. The painting is in the Duncan Phillips Collection, Washington, D. C.

201. BRIDGE AT OLD LYME

8⅞ by 11½ inches. Signed: C. H. 1905 and 1922 in lower left corner.

In the left foreground a large group of trees. In the centre a wooden bridge crossing a stream, on which is a single figure.

In the background a rolling country.

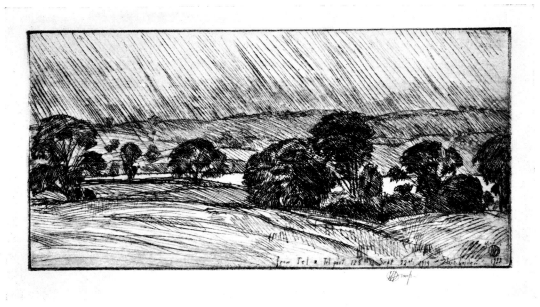

181. STOCKBRIDGE BOWL 4¼ by 8⅜ inches

202. WALKING OUT OF THE SURF

13 by 9 inches. Signed: C. H. 1922 in lower left corner.

The nude figure of a young woman is seen walking out of the water. In the background sand dunes and small bushes.

203. THREE LITTLE GIRLS OF COS COB

6⅝ by 5⅜ inches. Signed: C. H. 1922 in lower right corner.

Three nude figures of young girls standing at the edge of the water. Made from drawings as stated for the earlier plate.

204. A UNITED STATES SOLDIER

9⅜ by 4¼ inches. Signed: April 29, C. H. 1922 in upper left corner.

Three-quarter-length portrait of a young officer of the United States Army in full uniform. In his right hand he holds a cigarette in a long holder. Albert Smith.

205. GOLDEN ROD SHORE

9 by 13¼ inches. Signed: Bass Rocks 1919 C. H. 1922 in lower right corner.

A nude figure of a young woman standing with arm extended on the edge of the water. In front of her the shore is covered with stones and rocks and in the distance a few small trees. Made at Bass Rocks, Cape Ann.

[123]

188. SUNSET, EASTHAMPTON 4¼ by 8⅜ inches

206. SUNDOWN, APPLEDORE

4 by 6 inches. Signed: C. H. 1922 in lower left corner.
Dry-point.

207. FLYING SWANS

6 by 4 inches. Signed: C. H. 1922 in lower left corner.

The nude figure of a young woman with arms upraised standing at the edge of the
ocean. In the background the sea and a heavy surf. The wild swans fly from Old
Hook Pond to Georgica Pond. These ponds are separated from the sea by a few
yards of sands. A surf bather looks up as these beautiful great birds, sacred to Apollo,
swiftly pass just overhead with a whirr of wings—with the flash of sunlight.

208. MARY MULLANE

6 by 5 inches. Signed: Easthampton, June 13, C. H. 1922 in right mar-
gin near centre.

Made from a little Easthampton model directly on the plate.

C. I. L. A. M.

Bust portrait of a little girl with bobbed hair in white dress with wide collar seen
against a curtained window.

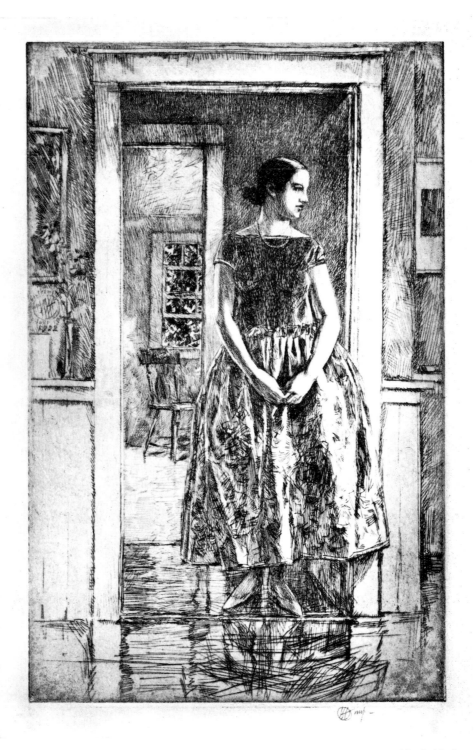

210. GIRL IN A MODERN GOWN 10⅞ by 6⅞ inches

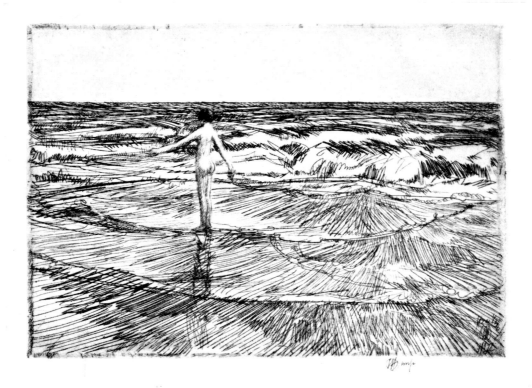

196. ALONG THE SHORE *4⅞ by 7 inches*

209. SAND DUNES, MONTAUK

> 6⅞ by 12¾ inches. Signed: C. H. 1922 in lower left corner.
>
> Plate destroyed. 5 proofs. Dry-point.

In the foreground a group of trees in which there is a house. Over the trees a wide expanse of sand dunes and the sea.

210. GIRL IN A MODERN GOWN

> 10⅞ by 6⅞ inches. Signed: Easthampton, C. H. June 19, 1922 at upper left margin near centre.
>
> C. I. L. A. M.

A young girl in a silk dress and wearing a row of pearls stands in a passage between two rooms of a colonial house. She is looking to the right. Los Angeles Museum.

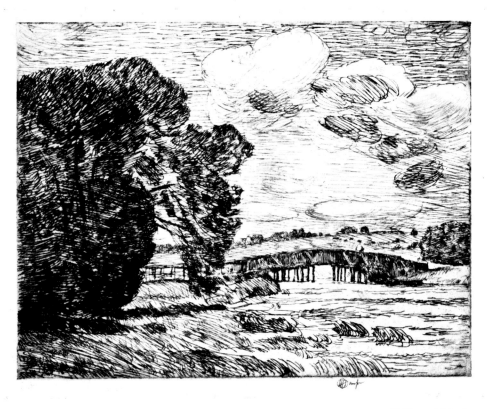

201. BRIDGE AT OLD LYME 8⅞ by 11½ inches

211. HARBOR OF A THOUSAND MASTS

9⅞ by 10⅞ inches. Signed: June 22, C. H. 1922 in lower right corner.
A view of the town and harbor of Gloucester. In the foreground a rocky shore on
which there are three houses. Many boats are in the harbor. On the skyline are
the steeples of three churches. Drawing is in the H. Egginton Collection.

212. BIRTH OF VENUS, MONTAUK

13 by 7 inches. Signed: Easthampton, C. H. June 21, 1922 in right
margin near bottom.

C. I. L. A. M.

Nude figure of a young woman with one arm extended arranging her hair. She is
looking toward the right. Behind her the sea and a heavy surf.

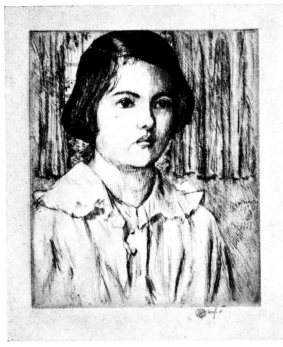

208. MARY MULLANE *6 by 5 inches*

213. HOUSE ON THE MAIN STREET, EASTHAMPTON

6 by 12⅛ inches. Signed: Easthampton, April 22, C. H. 1922 in lower left corner.

Drawing in the H. Eggington Collection.

C. I. L. A. M.

An old house with a piazza stands behind a fence. In the foreground are three large elm-trees. There is a figure on the piazza and another carrying an axe on the walk between the trees and the fence.

214. THE BIRCHES

10½ by 6 inches. Signed: 1922 C. H. in lower left corner.

Dry-point. Made on the plate from nature.

Plate destroyed. 15 proofs.

A group of four birch-trees at the centre and to the left, and at the right two flowing birches.

215. COLONIAL CHURCH, GLOUCESTER

13⅜ by 9⅞ inches. Signed: Gloucester, 1918, C. H. 1923, New York in lower right corner.

Made from a drawing. Collection of C. H. Drawing in the collection of Geo. J. Dyer.

The old church seen between two rows of elm-trees, which cast their shadow across the walk leading to the church.

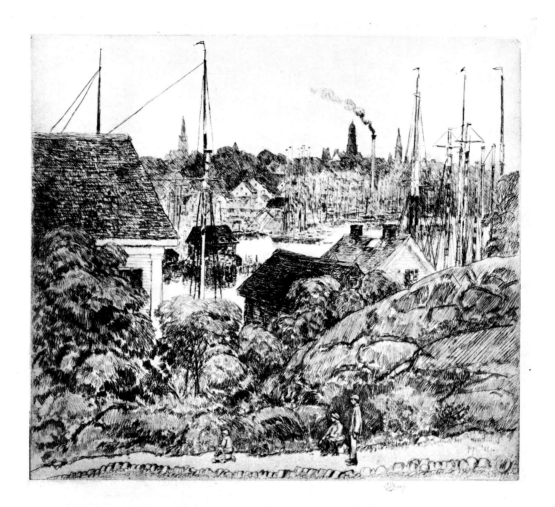

211. HARBOR OF A THOUSAND MASTS 9⅞ by 10⅞ inches

216. NYMPH OF THE GARDEN

4⅝ by 11¾ inches. Signed: January, C. H. 1923 in lower right corner.
L. A. M.

A draped figure of a young girl dances in the centre of a garden. Beside her are four rabbits and many birds. Two trees in the foreground. Made in the artist's Easthampton garden. L. A. M.

217. HIGH TIDE, MONTAUK

6⅜ by 8¾ inches. Signed: Studio, Jany. 13, C. H. 1922.

The nude figures of young women, one in the water and the others on the sand. Sand dunes in the background.

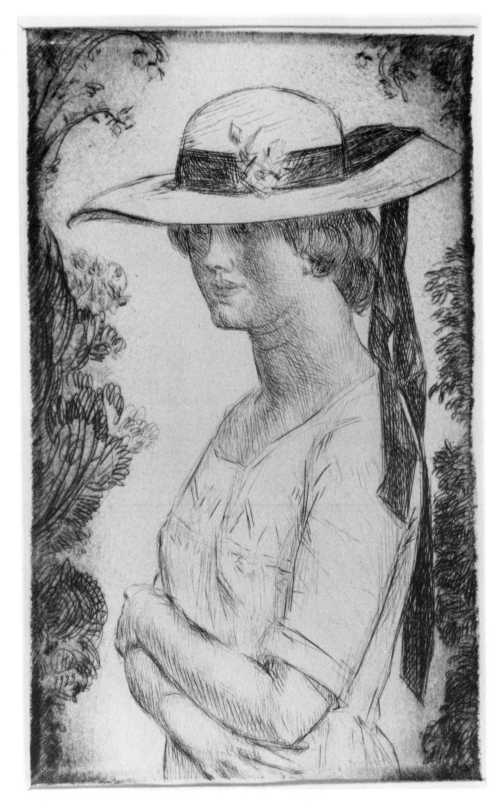

219. PHYLLIS IN A STREAMER HAT

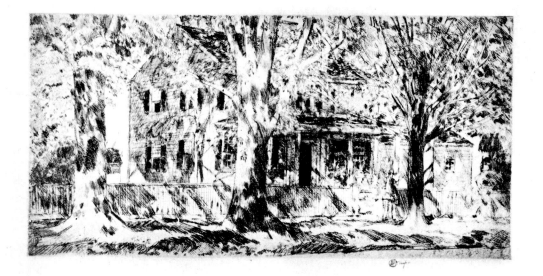

~ 213. HOUSE ON THE MAIN STREET, EASTHAMPTON *6 by 12⅛ inches*

218. SEA GULLS

11 by 6 inches. Signed: C. H. 1923 in lower right corner.

The nude figure of a young girl standing in shallow water near a cliff. She has both hands extended over her head, shading her eyes as she looks at the flight of a sea gull. To the left the sea and a distant shore. Los Angeles Museum.

219. PHYLLIS IN A STREAMER HAT

8⅛ by 4⅞ inches. Signed: June 4, C. H. 1923 in lower left corner.

Half-length portrait of a young girl in a white dress and with a large straw hat. She is faced to the left. A landscape with a village is seen in the distance. In the Catskills.

220. THE LITTLE CHURCH AROUND THE CORNER

8 by 11½ inches. Signed: Jany. 31, C. H. 1923 in lower right corner.

Made from a drawing. Collection of C. H.

Second state two nearest figures on left have been removed. 8 or 10 proofs of first state. This subject was reversed on the plate, consequently it is seen as it is in nature.

The old church covered with snow is behind the iron fence. In the sidewalk in front are a number of pedestrians.

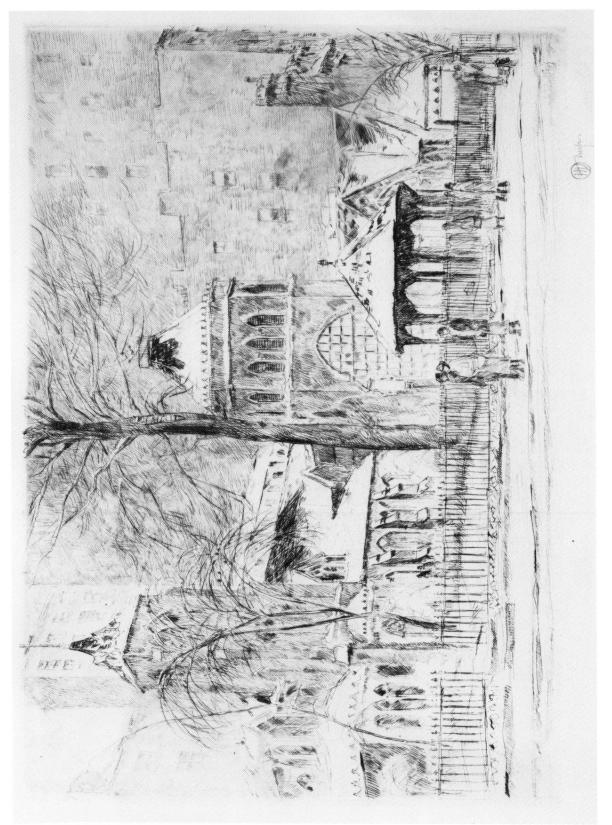

220. THE LITTLE CHURCH AROUND THE CORNER

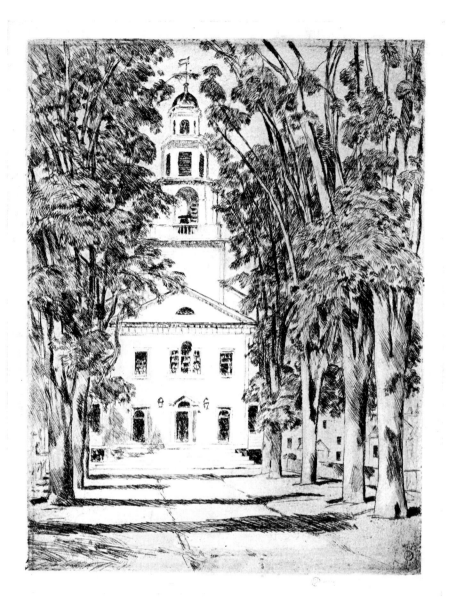

215. COLONIAL CHURCH, GLOUCESTER 13⅜ by 9⅞ inches

221. A VERMONT VILLAGE

6 by 8¾ inches. Signed: C. H. 1923 in lower right corner.

The main street of a village with a church with a white steeple in the middle distance. In the road is a cart drawn by two horses. This is the village of Peacham, Vermont, that our one-time Ambassador to Great Britain, George Harvey, made known as being one hundred per cent Anglo-Saxon.

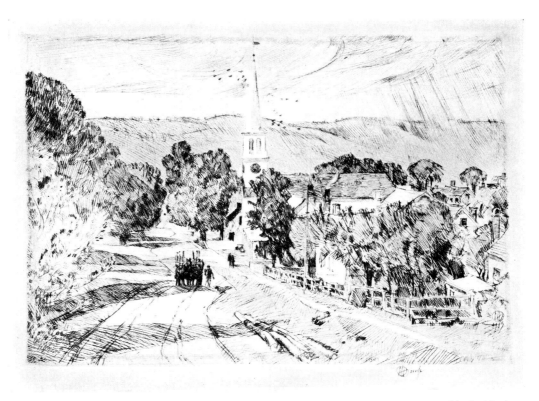

221. A VERMONT VILLAGE *6 by 8¾ inches*

222. VILLAGE ELMS, EASTHAMPTON

6⅞ by 8⅞ inches. Signed: 1923 C. H. in lower right corner.

Drawing in collection of Geo. J. Dyer.

An old house is seen behind a privet hedge. In the foreground are five elm-trees.
A young girl is on the pathway between the trees and the hedge.

223. AN EASTHAMPTON IDYLL

8⅞ by 7⅜ inches. Signed: July 11, C. H. 1923 in lower left corner.

Drawing in collection of Geo. J. Dyer.

Old houses and backyards with the farmer and his pail, and his wife hanging out the
clothes on the line. They rent their house—the natives, and live in the barns or
small outhouses for the summer.

224. OUTER HARBOR, GLOUCESTER

8½ by 10½ inches. Signed: Gloucester, C. H. 1918 in lower right corner.

A view of the harbor from a hill across the town. Made from a drawing.

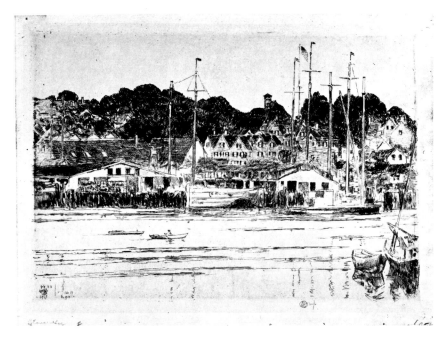

226. INNER HARBOR, GLOUCESTER

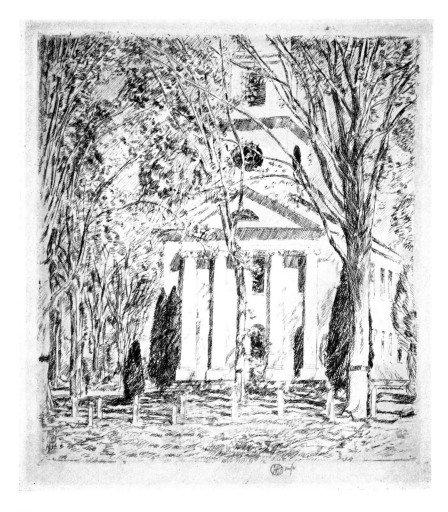

233. THE CHURCH AT OLD LYME

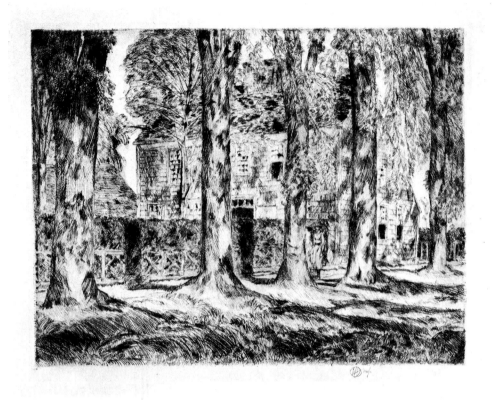

222. VILLAGE ELMS, EASTHAMPTON *6⅞ by 8⅞ inches*

225. PORTSMOUTH MANSION

8 by 11¾ inches. Signed: Portsmouth, Aug. 8, C. H. 1916, E. Studio 1923 in lower right corner.

Made from a drawing. Geo. J. Dyer collection.

An old house with a piazza and three chimneys at the edge of the water. Underneath the piazza is a line of clothes and in the yard to the left a woman is standing.

226. INNER HARBOR, GLOUCESTER

7⅝ by 11¼ inches. Signed: July 13, Gloucester, C. H. 1919, July 19, E. 1923 in lower left corner.

Made from drawing.

A view of the town from the river. On the river a number of boats, in one of which a man is rowing. Tall masts of many vessels are seen in the centre and to the right.

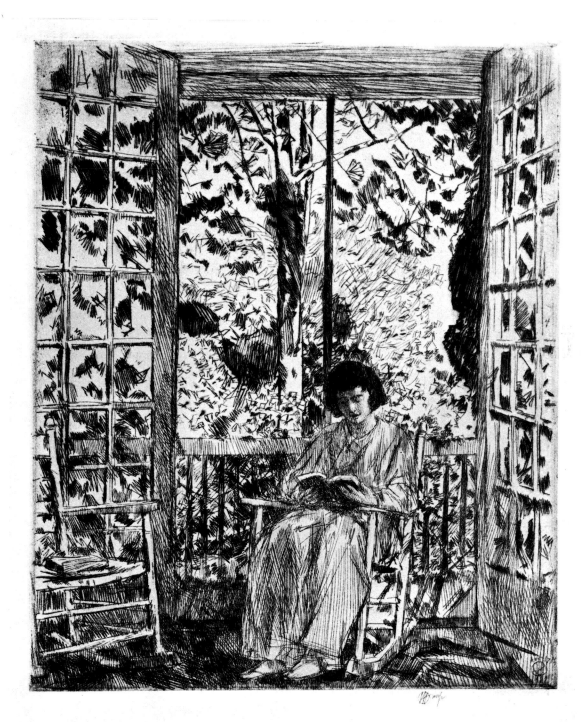

227. THE SUN ROOM 11½ by 9½ inches

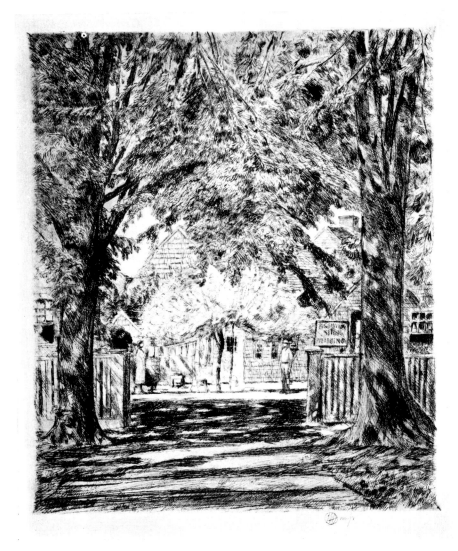

223. AN EASTHAMPTON IDYLL 8⅞ by 7⅜ inches

227. THE SUN ROOM

11½ by 9½ inches. Signed: Aug. 17, C. H. 1922 in lower right corner.
Made from drawing (collection C. H.), of the artist's niece, Virginia Rook.
L. A. M.

A young woman in a white dress, seated in a rocking-chair in a sun room, reading a
book.

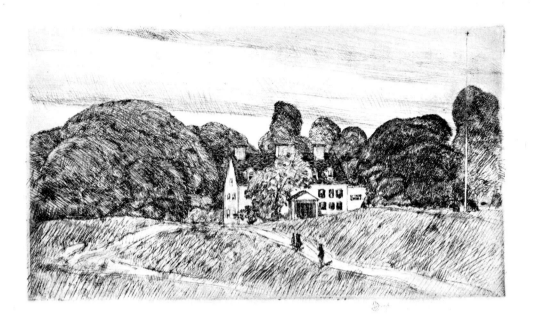

228 LION GARDINER MANOR, GARDINERS ISLAND *6¼ by 10⅞ inches*

228. LION GARDINER MANOR

6¼ by 10⅞ inches. Signed: Sept. 7, 1923, C. H. in lower left corner.

Etched on the plate from nature. The subject is, therefore, reversed.

In the centre a road, on which are three figures, leads to a large white house with three chimneys. In the background is a group of large trees. This is the Gardiners Island manor that has been in the possession of a Lion Gardiner since it was deeded to the first of the name by the Indians.

229. THE "HOME SWEET HOME" COTTAGE No. 2

5¾ by 9 inches. Signed: Easthampton, C. H. 1923 in lower right corner.

Made from nature.

The front of an old shingled house covered with vines is behind a fence which is also covered with vines. In the foreground are several birds and at the left is a windmill. Another view and another time of the year to celebrate the famous old house showing also one of the old windmills used by the early settlers—and moved there. The whole place will be preserved as it is—the house being filled with rare Americana and relics of John Howard Paine. "Home Sweet Home" was first sung in London over 100 years ago, the centenary having been celebrated in 1923.

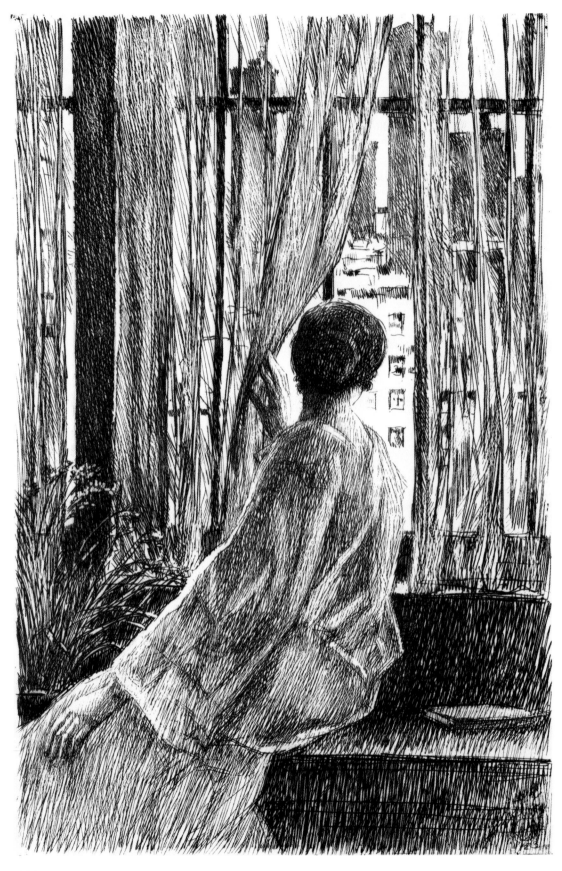

230. MARIE AT THE WINDOW

230. MARIE AT THE WINDOW

7 by 10⅞ inches. Signed: C. H. 1923 in lower right corner.

Made from the model in the artist's New York apartment.

A young woman in a light dress seated on a window-seat looks out of a New York apartment curtained window at the skyscrapers of the lower part of the city.

231. THE WHITE GLOVES

5⅜ by 9⅞ inches. Signed: Jan. 8, C. H. 1924 in lower right corner.

Three-quarter portrait of a young woman in a long fur coat and a dark hat. She holds a pair of long white gloves in her hands.

232. FIRE OPALS

6 by 9½ inches. Signed: C. H. 1924 upper left corner.

Made from the painting done in 1912 now in the Hassam room (Wm. Preston Harrison collection). Los Angeles Museum.

A young woman with a large flowered hat, black furs, and fire opals, a costume such as was worn, with the addition of gloves and an armful of American beauty roses, at outdoor weddings. Los Angeles Museum.

233. THE CHURCH AT OLD LYME

6½ by 7¼ inches.

Made from the painting owned by the Buffalo Museum.

The white church in a setting of elms in autumn and several arbor vitæ evergreens with the clock face and windows make the dark notes. The painting is white, gold, and blue. Los Angeles Museum.

234. THE JONATHAN BAKER FARM

4⅝ by 13⅜ inches. Signed: C. H. May 23d, 1924.

Made from the painting at the suggestion of Ernest Haskell, who said it is the same proportion as Rembrandt's "Gold beater field." So it was made on a plate of that size.

Across a field with some cotton-tails are seen the farm buildings and an old house. One of the last of the old farms left in Easthampton. This is where the Tile Club (a group of artists) who discovered Easthampton stayed in 1878.

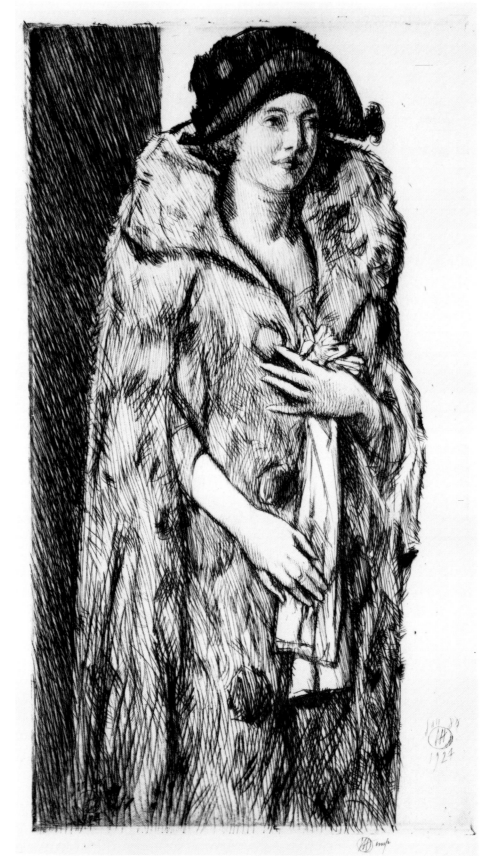

231. THE WHITE GLOVES

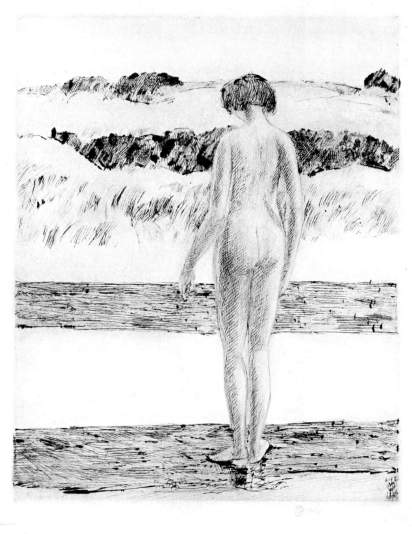

238. NAPEAGUE BEACH *8 by 10 inches*

235. THE WASHINGTON MONUMENT 3rd

12½ by 8¼ inches. Signed: Studio C. H. May 29th 1924. Baltimore April 29th.

First state 1 proof exists. There is work with the burin on the shaft and in the foliage and figures and on the walk in the second state.

The shaft is seen from the sidewalk of a cross street with three steps into the park—it looms still higher perhaps in this drawing. There is the white marble fountain slightly indicated, some figures, and walking into the park is a young girl with a violin case. Mansions (the Walters mansion on the left) and the church spire on the right.

236. THE WASHINGTON MONUMENT, BALTIMORE

8¾ by 11¾ inches. Signed: Studio June 2nd C. H. 1924 and Baltimore April 29th.

The tall classic simple shaft and base make one of the fine monuments of the world—most things in Europe look rather ornate and cheap in comparison—but no one expects Americans to appreciate or know their own country.

The drawing (collection of C. H.) was made in Baltimore with the two following ones on April 29th. Mr. Bendann, the print-seller, suggested the trip to his city. The view was taken from the Garrett Mansion (now used as the Baltimore Museum of Art) and shows a park with slender young trees just leafing and the towering and dignified shaft that dwarfs the surrounding buildings, the one on the right being the Peabody Institute. The drawings were all transferred to the plate and therefore, having been reversed, are true to the natural arrangement of the subject.

237. THE WASHINGTON MONUMENT 2nd

9 by 12 inches. Signed: June 1st C. H. 1924.

First state, 1 proof exists, sky having been changed in the upper portion.

A view of the shaft from below in the park with a white marble basin with dolphins. Mansions on the left and a church spire on the right.

238. NAPEAGUE BEACH

8 by 10 inches. Signed: Aug. 23 C. H. in lower right corner.

Four proofs exist from the copper. The plate has been steel faced.

The nude figure of a young woman walking out of the surf.

CATALOGUE OF THE
ETCHINGS AND DRY-POINTS OF
CHILDE HASSAM

PART TWO

THE LEONARD CLAYTON GALLERY
New York
1933

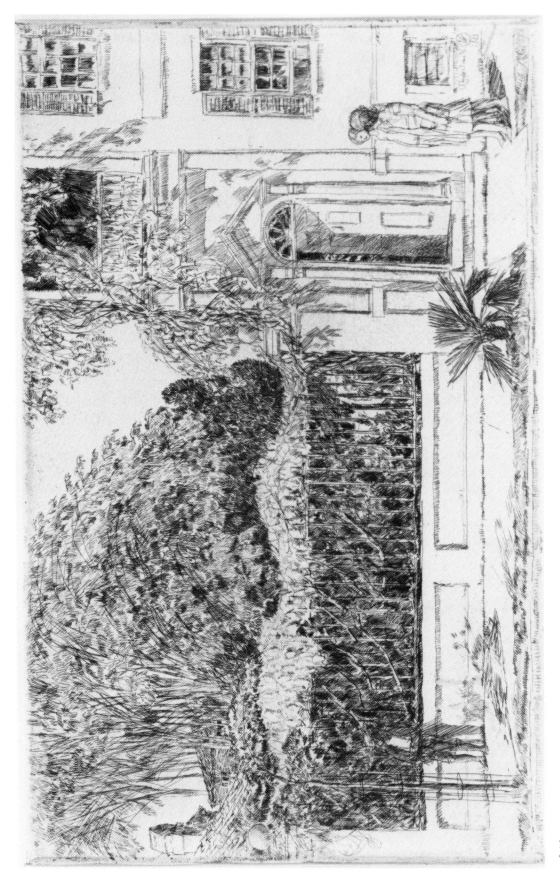

240. SPRING IN CHARLESTON

INTRODUCTION

IT was a privilege and a charming experience for me, to review the entire collection of Mr. Hassam's etchings and drypoints—the prints of three hundred and seventy-six copper plates— on which he has etched, with a painter's fine sense of color—as consistent a naturalist's philosophy as the naturalists and poets in other mediums have done with rhythmic metre and colorful word. His etchings are reminiscent of the prose of Burroughs and Thoreau and the poetry of Whitman, Whittier and Longfellow. In Mr. Hassam's New England group, one is constantly conscious of the charming splendor of the New England countryside—of the hickories and the elms in their varying seasons, of the old roads, and farms and churches. Later, when he travelled about the United States, and etched his fine plates, he expressed himself always with the refinement and free beauty—and yet restraint—the unique American—unique as the poetic American appears to the Englishman and to the cultured of other nations. It was interesting to go through the collection, print by print, and to discover Mr. Hassam's tastes and philosophy—at times the dry humorist—at times the stern prophet, but always the naturalist.

At the age of fifty-six, and after a period of full recognition, as one of our country's finest painters—Mr. Hassam took up the copper plate and etching needle as a definite medium for his mature expression. This was in the year 1915. There had been a number of earlier attempts, but 1915 marks the beginning of his continuous career as an etcher.

In 1898—he had worked on two of his foreign plates, Porte St. Martin, and Garden of the Luxembourg. These were completed in 1915. In the latter year, he began to work further on a number of his fine foreign etchings, the result being a delightful group of little English and French plates.

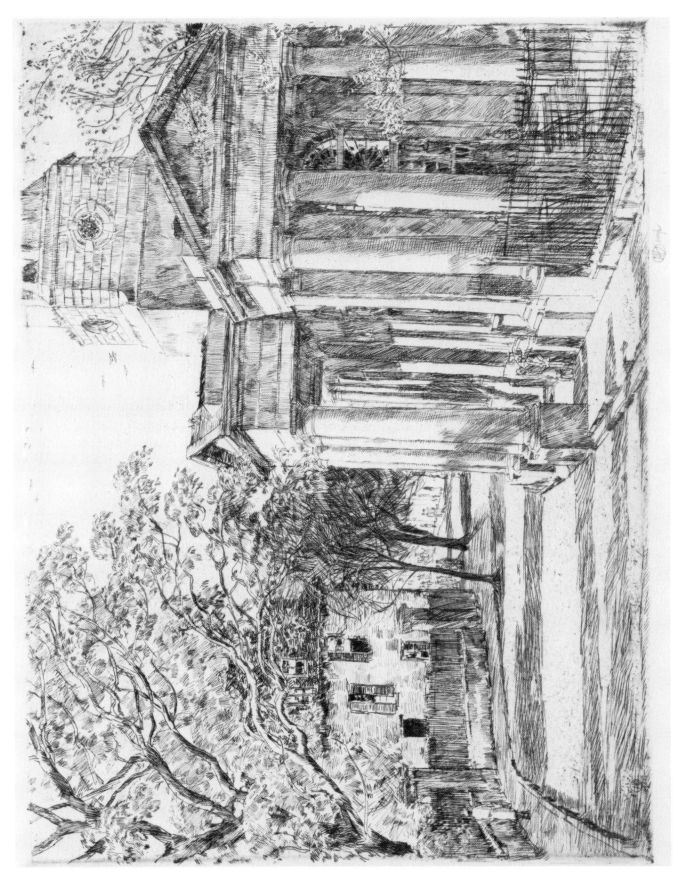

241. ST. PHILIP'S, CHARLESTON

As far back as 1883, at the age of twenty-four, he had started to work on the three little Edinburgh plates—Reid's Close, Plainstone Close, and the End of Plainstone Close—showing the houses, Arthur's seat and figures in the streets of Edinburgh, Scotland. These, he worked on again, as recently as 1926. The plate English Cottages also dates back to 1883, and was again worked on in 1929. Hogarth's House, in Chiswick, England, a simple line etching, a little over two inches by four inches, is the fifth etching that goes back to 1883. Four years later, in 1887, Mr. Hassam began the two little French and English plates, which were completed in 1916. Zola's House in Paris, simple in line—and Montmartre, Paris, in which a woman with a small boy nearby, is frying potatoes on an old French stove (brasier). In 1898—eleven years later, the etchings were begun for Porte St. Martin and Garden of the Luxembourg, and as I previously stated he did not take them up again until 1915. Lannion—a simple line print, and St. Sepulchre, Strand, belong to this early group and were worked on further in 1915. In 1910, Mr. Hassam again returned from Europe with the two little French plates, Rue de Nevers and Rue de Chat Qui Peche, and the humorous little English plate, Fish Shop, Jermyn Street, London. These were completed in 1916, when work with the burin was added.

A water color drawing made in Toledo, Spain, 1910, furnished the key for the etching Toledo, Spain, made in 1916. This is a colorful print, a proof of which is in the Hispanic Museum, in which a landscape of rocks and hills is the background for some figures and a donkey before houses near which a Spanish lamp is prominent. Whenever Mr. Hassam could, he printed his etchings on fine old bible paper—on which only one column of text appeared at the extreme end of the page—the blank space being left for commentaries. Whether he chose a text that was appropriate to the subject is an interesting conjecture, I shall not even attempt

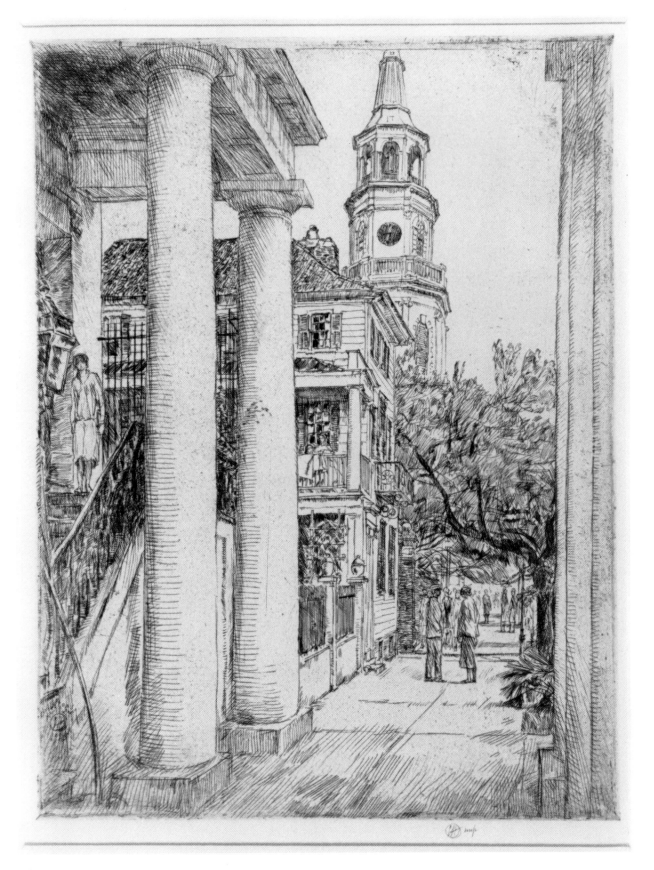

243. ST. MICHAEL'S, CHARLESTON, S.C.

to learn if the allusion was really meant. The etching I saw of Toledo was printed on a page from Samuel 2:22:29, in which David offers his psalm of thanksgiving... "For thou art my lamp oh Lord—and the Lord will lighten my darkness. . ." and previously—"I was also upright for him and have kept myself from mine iniquity." This completes the small set of foreign etchings which now exist.

The New England group of etchings which Mr. Hassam next applied himself to, with powerful energy and a keen mind, comprises fully over fifty plates made from nature in 1915—old houses, landscapes, nudes, interiors and trees. It is over-whelming to think with what great creative forces he came back to his native New England to let his art bring forth all the warm, inherited associations that were contained in him of this sterner and more conservative area of our country.

In the etching Connecticut Barns, 1915, Mr. Hassam began to manifest his sensitive play of light, sunshine and shadow. This plate marks the beginning of his characteristic and individual shadow patterns. The plate is drawn with a fine line that appears almost like a tone and long shadows play on the ground. This etching is of the Brush barn in Cos Cob. The Old House, 1915, an etching of the old Holley house—which is nearing its three hundredth birthday, marks the appearance of the characteristic shadows on the roof. And in the next etching, The Old House, Connecticut, this being the Brush House by the water side, Cos Cob—the shadows are worked out with more boldness on the roof.

The Holley House in Cos Cob—a typical old Colonial home, furnished the inspiration for a number of very fine and now famous plates. Among these are, The Steps; The White Kimono; The Dutch Door; The White Mantel; the Colonial Table; The Writing Desk; The Breakfast Room; Painting Fans.

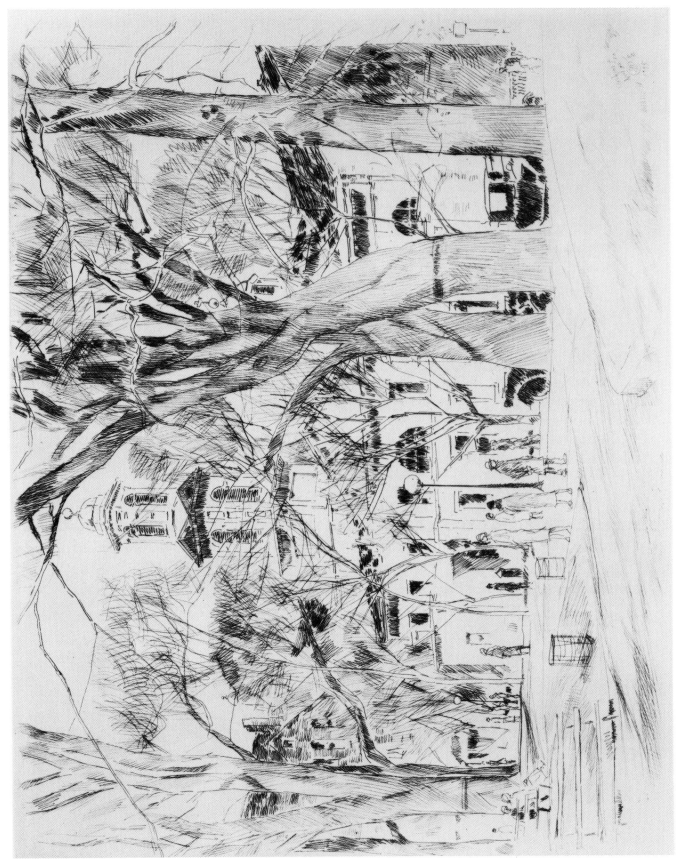

245. ST. JOHN'S, WASHINGTON

For the New England group, Mr. Hassam had found inspiration in every New England State. From Maine and the Isles of Shoals he brought back plates of landscapes, and buildings and nudes—in New Hampshire he did farms, trees and landscapes; and Vermont, Massachusets, Rhode Island and last but not least Connecticut, contributed to complete the chronicles for this etcher's wealthy mind.

In 1916, Mr. Hassam again brought forth over sixty etchings. Here his attention was concentrated on New York City, with some plates made in his New York studio; an occasional plate made in New England and in the South.

Checking up on the number of etchings he made in each year, became a pleasant pursuit—especially since Mr. Hassam had once remarked to me:

"A lifetime is only a fragment of a moment."

It is a great inspiration to see how fully one can crowd that moment with worthy work. In 1917, thirty-five plates were made—New Yorks, New Englands—and this year also marks the beginning of the ever refreshing plates of Easthampton, of which town Mr. Hassam has been a resident for the past 15 years. In the seventy-five plates he made of Easthampton, during the years 1917 to 1933—he has produced so much beauty from this quaint old village—which might otherwise have remained obscure—with its landmarks unnoticed—that he deserves to be honored as Easthampton's greatest poet, whose poems were sung on copper plate—with the rare command of colorful lines of light and shade for his words. The etching, Easthampton, made in 1917, bears for me, the finest proof of his mastery of light and shade; and The Lion Gardiner House—1920, comes close to it in beauty of conception of the varying play of shadows.

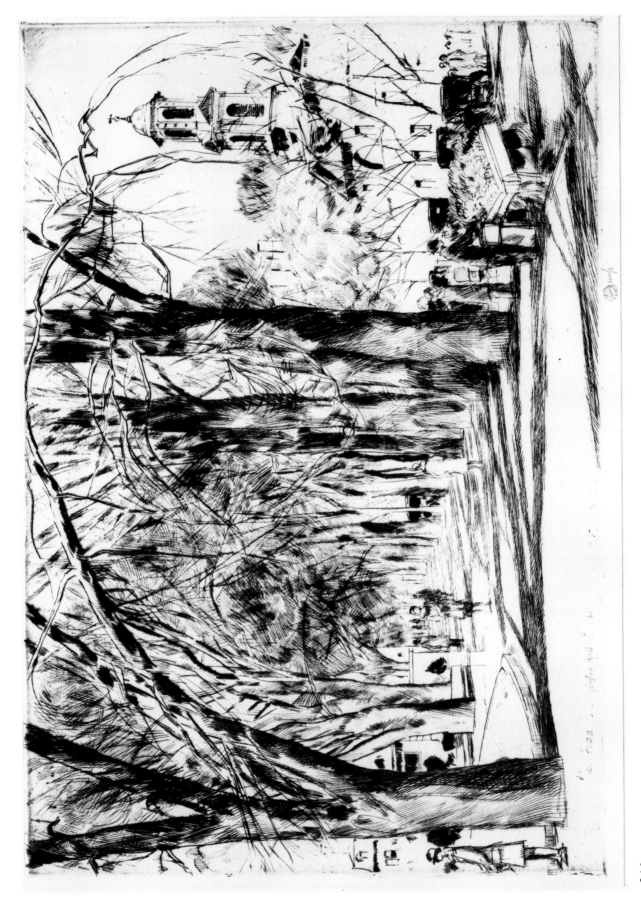

246. WASHINGTON ELMS IN APRIL

INTRODUCTION

1920 to 1924 were prolific years—when 80 plates were made of Easthampton, New England and New York. Then, in 1924, 1925, 1926, 1927, Mr. Hassam went to the South and the West, and brought back over fifty plates, that chronicled the places he had seen from New Mexico to California. After this followed a period of more leisurely work—the revisiting of loved land-marks—and the continuous making of beautiful plates—until we come to the eleven recent ones just completed of Easthampton, three of which are small of size, but great with poetic charm—St. Mathews, Easthampton; Amy's Lane, and Green Gate.

I found as a finished my study of the complete set of prints, that I had a great urge to classify Mr. Hassam's nudes. Viewing them in continuity, I found that the seventy fine prints of nudes, stirred up a vivid impression of the posed, Greek perfection with which he apparently views all womanhood. These prints condone vanity—and uphold dignity and health. The little print Hygea, the mystic Nude Hamadryad, the dancing girls, the various swimmers—and especially the figure of Young Sappho, seated in a garden—a sparking print—bear out his natural and graceful conception of women.

Finally, I wound up my tour through the set, by isolating all the trees. Here the naturalist is still best expressed in the thirty-seven plates of trees of nearly every species, which he made in different parts of the country. These plates contain all the best abstract poetry of his expression—and will be a perpetual delight to lovers of etchings and nature.

PAULA ELIASOPH.

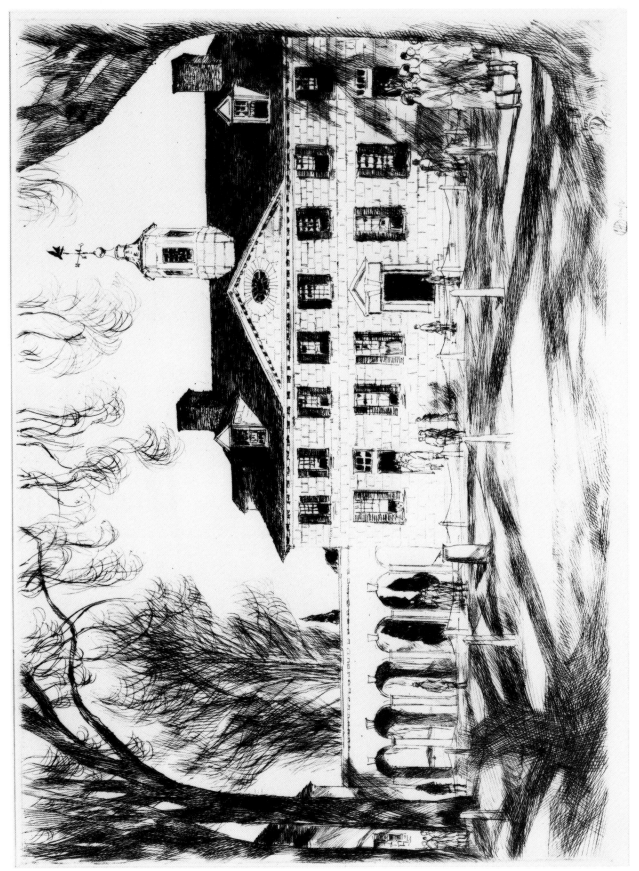

247. WASHINGTON'S HOME, MT. VERNON

239. ST. AUGUSTINE, THE OLD FORT

7 $^3/_8$ by 11 $^7/_8$ inches. 1925
Figures on bench. Shadows on ground.

240. SPRING IN CHARLESTON

7 $^1/_4$ by 11 $^3/_4$ inches. 1923
Three girls walking in front of house which has Colonial doorway —
and gate.

241. ST. PHILIP'S, CHARLESTON

8 $^7/_8$ by 11 $^3/_4$ inches. 1925
Trees and buildings.

242. PLAZA DE LA CONSTITUCION

9 $^7/_8$ by 7 $^7/_8$ inches. 1925
St. Augustine.

243. ST. MICHAEL'S, CHARLESTON, S.C.

11 $^7/_8$ by 8 $^7/_8$ inches. 1925
Figure on steps. Figures in street. Church at rear.

244. RICHMOND (OLD SLAVE MARKET)

10 $^{15}/_{16}$ by 8 $^7/_{16}$ inches. 1925.
Man on bench. Tree in foreground. Church.

245. ST. JOHN'S, WASHINGTON

8 $^3/_8$ by 10 $^7/_8$ inches. 1925.
Trees, street and church.

246. WASHINGTON ELMS IN APRIL

8 $^3/_8$ by 12 $^3/_8$ inches. 1925.
Trees and church. Carts and cars.

247. WASHINGTON'S HOME, MT. VERNON

8 $^3/_8$ by 12 inches. 1925.
Shadows on street. People walking.

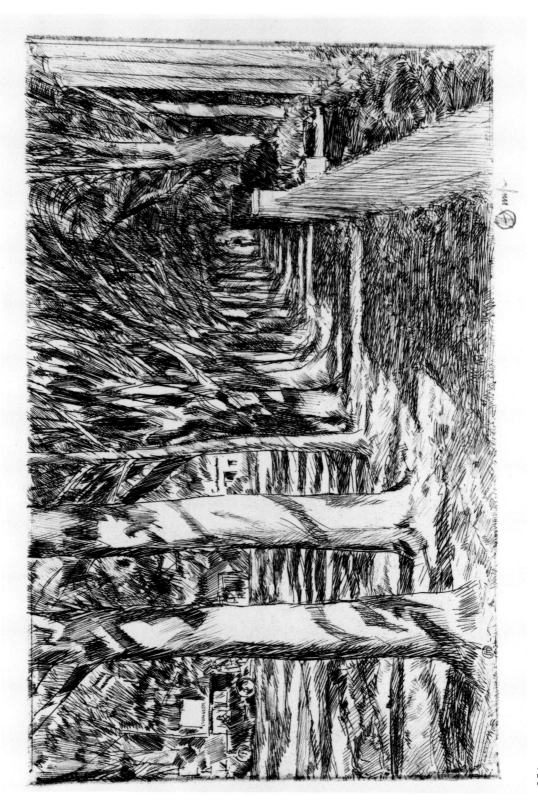

251. EASTHAMPTON, SIDEWALK

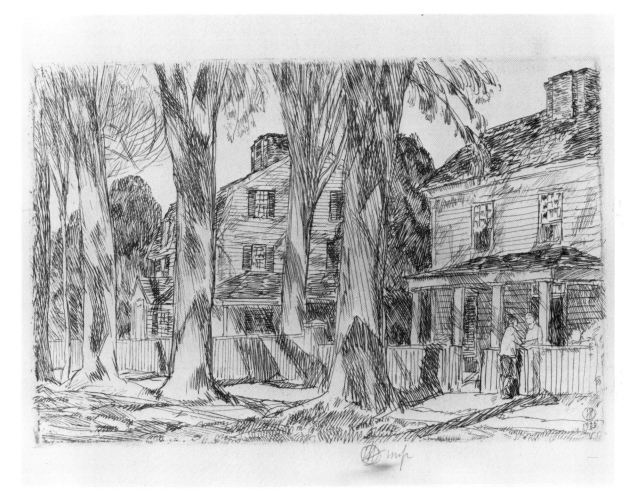

252. SUNLIT VILLAGE STREET

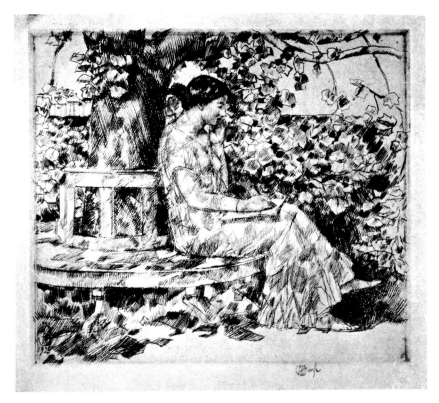

255. YOUNG SAPPHO

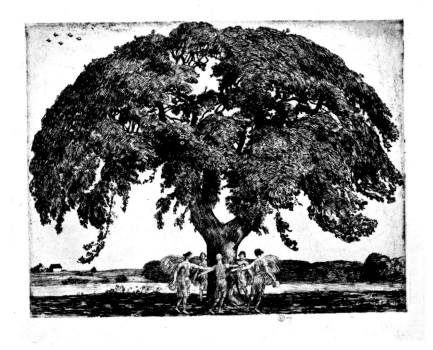

263. NYSSA SYLVATICA

248. **THE WHITE HOUSE, NO. 2**

7 3/8 by 10 7/8 inches. 1925.
White House, gate and people walking.

249. **A LIVE OAK GROWING IN THE SOUTH**

8 7/8 by 11 3/4 inches. 1925.
Large tree, pan piping near it. On Pimlico Plantation, Cooper River.

250. **TERPSICHORE**

9 3/4 by 6 7/8 inches. 1925.
Figure dancing, arms outstretched. Dark background.

251. **EASTHAMPTON, SIDEWALK**

5 by 7 7/8 inches. 1925.
Elms in village street. Shadows on ground.

252. **SUNLIT VILLAGE STREET**

4 by 5 7/8 inches. 1925.
Fine play of shadows. Trees, houses, women gossiping near a fence.

253. **THE VIADUCT (AT 138TH STREET)**

9 7/8 by 7 7/8 inches. 1925.
Arch in centre. Palisades in distance.

254. **EASTHAMPTON ELMS IN MAY**

8 7/8 by 11 7/8 inches. 1925.
Fine elms. Horses and trucks in street.

255. **YOUNG SAPPHO**

6 7/8 by 7 3/4 inches. 1925.
Figure seated in the artist's garden, under a liriodendron tulipifera tree.
Figure in Greek costume. Fine shadows and play of light.

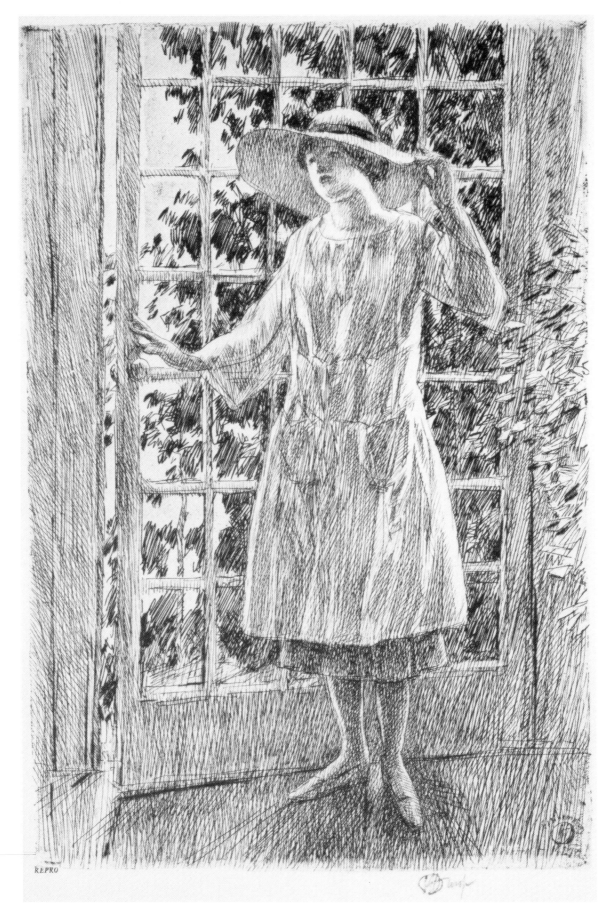

257. BONNIE MOORE

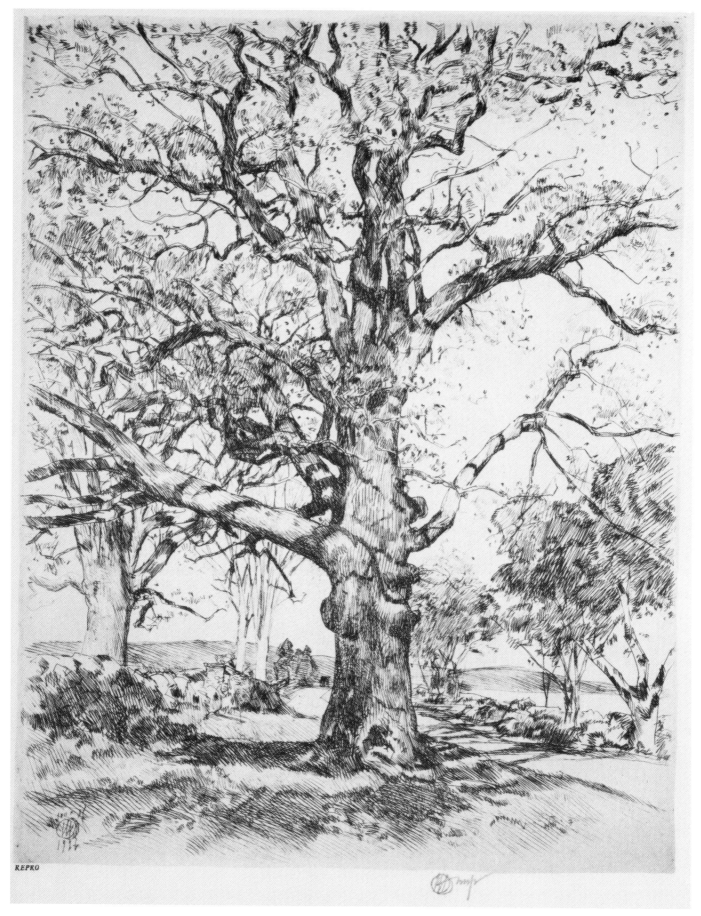

261. WAYSIDE INN—OAKS IN SPRING

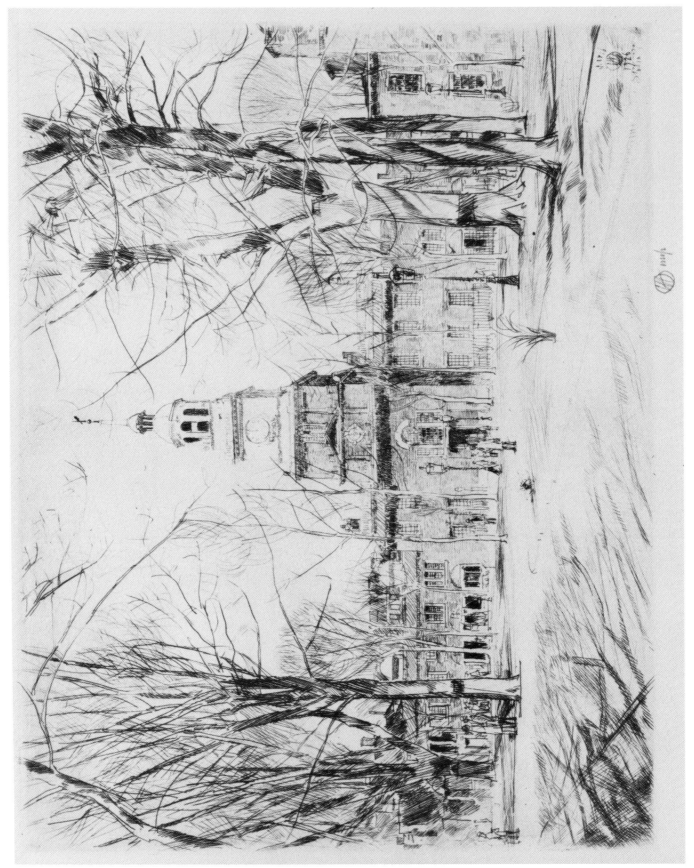

260. INDEPENDENCE HALL

256. THE WHITE HOUSE (No. 3)

3 $^7/_8$ by 5 $^7/_8$ inches. 1925.
People in street. Fence near White House.

257. BONNIE MOORE

8 $^7/_8$ by 5 $^7/_8$ inches. 1925.
Figure of girl, wearing hat. Standing near French door.

258. THE BEACH GRASS NUDE, EASTHAMPTON

8 $^7/_8$ by 5 $^7/_8$ inches. 1925.
Nude figure on beach.

259. UNIVERSITY OF VIRGINIA

11 $^7/_8$ by 8 $^7/_8$ inches. 1926.
Corridors of university. Students in foreground.

260. INDEPENDENCE HALL.

6 $^3/_4$ by 8 $^7/_8$ inches. 1926.
Shadows on foreground. Independence Hall, Philadelphia.

261. WAYSIDE INN — OAKS IN SPRING

10 $^1/_4$ by 7 $^7/_8$ inches. 1926.
Oak with knots, young leaves. Landscape, Sudbury, Mass. Fine shadows on ground.

262. LAFAYETTE SQUARE, WASHINGTON.

8 by 6 $^7/_8$ inches. 1926.
Figures, trees and buildings. Shadows on ground.

263. NYSSA SYLVATICA

8 $^1/_2$ by 11 inches. 1926.
The big Pepperidge Tree at Bridgehampton, Long Island. Large tree with heavy foliage. Nymphs dancing beneath it.

[165]

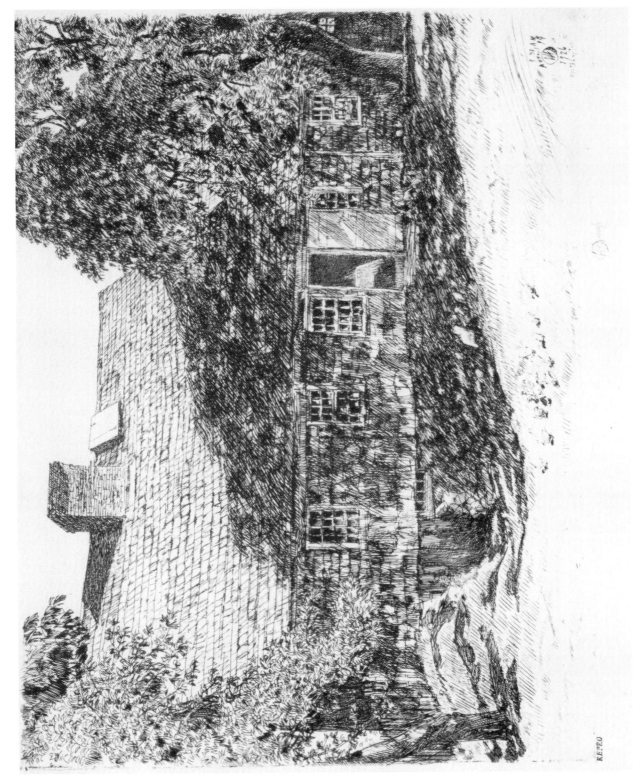

RETO

264. THE OLD MULFORD HOUSE

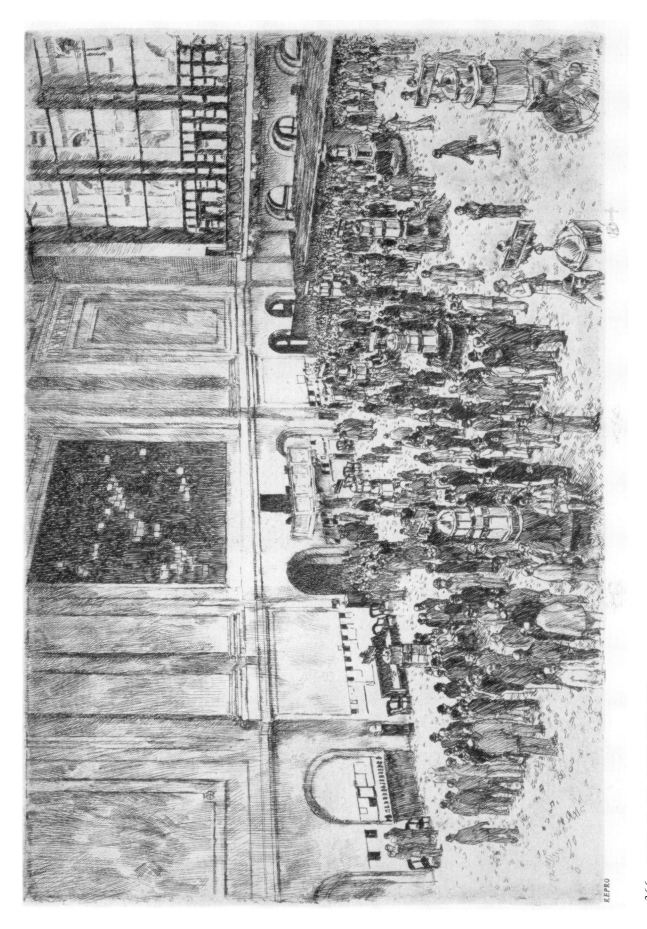

266. FLOOR OF THE STOCK EXCHANGE

[167]

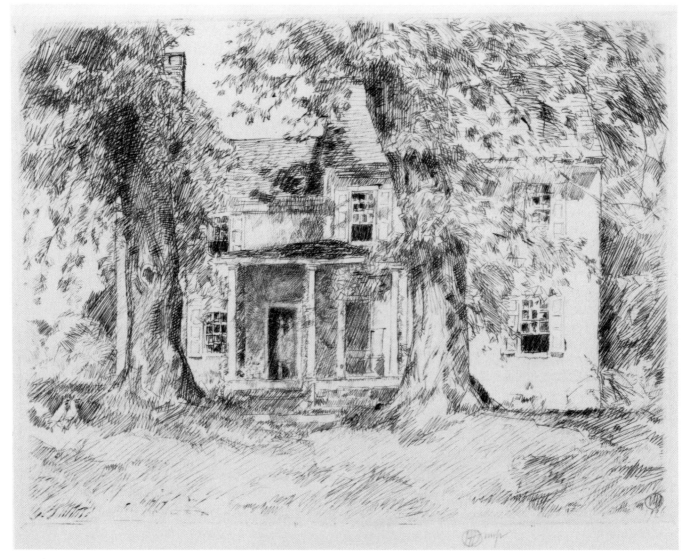

265. WASHINGTON'S HEADQUARTERS NEAR VALLEY FORGE

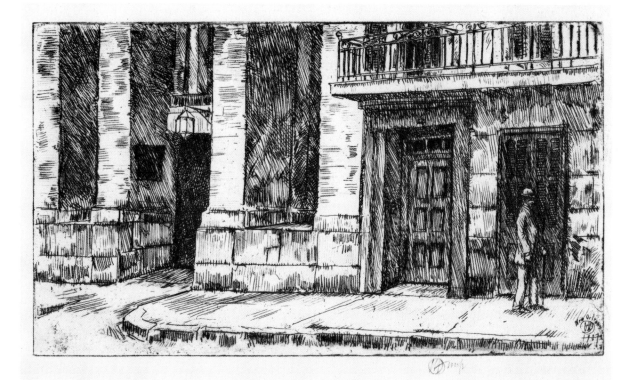

269. GENERAL JACKSON'S HOUSE

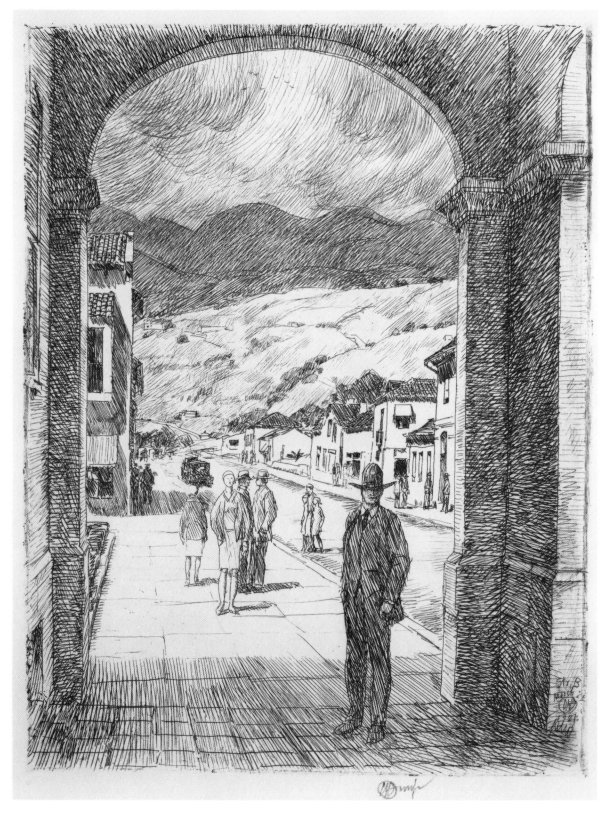

270. SANTA BARBARA

264. **THE OLD MULFORD HOUSE.**

8 $^1/_4$ by 10 $^3/_4$ inches. 1926.
Old house at Easthampton. Fine shadows on building and roof.

265. **WASHINGTON'S HEADQUARTERS NEAR VALLEY FORGE**

5 $^3/_8$ by 6 $^7/_8$ inches. 1926.
Two figures in the doorway. Trees.

266. **FLOOR OF THE STOCK EXCHANGE.**

9 $^7/_8$ by 14 $^3/_4$ inches. 1927.
Many figures on the floor of New York Stock Exchange. Arched windows.

267. **DESERT GARDEN — (ARIZONA)**

3 $^7/_8$ by 5 inches. 1927.
Cactus — hills.

268. **POINT LOMA**

9 $^3/_{16}$ by 13 $^3/_{16}$ inches. 1927.
Tamarisks and Palms of Coronado Beach, in the distance. Point Loma, California.

269. **GENERAL JACKSON'S HOUSE**

3 $^1/_2$ by 6 inches. 1927.
New Orleans. Man on street.

270. **SANTA BARBARA**

7 $^7/_8$ by 5 $^7/_8$ inches. 1927.
Portrait of Ed. Borein in a sombrero. Borein in foreground under arch. Hills in distance, street, figures. Borein is known as the "Cowboy Etcher".

271. **CONTOURS OF LOS ANGELES**

6 by 10 $^7/_{16}$ inches. 1927.
Palms, houses, hills in distance. Sun on the buildings.

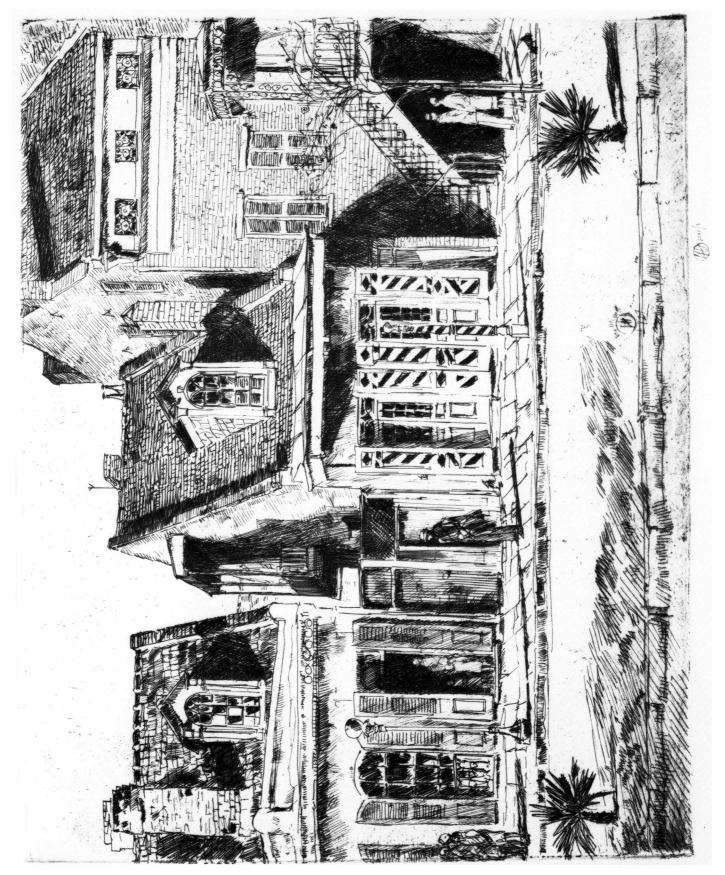

273. RAMPART STREET (NEW ORLEANS)

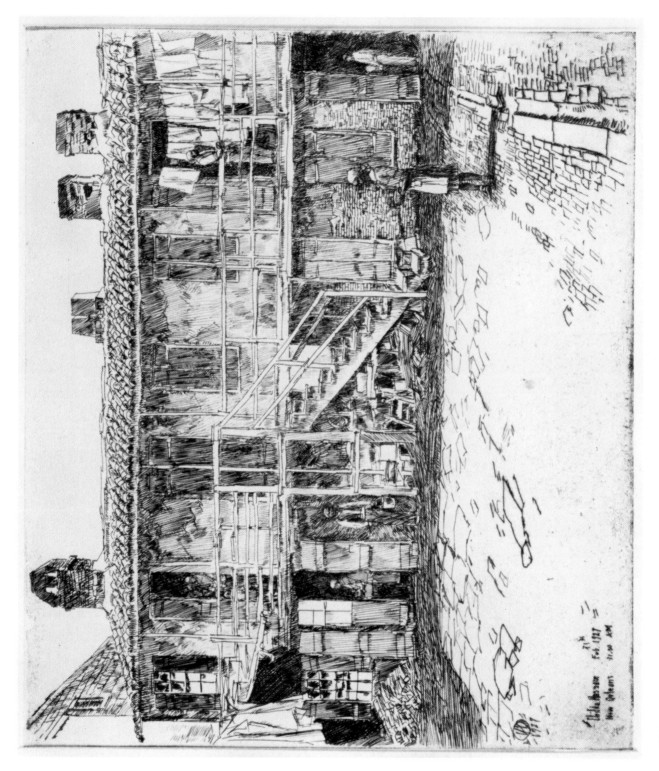

276. PATIO IN THE VIEUX CARRE

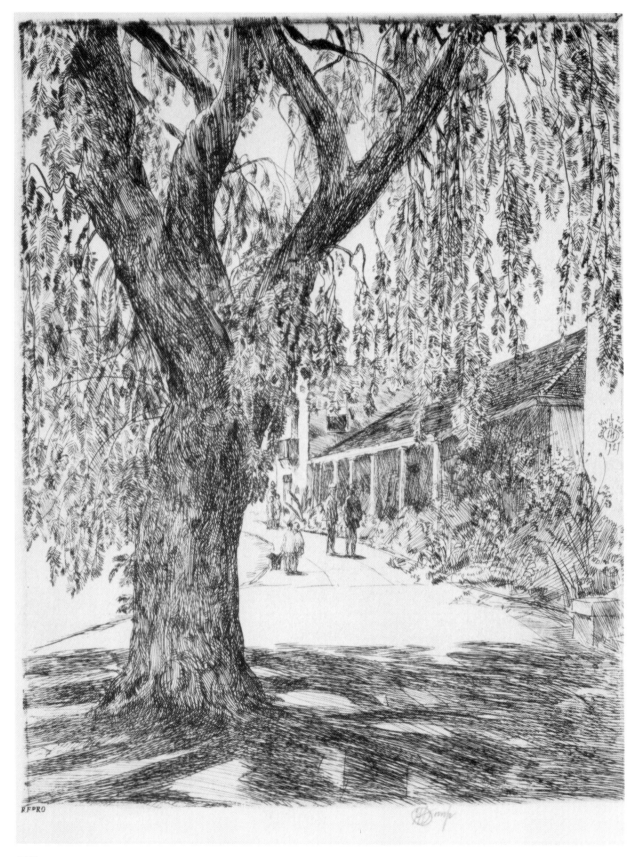

272. PLAZA, SANTA BARBARA

272. PLAZA, SANTA BARBARA

9 by 6 $^7/_8$ inches. 1927.

Tree, shadows on ground.

273. RAMPART STREET (NEW ORLEANS)

7 $^7/_8$ by 9 $^7/_8$ inches. 1927.

Houses; cacti; figures on street. Shadows on buildings.

274. CORONADO BEACH

9 by 13 $^1/_8$ inches. 1927.

Beach at California. Figures on beach. Turf.

275. EUCALYPTUS TREES

9 $^7/_8$ by 10 $^{13}/_{16}$ inches. 1927.

San Diego — Coronado. Trees, golfers, water and hills in background.

276. PATIO IN THE VIEUX CARRE

8 $^7/_{16}$ by 9 $^7/_8$ inches. 1927.

House in New Orleans. Figures in foreground. Stairway at side of building. Tile roofs. Wash on balcony.

277. THE CABILDO, NEW ORLEANS

10 $^5/_8$ by 8 $^1/_8$ inches. 1927.

Southern house, with two balconies. Figure on second balcony.

278. TIA JUANA

3 $^{15}/_{16}$ by 5 $^1/_2$ inches. 1927.

Palms; megaphones on poles — race track.

279. CORPUS CHRISTI FROM CORONADO

3 $^7/_8$ by 5 $^3/_8$ inches. 1927.

Trees, figures on beach. Mountains in distance.

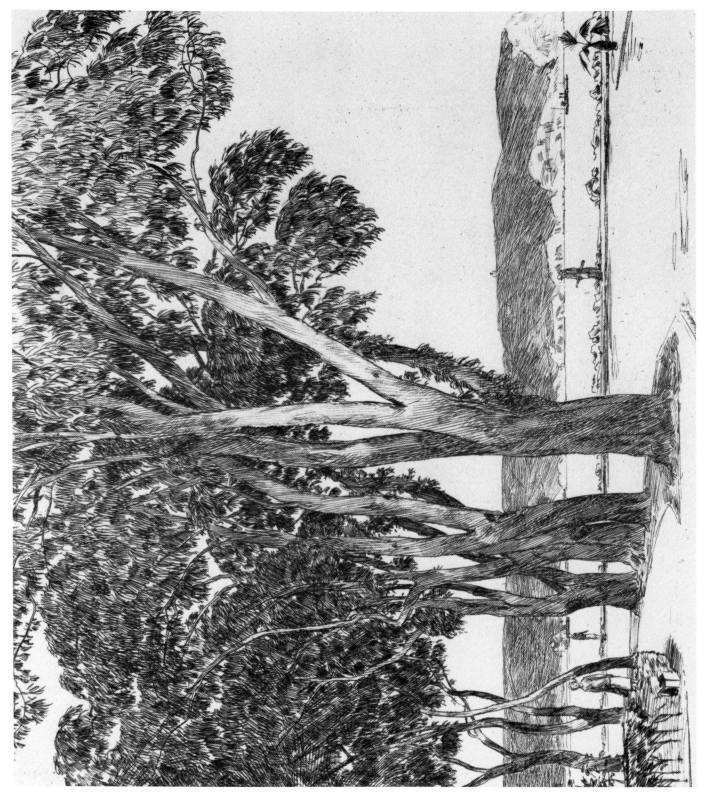

275. EUCALYPTUS TREES

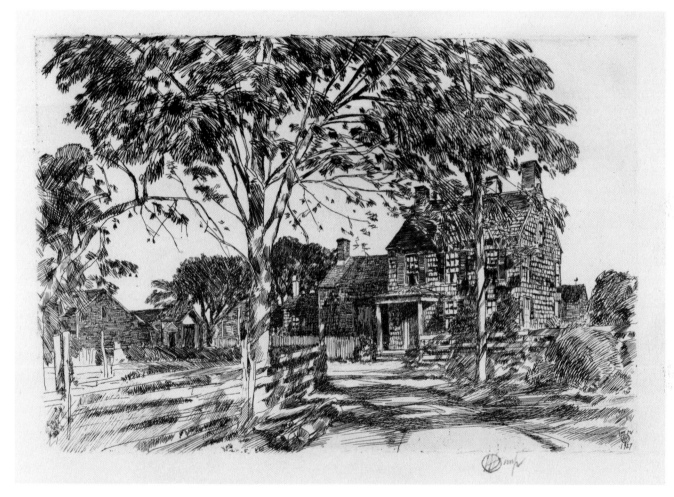

284. WALT WHITMAN'S BIRTH-PLACE

282. NEW ORLEANS

280. CORONADO AND POINT LOMA

4 $^1/_2$ by 6 $^7/_{16}$ inches. 1927.

Coronado Beach, California. Logs, benches, figures and trees. Mountains in distance.

281. COURT IN THE VIEUX CARRE

8 $^{15}/_{16}$ by 6 $^7/_8$ inches. 1927.

New Orleans. Shadows on ground. House with wash on lines on balconies. Woman with baby and carriage. Figures in windows and on balcony.

282. NEW ORLEANS

8 $^3/_4$ by 11 $^3/_4$ inches. 1927.

Monument. Figures in street. Palms, church. Modelled sky.

283. CALIFORNIA OIL FIELD

8 $^7/_8$ by 13 $^7/_8$ inches. 1928.

Oil wells and drills. Hills. Figures and trestles.

284. WALT WHITMAN'S BIRTH-PLACE

4 $^7/_{16}$ by 6 $^3/_8$ inches. 1927.

Trees, shadows in road and on house. Long Island. Fine shading.

285. REID'S CLOSE, EDINBURGH

6 $^5/_{16}$ by 4 $^1/_2$ inches. 1927.

Started in 1883. Shadows on ground. Houses, hills. Etching started in Scotland.

286. PLAINSTONE CLOSE, EDINBURGH

6 $^3/_8$ by 4 $^3/_8$ inches. 1927.

Started in 1883. Figures walking. Houses, and figures seen through arch.

287. YUMA, ARIZONA.

5 by 7 $^7/_8$ inches. 1927.

Cacti. Figure and horse. Desert. Hills in the distance.

291. ROAD TO PROMISED LAND

288. GIANT CACTUS

5 $^7/_8$ by 8 $^7/_8$ inches. 1927.
New Mexico. Giant cactus and smaller cacti. Desert. Mountains in distance.

289. POINT LOMA (VERSION A)

5 $^7/_{16}$ by 9 $^3/_4$ inches. 1927.
Coronado Beach, California. Point Loma in background; surf and sky.

290. GIANTS AND PIGMIES

8 $^3/_8$ by 11 inches. 1927.
California in the spring. Large redwoods. Figures dancing near trees.

291. ROAD TO PROMISED LAND

9 by 12 $^7/_8$ inches. 1928.
Easthampton. Group of oaks, some distorted — being bent as young saplings to make what was called a live fence. Shadows on the ground.

292. HOME SWEET HOME COTTAGE, No. 3, EASTHAMPTON

8 $^7/_8$ by 10 $^{13}/_{16}$ inches. 1928.
Fine shadows on famous old house where Thomas Paine's boyhood was passed. Motif for the most famous lyric in the world. Remarkable play of light.

293. POINT LOMA (VERSION B)

5 $^7/_{16}$ by 9 $^3/_4$ inches. 1928.
Coronado Beach, California. Surf, water, Point Loma in distance.

294. IN THE CATSKILLS

7 $^7/_8$ by 5 inches. 1928.
Made in studio from drawings of 1917. Ash tree, on a hill. Below is a valley with houses and fields.

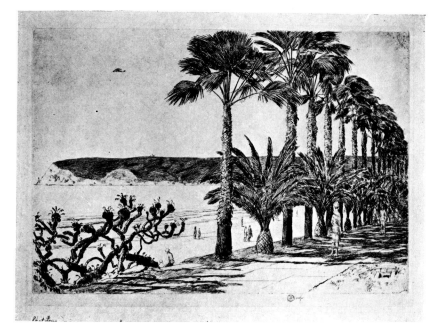

268. POINT LOMA

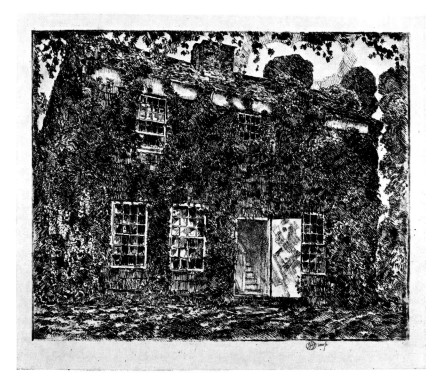

292. HOME SWEET HOME COTTAGE, NO. 3, EASTHAMPTON

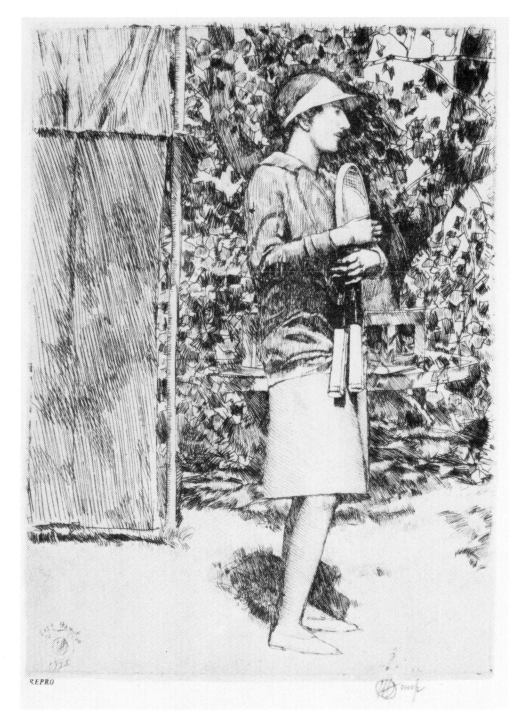

298. HELEN WILLS AT EASTHAMPTON, NO. 1

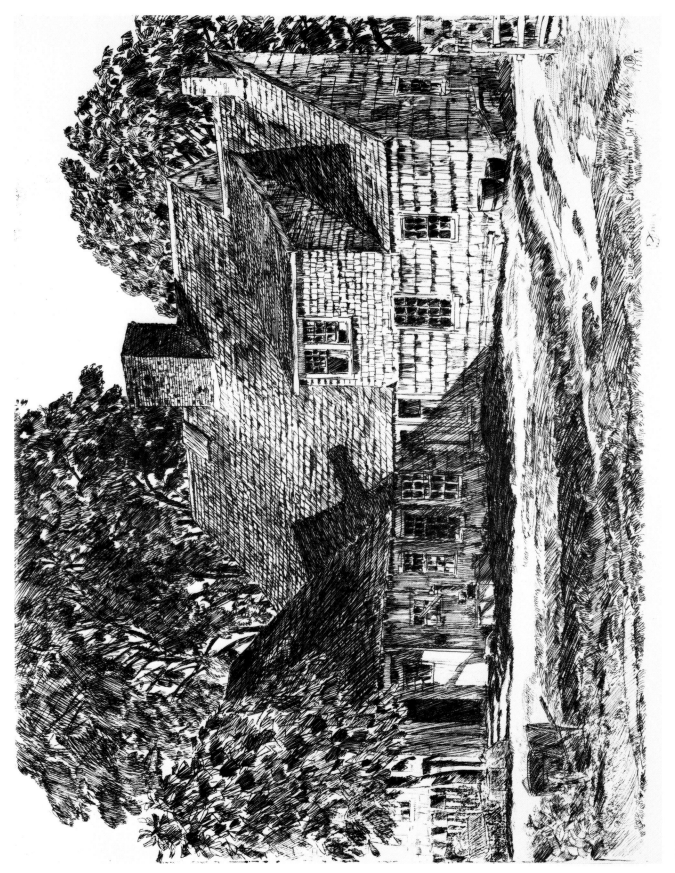

303. OLD DOMINY HOUSE

295. **THE GIANT**

6 $^7/_8$ by 4 $^1/_8$ inches. 1928.

Made in studio from drawing of 1927. Large and small trees. Shadows on trees. One of the giant Sequoias.

296. **THE REDWOODS**

6 $^7/_8$ by 4 $^7/_8$ inches. 1928.

From drawing of 1927. Dark trees. Three figures. Shadow on ground. California.

297. **CALIFORNIA**

9 $^7/_8$ by 8 inches. 1928.

Made in studio from drawing of 1927. Redwoods, nude near tree. Shadows on tree. Two states.

298. **HELEN WILLS AT EASTHAMPTON, No. 1**

6 $^7/_8$ by 4 $^7/_8$ inches. 1928.

Figure of famous tennis player in foreground on tennis court, holding two rackets, in her characteristic pose. One of Mr. Hassam's favorite plates. Tree at the back.

299. **HELEN WILLS AT EASTHAMPTON, No. 2**

8 $^3/_4$ by 4 $^7/_8$ inches. 1928.

Helen Wills on the tennis court of the Maidstone Club. Dark background.

300. **HELEN WILLS AT EASTHAMPTON, No. 3**

6 $^3/_8$ by 4 $^3/_8$ inches. 1928.

Helen Wills ready to strike the ball. Screen and trees at back.

301. **THE TENNIS PLAYER**

6 $^7/_8$ by 4 $^7/_8$ inches. 1928.

Easthampton. Figure on tennis court, ready to serve.

302. **CEDARS AND SAND DUNES**

4 $^7/_8$ by 6 $^7/_8$ inches. 1928.

Montauk Point, Long Island. Hills, sky and bent tree.

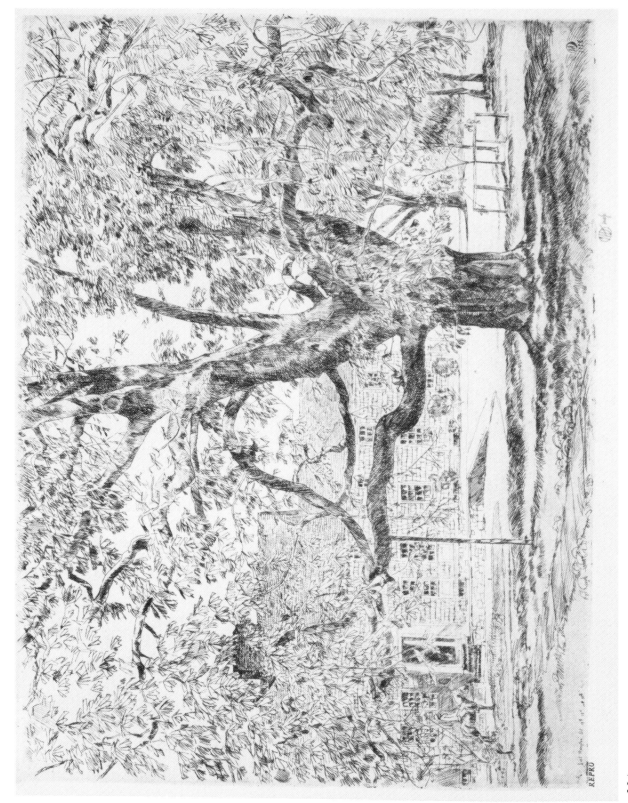

304. THE BIG HORSE CHESTNUT TREE, EASTHAMPTON

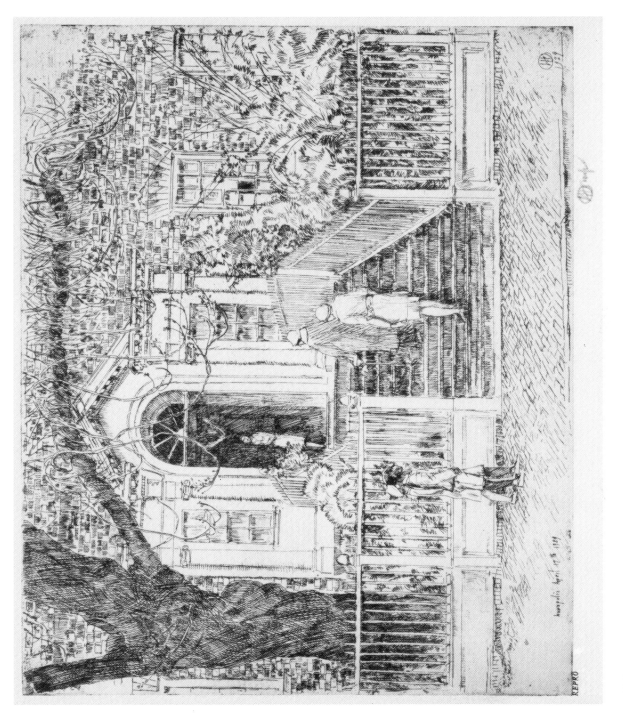

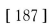

309. THE CHASE HOUSE

[187]

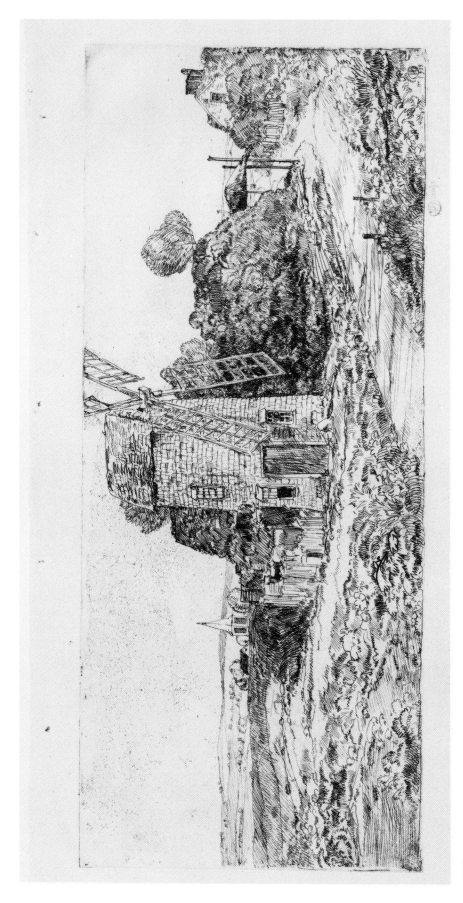

305. A LONG ISLAND WINDMILL

[188]

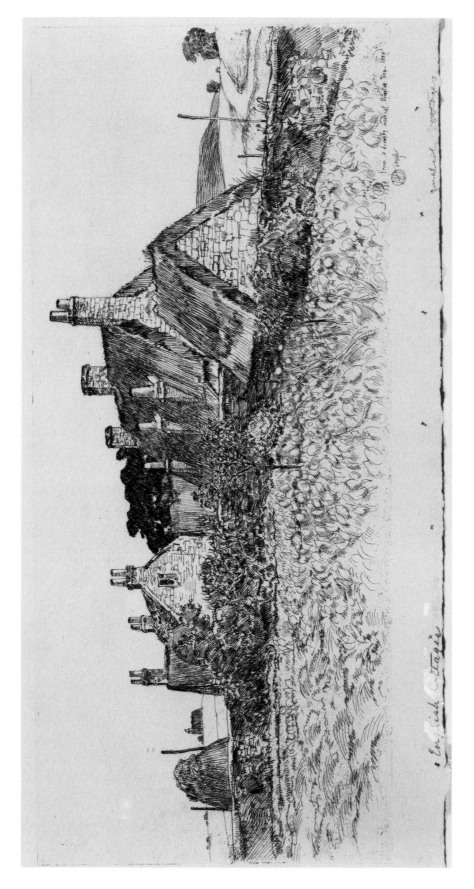

307. ENGLISH COTTAGES

308. RAINY DAY, WILLIAMSBURG, VIRGINIA

303. ## OLD DOMINY HOUSE

8 7/8 by 11 7/8 inches. 1928.

Easthampton. Wonderful play of light and shade on old Dominy House.

304. ## THE BIG HORSE CHESTNUT TREE, EASTHAMPTON

8 7/8 by 11 3/4 inches. 1928.

Fine etched tree, supported by a crutch. House at back, a rider on horseback.

305. ## A LONG ISLAND WINDMILL

4 5/8 by 10 7/8 inches. 1929.

Windmill, house in distance, church and sky. Easthampton.

306. ## THE BATHING TENT

6 15/16 by 4 15/16 inches. 1929.

Montauk, L. I. Nude figure in bathing tent.

307. ## ENGLISH COTTAGES

4 5/8 by 10 13/16 inches. 1929.

Made from a drawing and started in 1883. Brighton, England. Flower fields, hay stacks, houses with low thatched roofs.

308. ## RAINY DAY, WILLIAMSBURG, VIRGINIA

7 5/8 by 4 1/2 inches. 1927.

Men in street. Church, trees. Some printed on old paper.

309. ## THE CHASE HOUSE

7 by 8 7/16 inches. 1929.

Annapolis, Md. Tree, girls on street; steps of Chase House. Arched doorway. Figures going up the steps.

310. ## SPRING IN ANNAPOLIS

8 7/8 by 11 7/8 inches. 1929.

Trees. Back of the Chase House. Arched window with balcony, shadow on walls.

310. SPRING IN ANNAPOLIS

[192]

312. SPRING IN MILLIGAN PLACE

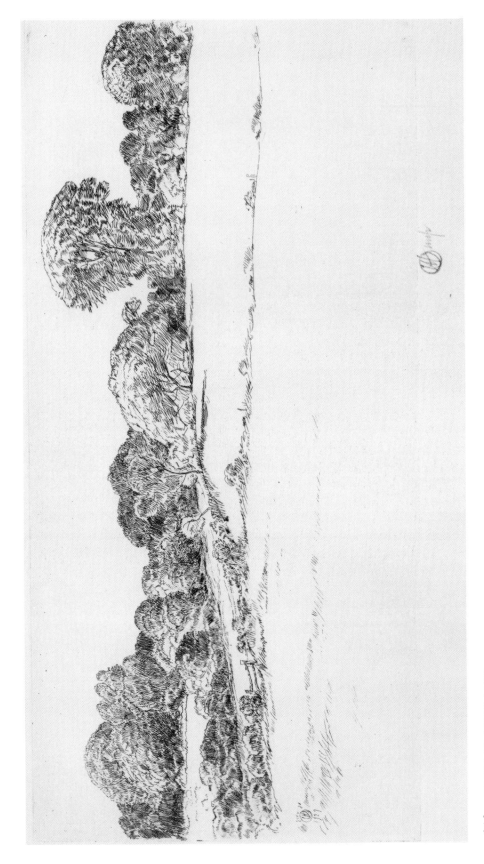

313. SPRING IN EGYPT LANE

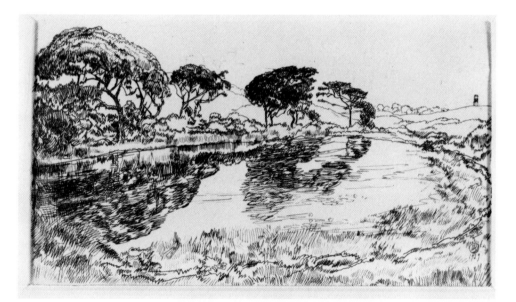

315. SCUTTLE-HOLE POND

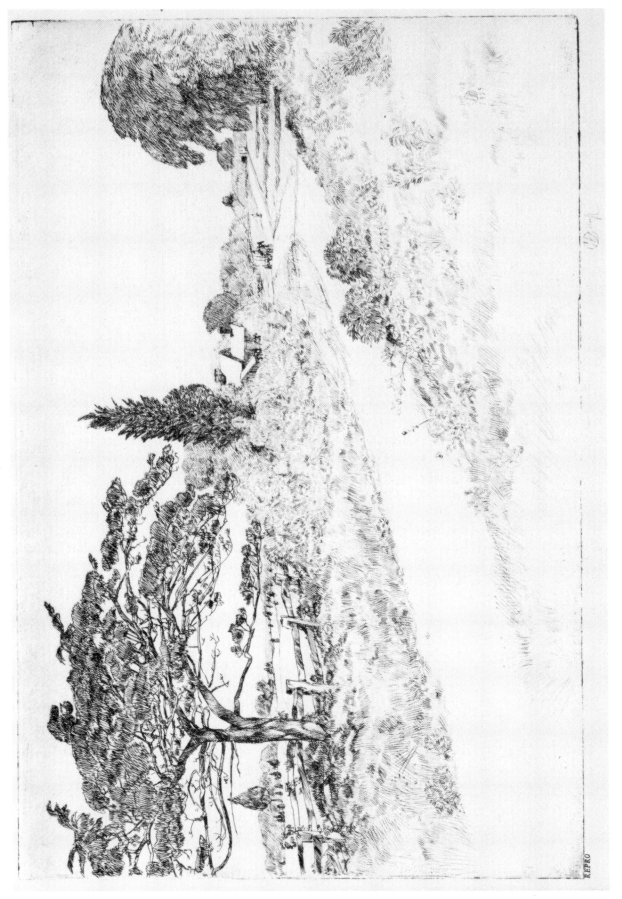

317. THE SKIMHAMPTON ROAD

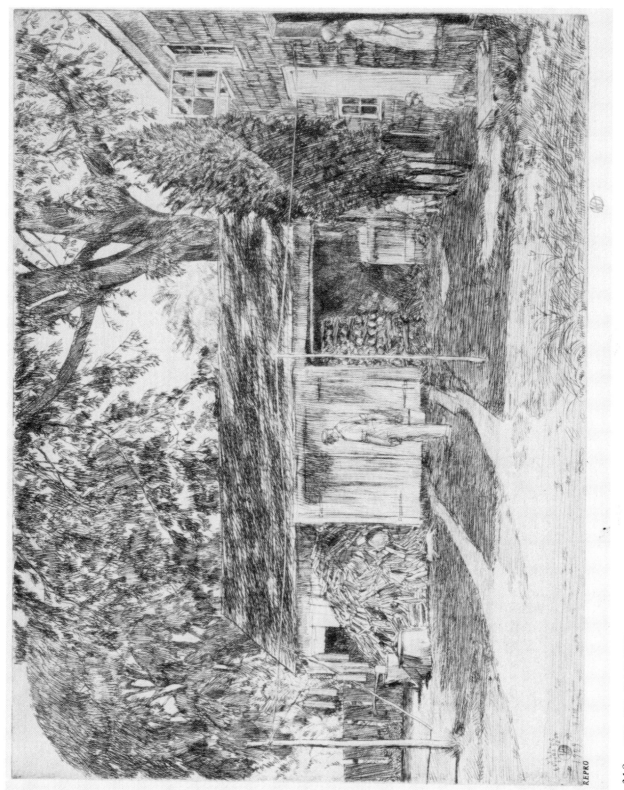
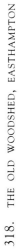

318. THE OLD WOODSHED, EASTHAMPTON

319. THE OLD MULFORD FARM

311. MAC DOUGAL ALLEY

6 $^7/_8$ by 4 $^{15}/_{16}$ inches. 1929.
Figures on street. Buildings in famous alley of New York City.

312. SPRING IN MILLIGAN PLACE

5 $^1/_4$ by 9 $^3/_8$ inches. 1927.
Street, trees and buildings of lower New York City.

313. SPRING IN EGYPT LANE

4 $^1/_4$ by 8 $^{15}/_{16}$ inches. 1927.
Easthampton. A field, trees and sky.

314. THE FROG POND — BOSTON

3 $^7/_8$ by 5 $^7/_8$ inches. 1917. Pond, figures on bench, trees, house, and
church spire in distance.

315. SCUTTLE-HOLE POND

2 $^7/_8$ by 4 $^7/_8$ inches. 1927.
Easthampton. Shadow in pond. Trees, sky. Some printed on old account
book paper.

316. OLD VIRGINIA HOME

7 $^1/_8$ by 10 $^{11}/_{16}$ inches. 1929.
The Thomas Nelson Page House, Hanover County, Virginia. Tulips,
shadows in foreground, trees, house and shadows on roof. Figures going
up the steps.

317. THE SKIMHAMPTON ROAD

8 $^1/_8$ by 12 $^7/_{16}$ inches. 1929.
Easthampton. Field, road, figure in road; horse and haywagon. Trees.

318. THE OLD WOODSHED, EASTHAMPTON

8 $^7/_8$ by 11 $^{15}/_{16}$ inches. 1929.
Shadow on ground. Farmer in foreground with 3 children. Wood-pile.
Shadows of trees on roof. Wood stacked in barn.

320. SENECA STREET GENEVA

319. **THE OLD MULFORD FARM**

9 by 11 $^7/_8$ inches. 1929.
Shadows on foreground of old house. Barn and shadows on barn. Farmer; hay wagon in barn.

320. **SENECA STREET GENEVA**

9 $^7/_8$ by 7 inches. 1927.
Street in Geneva, New York. Shady and sunny skies. Town Hall at end of street. People on street. Cars.

321. **SPRING IN WASHINGTON, ST. JOHN'S**

6 by 8 $^{15}/_{16}$ inches. 1929.
Church in Washington, D. C. Trees, fence.

322. **JUNO**

5 by 3 inches. 1929.
Nude figure, kneeling — shadow on back of figure.

323. **HYGEA**

5 by 3 inches. 1929.
Nude figure, holding draped cloth. Shadow on figure. Leaves in background.

324. **EGERIA**

5 by 3 inches. 1929.
Nude figure. Shadow on figure. Dark background.

325. **FLORA**

12 by 9 inches. 1929.
Figure in Greek costume wearing sandals, standing in a garden. Holding flowers.

326. **GIANT ELM, EASTHAMPTON**

12 by 10 inches. 1929.
Shadows on ground and house. This is on the Lion Gardiner grounds.

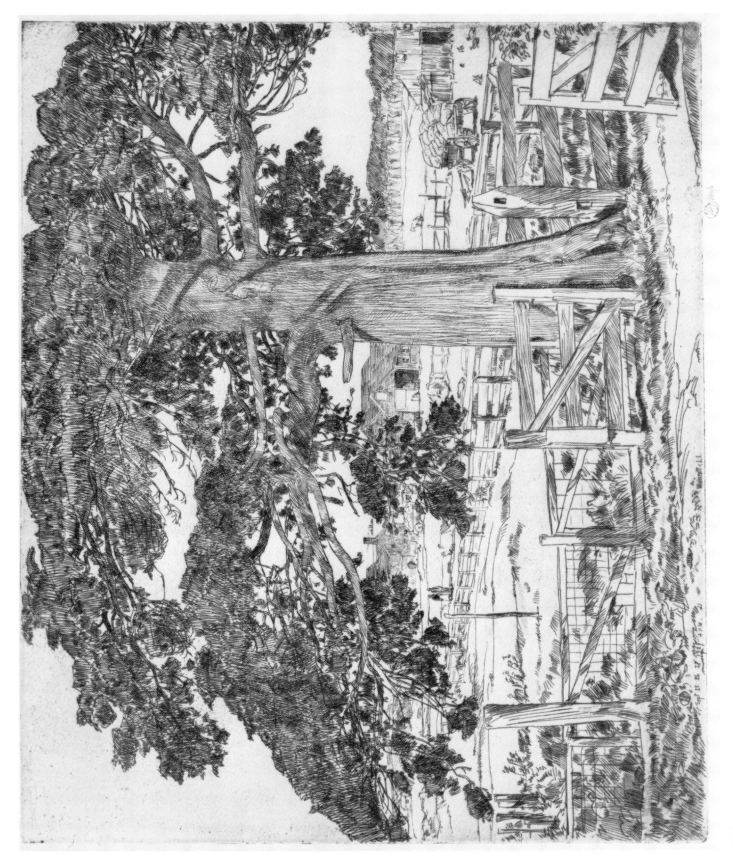

328. THE BIG CEDAR

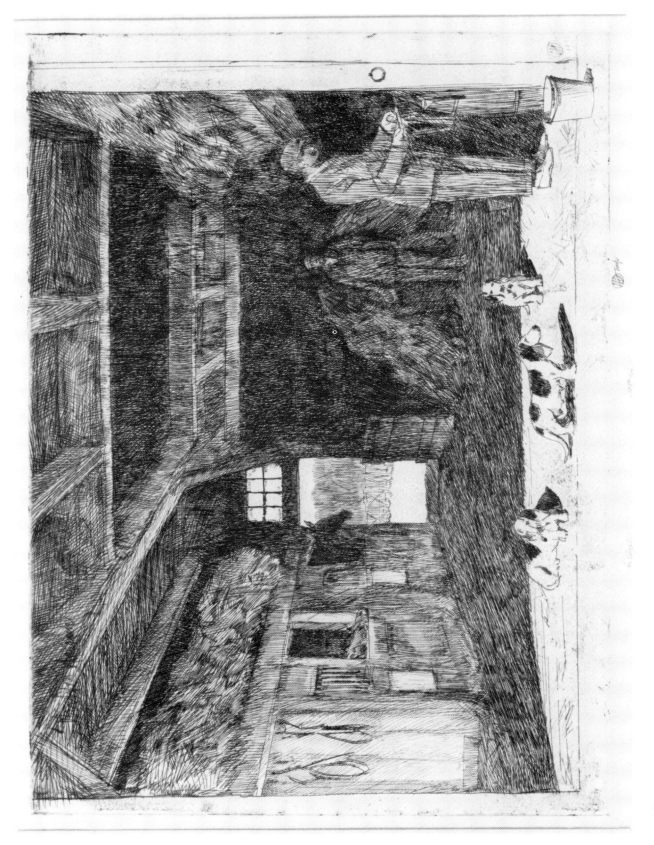

333. OLD BARN, BAYSIDE, L. I.

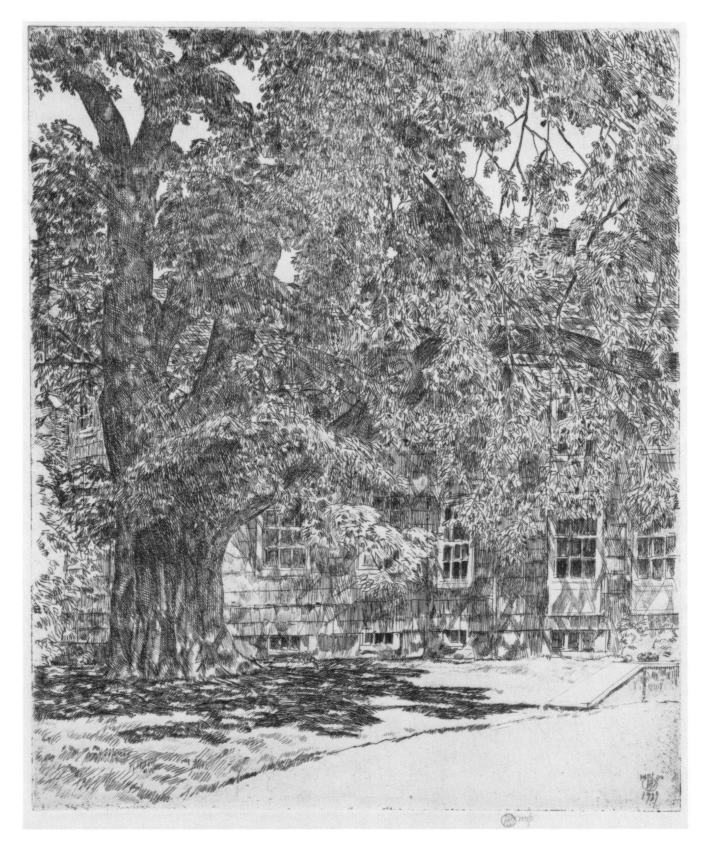

326. GIANT ELM, EASTHAMPTON

327. HOGARTH'S HOUSE, CHISWICK, ENGLAND

2 11/$_{16}$ by 4 1/$_{16}$ inches. 1927.
Started in 1883. Horse with feedbag in foreground. House and trees in distance. Some printed on old paper.

328. THE BIG CEDAR

10 by 12 inches. 1927.
Old tree in Wainscott, L. I. Fence, hay-wagon. Dark foliage on tree, corn stacks, barns.

329. TIGER LILY

8 1/$_2$ by 7 inches. 1927.
Made in Easthampton. Single flower and leaves.

330. MADRIGAL

5 by 9 inches. 1927.
Draped figure. Trees and sky. 5 or 6 versions.

331. THE CAMPUS AND LIBRARY — ANDOVER

6 7/$_8$ by 9 7/$_8$ inches. 1930.
Andover, Massachusetts. Tree. Shadows on ground.

332. CAMPUS — ANDOVER, MASS.

5 by 8 7/$_8$ inches. 1931.
Shadows on ground. Avenue of trees. Buildings and figures on campus.

333. OLD BARN, BAYSIDE, L. I.

10 3/$_8$ by 13 7/$_8$ inches. 1931.
Interior of barn. Bassett hounds in foreground. Men in barn, hay in loft and on ground. Horse in stall and two colts in other stall.

334. THE PONEYS

5 7/$_8$ by 9 3/$_4$ inches. 1931.
Same barn as above, in Bayside, L. I. Shadows on ground. Cat. Man feeding colts. Horse in stall next to colts.

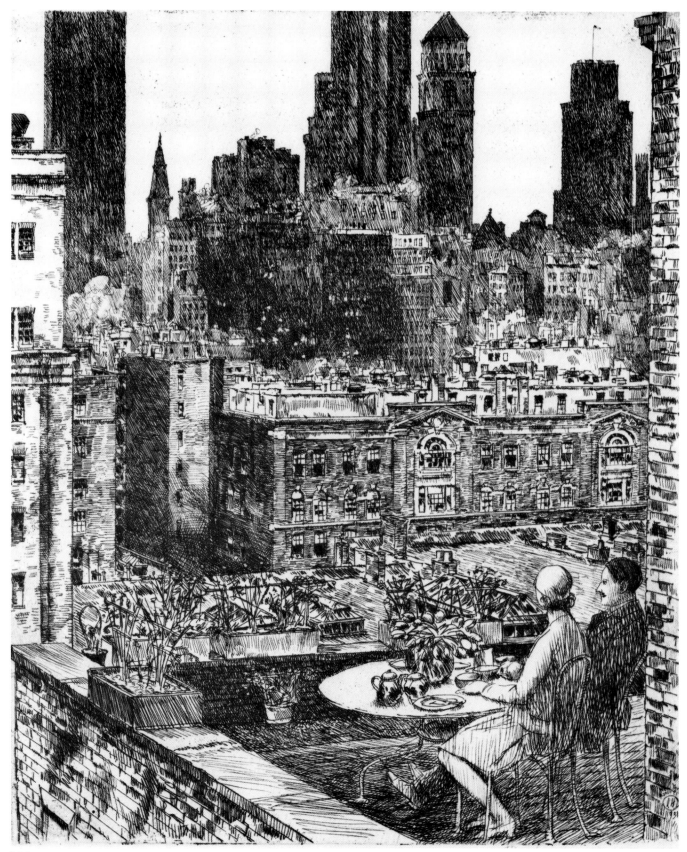

336. NEW YORK, 1931

335. IO

2 $^9/_{16}$ by 3 $^1/_2$ inches. 1931.
Head of woman. Dark hair. Tone on background. Mythological.

336. NEW YORK, 1931

12 $^3/_4$ by 10 $^3/_8$ inches. 1931.
Sky line of New York from artist's studio window and balcony on 57th
street. Figures of man and woman on balcony. Awarded Joseph Pennell
Gold Medal, 1931, Pennsylvania Academy of Fine Arts.

337. MAPLES IN EARLY SPRING

10 $^3/_8$ by 6 $^7/_8$ inches. 1931.
Shadows on ground. Maples, road and figure. Weather vane on barn door
in foreground. At boundary line of Ridgefield and Branchville, Conn.
Country place of J. Alden Weir.

338. HARVARD MEMORIAL HALL

7 $^3/_8$ by 6 $^3/_8$ inches. 1931.
From drawing of 1924. Shadows on ground. Figures.

339. ON THE BEACH

5 $^7/_8$ by 7 $^7/_8$ inches. 1931.
From a drawing of 1925. Nude on beach at Easthampton. Shadow on
figure, contre-jour.

340. YOUNG PAN

7 by 8 $^7/_8$ inches. 1931.
Tree, which had been struck by lightning. Pan piping beneath it. Old
Lyme, Conn. From drawing of 1907. Rocks and sky.

341. FIRST LEAVES —
SPRING IN WASHINGTON, ST. JOHN'S

6 by 8 $^7/_8$ inches. 1929.
St. John's, Washington.

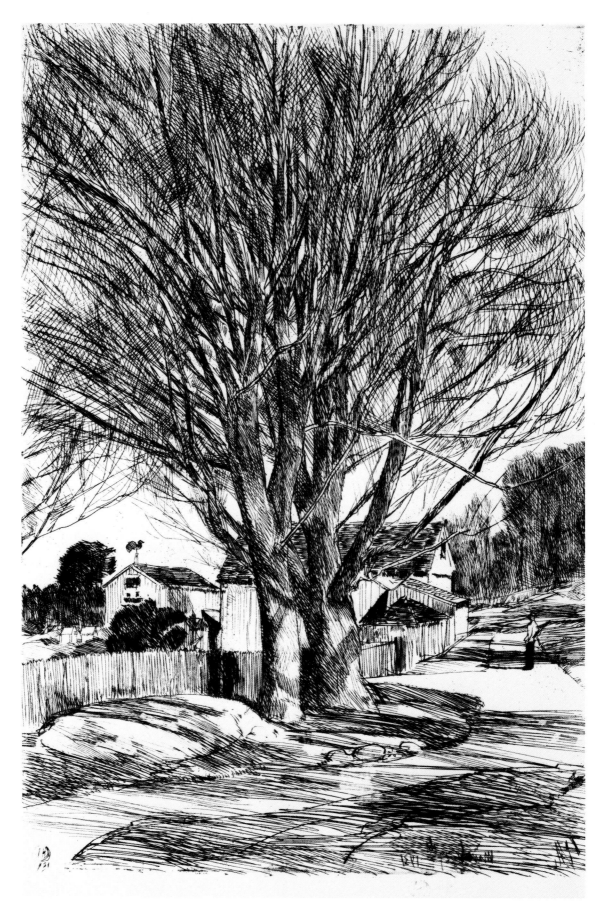

337. MAPLES IN EARLY SPRING

342. AMERICAN ELMS, BELFAST, MAINE

13 $\frac{3}{4}$ by 9 $\frac{3}{4}$ inches. 1931.
From a drawing of 1914. Shadows on street. Elms form an arch over
street. Houses on street. Figures.

343. DOWN HILL — WEST 152ND STREET

5 $\frac{15}{16}$ by 4 inches. 1931.
From a drawing of 1921. Boys playing marbles on street in New York.
View of Hudson and the Palisades.

344. OAK AND OLD HOUSE IN SPRING

8 $\frac{3}{8}$ by 11 $\frac{1}{8}$ inches. 1931.
Easthampton. Shadow on ground and house.

345. AUTUMN AFTERNOON

8 $\frac{3}{8}$ by 11 $\frac{1}{8}$ inches. 1931.
Trees and cemetery. Leaves and shadows on ground.

346. THE GUILD HALL, EASTHAMPTON

6 $\frac{1}{2}$ by 8 $\frac{3}{8}$ inches. 1931.
Fence, figures. Billboards in front of Guild Hall. Elms.

347. THE BIRCH GROVE

9 $\frac{1}{8}$ by 6 $\frac{3}{8}$ inches. 1931.
Birches. Foliage.

348. THE HEART OF EASTHAMPTON

7 $\frac{1}{2}$ by 15 $\frac{1}{4}$ inches. 1931.
Foreground with man and milk pail. Chickens. Gothic church.
Windmill shown in back of "Home Sweet Home Cottage" and the
Mulford House.

349. BEECH TREES AND OBELISK

10 $\frac{3}{8}$ by 6 $\frac{3}{8}$ inches. 1931.
Trees in Central Park. Tall Beeches. Paths, people, and Obelisk in
distance.

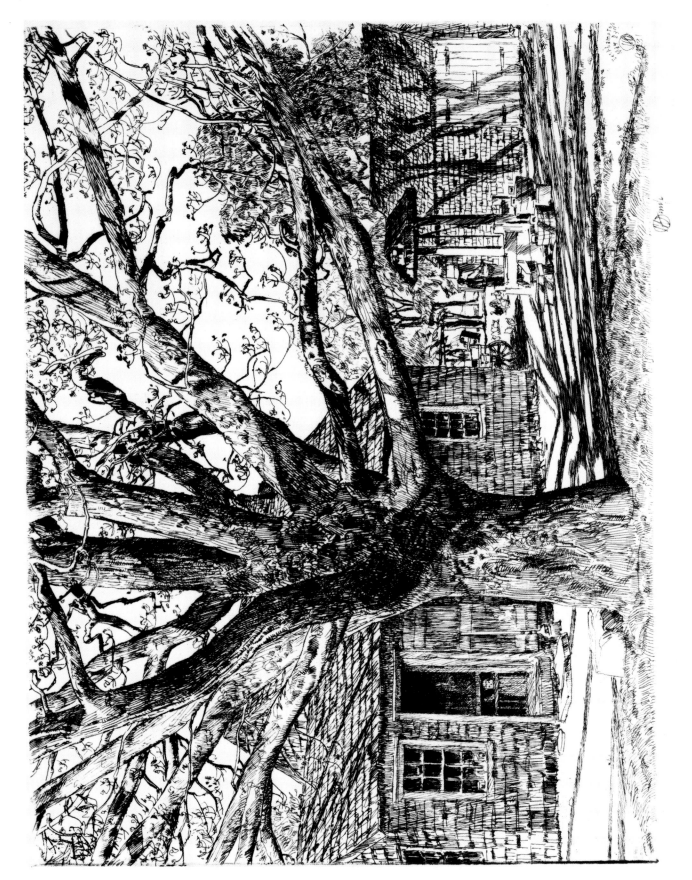

344. OAK AND OLD HOUSE IN SPRING

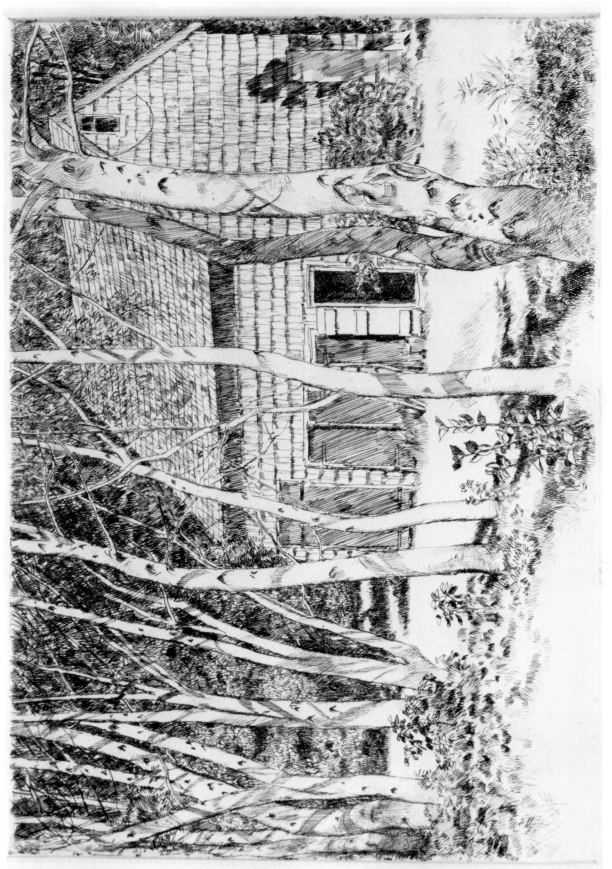

364. THE OLD BARN AND THE BIRCHES

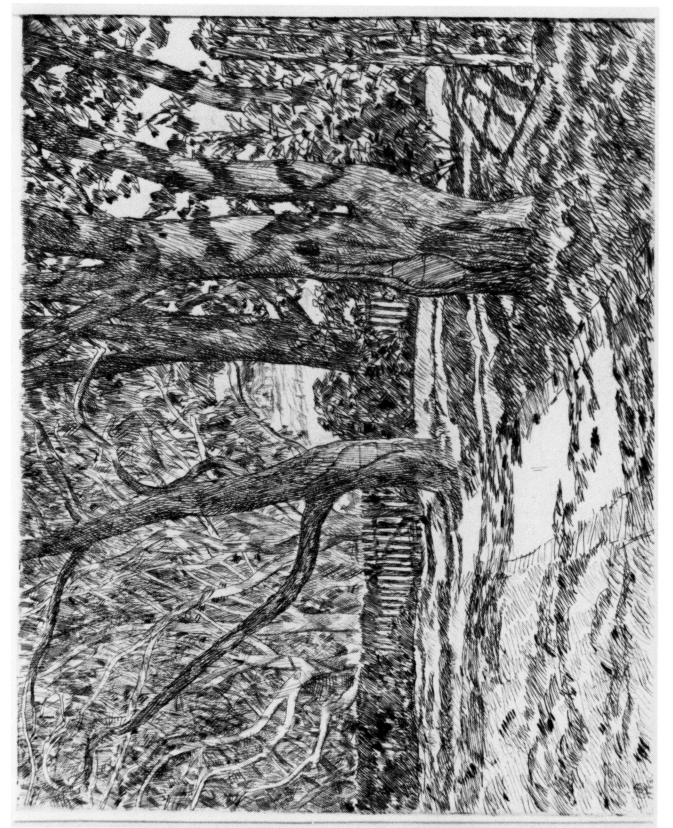

368. THE OLD ORCHARD, EASTHAMPTON

350. MOUNT VERNON, WASHINGTON

6 $^3/_8$ by 10 $^7/_8$ inches. 1932.
Washington's home. Modelled sky. Figures in background.

351. AFTER STUART —

9 $^5/_8$ by 6 $^5/_8$ inches. 1932.
Portrait of George Washington.

352. THE PANAMA HAT

3 $^1/_2$ by 3 inches. 1929.
Girl with face in shadow. Leaves in background.

353. ROSE OF GREENWICH VILLAGE

5 $^7/_8$ by 3 $^3/_8$ inches. 1932.
Shadow at back of figure.

354. THE ARSENAL — CENTRAL PARK

11 $^3/_8$ by 6 $^3/_8$ inches. 1932.
Figures in foreground. Dark entrance to old Arsenal Building, used for
police station of Central Park. Eagle shown in front of building. 64th
street, near 5th Avenue.

355. THE LITTLE SYCAMORE TREES

11 $^3/_8$ by 6 $^3/_8$ inches. 1932.
West 54th Street. Figures walking in street. Buildings in shadow.
Some pulled on old paper.

356. THE LOCKET

3 by 2 inches. 1921.
A baby's head — face in shadow. Dark background. Some pulled on old
account book paper.

357. THE WATCH CHARM

2 by 2 inches.
Head of a woman in a circle.

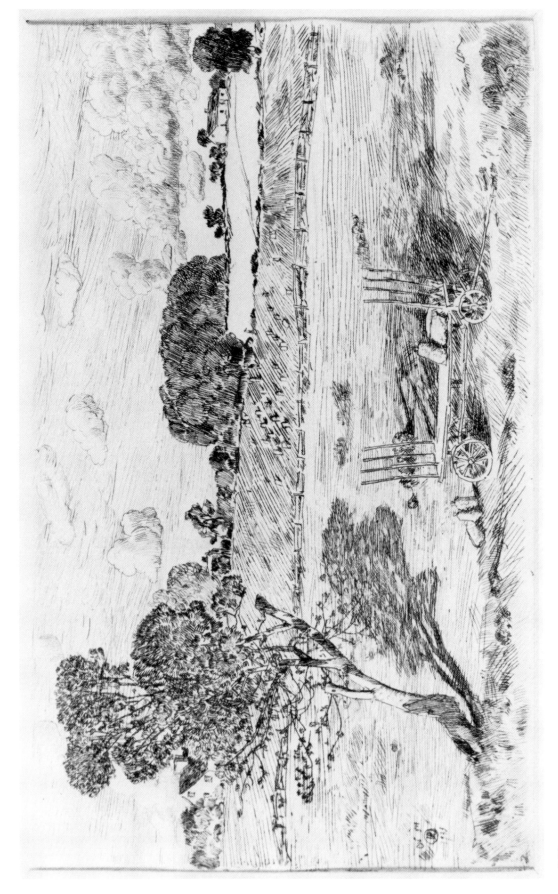

369. THE OLD WILD CHERRY TREE

358. THE HOUSE UNDER THE LEDGE — GLOUCESTER

4 $^7/_8$ by 7 inches. 1919.

Houses, trees.

359. GENEVA, N. Y.

7 $^1/_{16}$ by 5 $^1/_{16}$ inches. 1929.

Children in foreground. Steps ascending hilly street. Trees and houses at top of hill. Washington Street.

360. ST. MATTHEWS, EASTHAMPTON

4 $^1/_2$ by 3 inches. 1933.

Old church in Easthampton.

361. AMY'S LANE, EASTHAMPTON

3 by 4 $^5/_8$ inches. 1933.

A lane and fields in Easthampton.

362. GREEN GATE

4 $^1/_2$ by 3 inches. 1933.

A gate in Easthampton. Foliage in background.

363. THE BEACH CLUB, EASTHAMPTON

4 $^5/_8$ by 11 $^1/_8$ inches. 1933.

Figures on beach of Easthampton. Swimmers in water.

364. THE OLD BARN AND THE BIRCHES

7 $^9/_{16}$ by 10 $^{13}/_{16}$ inches. 1933.

Easthampton. View at the rear of artist's summer home. Old barn with group of birches.

365. THE MAIDSTONE BEACH CLUB, EASTHAMPTON

4 $^9/_{16}$ by 12 $^1/_8$ inches. 1933.

Figure of young woman on beach. People, surf and sky.

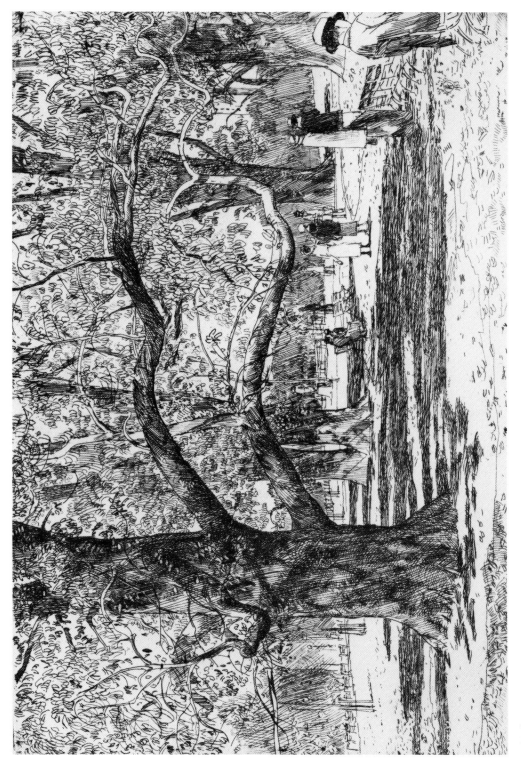

375. THE ENGLISH ELMS

366. THE BLACK WALNUT TREE

11 $^5/_8$ by 8 $^1/_4$ inches. 1933.
Young woman seated on bench on open porch facing tree in Easthampton.

367. AEOLUS AND CHLORIS
[THE GREAT DUNE, EASTHAMPTON]

5 $^7/_8$ by 12 $^7/_8$ inches. 1933.
Two nude figures walking over the dune, sky and surf.

368. THE OLD ORCHARD, EASTHAMPTON

8 by 10 inches. 1933.
Old trees and path. Shadows on ground.

369. THE OLD WILD CHERRY TREE

5 $^{15}/_{16}$ by 9 $^7/_8$ inches. 1933.
Old tree in Easthampton. Wagon and field. Houses in distance.

370. OUT-OF-DOORS, SELF-PORTRAIT

9 $^1/_{16}$ by 7 $^1/_8$ inches. 1933.
Full length Self-Portrait of the artist, made in Easthampton.
Mr. Hassam is etching on a copper plate — standing on a boardwalk —
being reflected in a mirror in one of the Cabañas of Maidstone Beach
Club. Probably first time in history of graphic art that a self-portrait
was made out-of-doors in sunlight.

371. EIGHTEEN HUNDRED AND FIFTY-NINE

10 by 8 inches. 1933.
Interior of old house with mantel, Easthampton, dating to 1859; which is
incidentally the birth year of the artist. Costumes of 1859 —
found in attic — Jonathan Thompson Gardiner House.

372. MISSISSIPPI STEAMBOAT

3 $^{15}/_{16}$ by 6 $^3/_8$ inches. 1933.
Made from drawing of 1925. Old river boat on Mississippi, rear
paddlewheels turning.

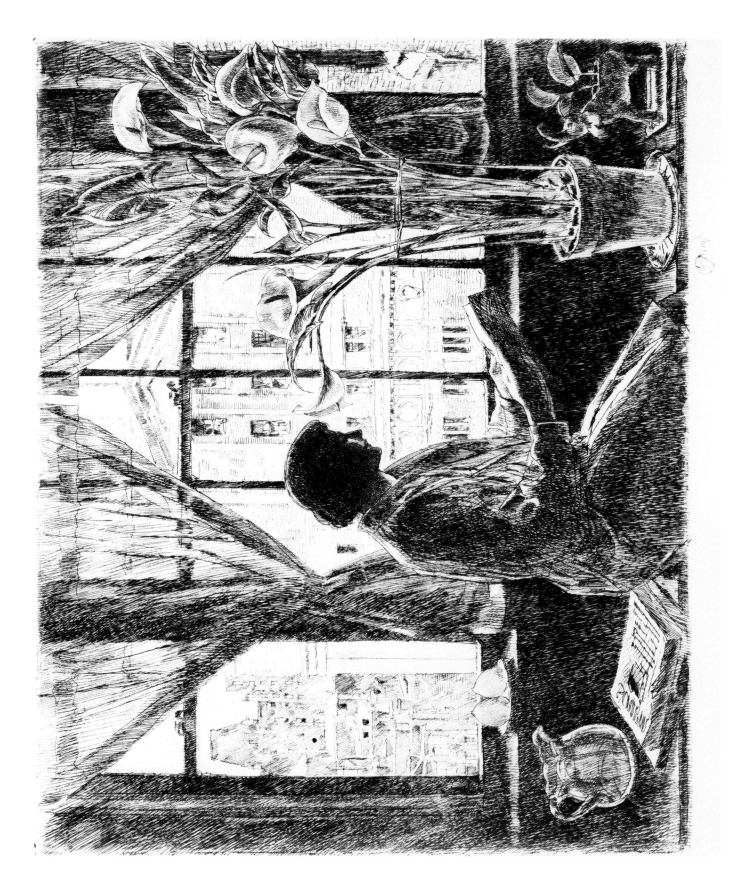

378. VIRGINIA AND A NEW YORK WINTER WINDOW

373. APPLEDORE, SECOND VERSION

9 3/8 by 6 1/2 inches. 1922.
Nude figure of young woman at shore. Near a cliff.

374. END OF PLAINSTONE CLOSE

7 by 5 inches. 1927.
Started in 1883. 2nd Version of drawing made in Edinburgh, Scotland.
Figures and rear of Close.

375. THE ENGLISH ELMS

5 1/8 by 7 7/8 inches. 1933.
Large English elms at left of south end of the Mall of Central Park, New
York. Figures, statue, shadows on ground.

376. KAMENOI OSTROV

3 1/2 by 7 3/4 inches. 1933.
Started in 1913. Etching of Appledore and Smutty-nose — with a little
nude figure plunging into the live water — back of huge geyser of spray.
Named after well known composition by Rubenstein.

377. BOWLING ON THE GREEN

8 3/16 by 13 1/2 inches. 1931.
Published by the American Art Foundation in *Twenty Masterpieces in
Etching* (Life of George Washington), a portfolio with works by twenty
artists.

378. VIRGINIA AND A NEW YORK WINTER WINDOW

10 7/16 by 12 29/32 inches. 1934.

379. THE PLATE PRINTER, PETER J. PLATT

12 7/8 by 12 3/8 inches. 1934.

380. C.H. ETCHING 1934

9 23/32 by 7 11/16 inches. 1934.

CORRECTED INDEX

TO

CATALOGUE OF THE ETCHINGS AND DRY-POINTS OF CHILDE HASSAM, N.A.
Revised Edition 1989

CORRECTED INDEX

CORRECTED INDEX

CORRECTED INDEX

INDEX

INDEX

INDEX

LIST OF REPRODUCTIONS